T0055268

ABSINTHE

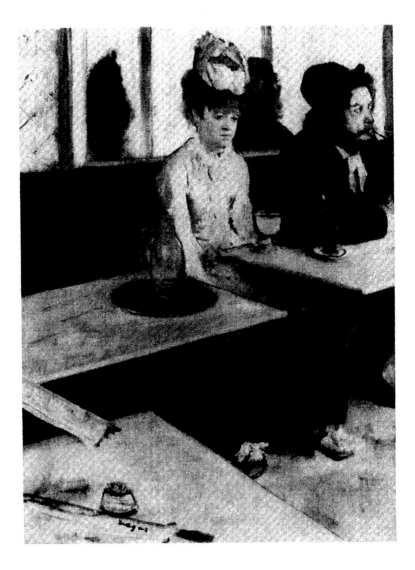

ABSINTHE

The Cocaine of
the Nineteenth Century

*A History of the Hallucinogenic Drug
and Its Effect on Artists and Writers
in Europe and the United States*

by DORIS LANIER

McFarland & Company, Inc., Publishers
Jefferson, North Carolina, and London

The present work is a reprint of the library bound edition of Absinthe — The Cocaine of the Nineteenth Century: A History of the Hallucinogenic Drug and Its Effect on Artists and Writers in Europe and the United States, *first published in 1995 by McFarland.*

Frontispiece: Edgar Degas, *L'Absinthe* (1878) Musée d'Orsay, Paris (79EN505). Marcellin Desboutin and Ellen Andree are the subjects in the painting.

LIBRARY OF CONGRESS CATALOGUING-IN-PUBLICATION DATA

Lanier, Doris.
 Absinthe — the cocaine of the nineteenth century : a history of the hallucinogenic drug and its effect on artists and writers in Europe and the United States / by Doris Lanier.
 p. cm.
 Includes bibliographical references and index.

 ISBN 0-7864-1967-9 (softcover : 50# alkaline paper) ∞

 1. Absinthe — History. 2. Drinking customs — France — History —19th century. 3. Drinking customs — United States — History —19th century. I. Title.
GT2898.L36 2004
394.1'3 — dc20 94-29166

British Library cataloguing data are available

©1995 Doris Lanier. All rights reserved

No part of this book may be reproduced or transmitted in any form or by any means, electronic or mechanical, including photocopying or recording, or by any information storage and retrieval system, without permission in writing from the publisher.

Front cover: Background photograph ©2004 Dynamic Graphics; foreground image ©2004 Clipart.com

Manufactured in the United States of America

McFarland & Company, Inc., Publishers
 Box 611, Jefferson, North Carolina 28640
 www.mcfarlandpub.com

CONTENTS

Preface vii

1 A History of the Drink 1

2 Abuse and Prohibition in France 14

3 Verlaine, Rimbaud, Wilde and the Others 46

4 From Van Gogh to Picasso 75

5 New Orleans and Elsewhere in the United States 123

Conclusion 152

References 157

Bibliography 169

Index 177

PREFACE

During the late nineteenth and early twentieth centuries, absinthe drinking was a major social, medical, and political phenomenon, particularly in France, but also in other parts of Europe and in the United States. A bitter, potent drink, with an alcoholic content as high as 80 percent, absinthe was made by mixing the leaves of the plant wormwood (*Artemisia absinthium*) with plants such as angelica root, fennel, coriander, hyssop, and marjoram and adding anise for flavor. Though wormwood was used in ancient times to alleviate the symptoms of a host of ailments, among them epilepsy, gout, drunkenness, kidney stones, colic, and headaches, when combined with alcohol and consumed in excess, it became a narcotic poison, producing a variety of disturbing physical and mental problems. French soldiers were introduced to absinthe in the early nineteenth century in Algiers, where they drank absinthe to alleviate the symptoms of fever and dysentery and to purify water. It was first produced in quantity in France not long after, in the early part of the nineteenth century, when the Swiss firm of Pernod set up a factory in Pontarlier in the Doubs region. At first popularly known as "the green fairy," it came to be called, as its deleterious qualities became better known, "the plague," "the enemy," and "the queen of poisons."

This book is a study of absinthe use and abuse in Europe, principally in France, and in the United States, mainly in New Orleans. For several decades, the drink caused social problems of great magnitude—similar to the cocaine problems of this century—partly because it became associated with inspiration and freedom and became a symbol of French decadence. The book examines the extent to which the lives of talented young writers and artists of the period became caught up in the absinthe craze.

Following a brief history of the drink, I proceed chronologically. I discuss the drink's rise in popularity in the late nineteenth century,

the extent to which it was consumed and by whom, the resulting epidemic of absinthe addiction, the problems created by addiction, and the resulting temperance movement. I next look at the artists and writers of the period who become involved in what one writer refers to as "the great collective binge." A major part of the work deals with the literary men and artists whose lives become entangled with "the green fairy"—either from becoming addicted to the drink or by producing writings or art that reflect the absinthe era. Among the artists and writers discussed are the poets Verlaine, Rimbaud, Wilde, and others, and such artists as Van Gogh, Degas, Manet, Toulouse-Lautrec and Picasso. I also discuss the extent to which absinthe drinking became a problem in the United States, particularly in New Orleans. Included herein are numerous illustrations, including reproductions of absinthe-related paintings by the artists who participated in and observed the absinthe phenomenon.

I have included a great deal of biographical information on the poets, writers, and artists of the period, many of whose lives were devoted as much to the green drink as to their art. This information, generally, illuminates the experiences and forces in the lives of these talented people that made them more vulnerable to the allure of the drink than many of their contemporaries, who looked upon their debauchery with fascinated wonder. The biographical material shows the isolation and loneliness of these people, whose talents set them apart at an early age, making them feel rejected, different, and separate from the rest of humanity.

I have also made heavy use of anecdotes, which not only add interest but also bring the people and the period to life. While they may not always be thoroughly reliable, the anecdotes reflect the feelings and the attitudes of the people of the period in a way not possible by other means. In addition, at times, I have quoted extensively from on-the-scene observers, which, I feel, adds authenticity and immediacy to the work. It seems to me that no paraphrase can do justice to words spoken by someone who witnessed a scene a century ago and who intimately knew the participants and were familiar with the surrounding circumstances.

Finally, the extensive bibliography, which is the result of ten years of research and which covers more than a century, will be of interest to social historians, literary scholars, and art historians. Though some French scholars have discussed the absinthe problem in France, most of what has been written on the subject is in magazine articles, chapters or pages in books, or old newspapers, which

I found to be a rich source of information. The book includes a goodly amount of material that has not been published previously in book form and has, therefore, not been readily available to scholars.

Doris Lanier
Summer 1994

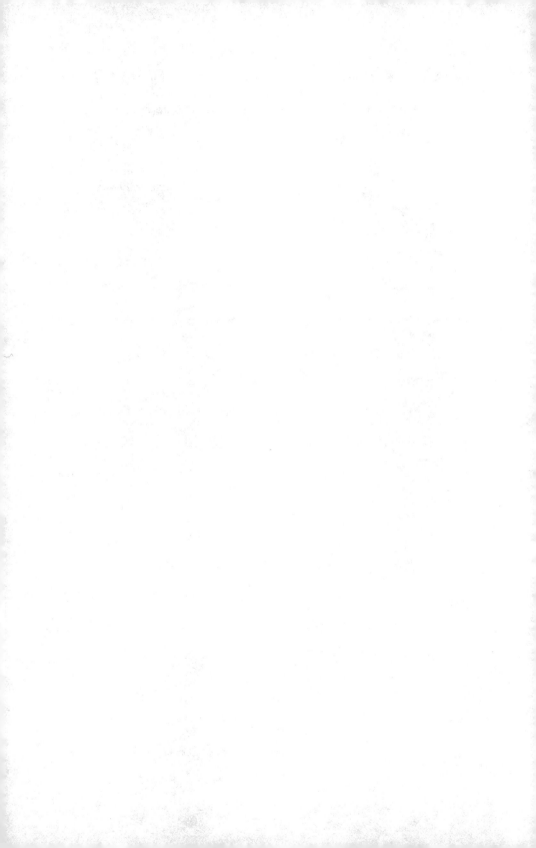

1

A HISTORY OF
THE DRINK

In discussing drinks flavored with anise, one of which is absinthe, the food and travel writer for a popular home magazine attributes part of their appeal to the fact that they "call up a sort of sweet decadence because of a history rich in carnal and narcotic connotation." The same writer says, "What anise drinks offer is a sweet snifter of history, an immensely evocative tipple—none more so than the absinthe that was the cocaine of the nineteenth century."[1] It is no wonder that the term "absinthe," which refers to an aperitif popular in the late nineteenth and early twentieth centuries, evokes thoughts of narcotic intrigue, euphoria, eroticism, and decadent sensuality. All of these qualities became associated with the drink during what one writer calls "the great collective binge"[2] that occurred between 1880 and 1914, especially in France, but also in other parts of Europe and the United States. Since that time, absinthe has been banned in all countries except Spain.[3]

Ironically, the Greek word *apsinthion*, from which the term absinthe was derived, means *undrinkable*. The common English term is *wormwood*,[4] which is usually associated with bitterness or extreme sorrow. Oil of wormwood was used as a medicine in ancient times to kill intestinal worms, thus the name.[5] Its effectiveness in this area was recognized over the centuries. In 1597, writing in his book *Herball*, John Gerard said that "Wormwood voideth away the wormes of the guts."[6] But, in spite of its meaning, according to those familiar with the effects of the drink, absinthe can produce "euphoria without drunkenness," a "heightening of the senses," and, in general, an effect similar to that produced by opium or cocaine.[7] Overindulgence

1

in the drink, however, can result in addiction, after which one can expect rapid mental and physical deterioration and a premature death.

A bitter liquor, absinthe is made chiefly from the leaves and the top part of the plant wormwood (*Artemisia absinthium*) and certain aromatics such as angelica, anise, balm mint, and hyssop. The drink is concocted by mixing the leaves and the top parts of the wormwood plant with angelica root, star-anise seeds and other aromatics and allowing them to macerate in alcohol for about eight days, after which the liquor is distilled and anise oil is added. The combination of herbs, oils, and alcohol may vary, depending on whether the drink is of good or inferior quality.[8] Pale green, almost emerald in color, the drink has a strong, licorice-like flavor, which is contributed by the anise and which disguises the bitter taste of the wormwood in the drink.[9] The absinthe consumed in the late nineteenth and early twentieth centuries in Europe and America had an alcoholic content of about 72 to 80 percent.[10] According to one researcher, "drinking [absinthe] straight [was] about the same as drinking pure alcohol diluted one third with water."[11]

The plant *artemisia* may have been named after the Greek goddess of the hunt, Artemis, whose temple at Ephesus in Asia Minor was marvelled at in ancient times. Or it may have been named for the ancient Queen Artemisia II of Asia Minor, queen of Halicarnassus in Caria, who was knowledgeable about the healing properties of certain plants and was supposed to have been healed by the plant. Unfortunately, however, the plant did not keep her husband Mausolus from his death. The mausoleum she built at Halicarnassus to honor him after he died was another of the wonders of ancient times. It has been said that so great was her grief at his death that she mixed his ashes in a drink and consumed them. Other mythological sources say that Diana gave the plant to Chiron, the Centaur, to help him heal diseases.[12] Copies of the Ebers Papyrus, which include writings from 3550 to 1550 B.C., probably contain the earliest account of man's use of wormwood.[13]

The most dangerous ingredient in absinthe is the potent, bitter oil which is extracted from the wormwood and which contains the narcotic *thujone*. Some believe *thujone* can cause vicious behavior, nervous problems, and even insanity.[14] Indeed, since Biblical times, wormwood has been symbolical of bitter sorrow, calamity, or cruel punishment. In Jeremiah (9:15 and 23:15), for example, a wrathful God promises to punish the people of Israel with wormwood and gall, and in Revelation (8:11) a star called Wormwood falls to the

earth, causing a third of the water to become bitter and to kill many people.[15] Many times in the Bible wormwood is connected to gall to express something offensive and nauseous—or to express the extremity of bitter experience; wormwood also has been traditionally associated with Christ's crucifixion in that some people believe that Christ was given wormwood to drink when he was crucified. One legendary account of the origin of the plant says that wormwood "grew up in the winding track of the serpent as she departed from paradise."[16]

Wormwood was also believed to be beneficial when used for medicinal purposes; Jerome Moses, in discussing various qualities of the plant, says that in early times, "*artemisia* had special value, especially for women who used them for steam baths." "The plants from this genus," he says, "allegedly could drive sickness from the body, enhance fertility in barren women, break up gall stones, restore the memory, prevent tiredness, and ward off dangerous animals."[17] The ancient Greek physician Hippocrates, known as the father of modern medicine, prescribed it for various ailments, among them menstrual pains, anemia, and rheumatism. Wormwood was also reputed to prevent lice and to act as an antidote to poisonous fungi, to hemlock, and to bites of certain poisonous reptiles.

Dioscorides, writing in the *Juliana Codex* in the first century, said that wormwood "was a fine antidote to intoxication." It was described at length in his *De Materia Medica*, which was written in A.D. 65 and was considered an authoritative text for pharmacy for over a thousand years. Wormwood plants were often thrown on fires to fumigate sick rooms or rooms in which someone had died.[18] The Greek physician Galen (138?–201?), who achieved fame for his studies in physiology, recommended absinthe for physical infirmities and fainting spells,"[19] while the medieval alchemist Paracelsus was the first to use wormwood to treat fever, especially malaria. This plant and other herbs were frequently mixed with alcoholic concoctions and dispensed as medicines during the Middle Ages.[20]

Along with the belief that wormwood had medicinal value, other beliefs and various legends became associated with the plant over the centuries. In Europe at one time it was believed that on St. Luke's Day a person could see a vision of his heart's desire if he would drink a mixture made of vinegar, honey, various herbs, and wormwood. Indeed, such a concoction probably would produce hallucinations if drunk in large quantities. In the Middle Ages, the plant was believed to have qualities that would ward off evil of various kinds. It was sometimes worn about the waist, as were other

herbs, to protect a person from witchcraft and to insure that no one could cast an evil spell over the person. It was common practice for the fires of Midsummer Eve to be fueled with the plant to ward off evil for an entire year.[21]

According to Pliny the Elder, a first century Roman scholar, in his day, the winner of the chariot races was often required to partake of a brew of absinthe and wine "to remind him that even glory has its bitter side."[22] He also refers to a wine containing wormwood called "absinthites." Vermin of various kinds could also be controlled by using wormwood. Gnats and fleas were repelled by the oil of the plant, and moths would not bother clothing that was stored with leaves of the plant.[23] In 1486 *St. Alban's Hawking Book* recommended absinthe for ridding hawks of mites. In 1577 in *July's Husbandry*, Thomas Tusser wrote: "Where chamber is swept, and wormwood is strown, no flea for his life dare abide to be knowne." And in 1626, in *Anything for a Quiet Life*, Thomas Middleton mentions wormwood's being used to exterminate fleas out of doors.[24]

Since earliest times the plant has been used in the preparation of various drinks. One practical use of the plant was as a preventive for wine spoilage—a small sprig of wormwood was added to the wine to discourage the growth of microorganisms that caused the wine to spoil. The German word for wormwood is *Wermut*, or vermouth. Originally vermouth, the "progenitor of absinthe," had either wormwood leaves or some oil of wormwood added. Teas were also made from the plant. In 1577, writing in *July's Husbandry*, Tusser praised the plant for its comforting qualities. "It is a comfort for hart and the braine, and therefore to have it is not in vaine," he said.[25] In 1559 Peter Morwyng's publication *Treasure of Evonymous* included information about a drink made from soaking wormwood leaves in wine.

The working classes of Tudor times enjoyed the "purl" of England, an ale made partly from *Artemisia maritima*; Shakespeare refers to purl in *The Merry Wives of Windsor*. And even Samuel Pepys, in his diary, mentions drinking some "wormwood ale" in "a bawdy house."[26] And the renowned medical botanist Dr. John Hill in 1772 recommended as a remedy for gout and gall stones a concoction that was made by steeping the flowers of wormwood in a pint of brandy for about six weeks. He claimed that he had used the remedy, which he got from Baron Haller, with great success.[27]

Many people in the eighteenth century, believing that wormwood was a preventive for plagues, kept liberal quantities of it in their

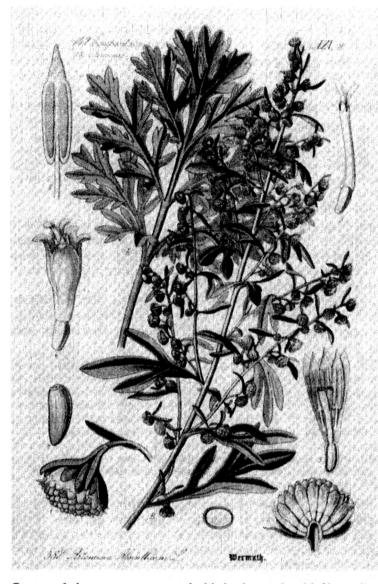

Commonly known as wormwood, this herb was the chief ingredient in absinthe drinks in the late nineteenth century. The plant was also used as a remedy for stomach worms, gout, kidney stones, jaundice and muscle sprains. California Academy of Sciences, Special Collections.

homes, either scattered about the floor, hung on the walls, or stuffed in pillows. It was burned in fireplaces as a fumigant, and clothes were boiled in vats to which the plant had been added as a disinfectant. According to biologist Dr. William Emboden, research associate of the Natural History Museum of Los Angeles County and the Botanical Museum of Harvard University, "the wormwood trade in London was greatly enhanced by a rumor in July of 1760." He explains:

It was whispered all over town that the plague had broken out in St. Thomas's Hospital. On the day following the instigation of that rumor, the demand for wormwood was so great that the herb sellers in Covent Garden could not meet it. In the following days, the price of the herb rose by 40%; and villagers from outlying areas flocked into London to make a handsome profit on their wormwood. When the supply was all but gone, it was found that the rumor of the plague was false.[28]

According to Emboden, wormwood's reputation was improved considerably in England by Nicholas Culpepper, an astrologer, physician, and botanist, who lauded the virtues of the plant in his book *The English Physician*, which has remained in print since its publication in the seventeenth century.[29]

In the 1780 edition of *The English Physician*, after delightfully commenting that "the herb [Artemisia] is good for something, because God made nothing in vain," Culpepper describes the various qualities of the plant as follows:

Wormwood is an herb of Mars . . . it is hot and dry in the third degree. Wormwood delights in Martial places, for about forges and iron works you may gather a car-load of it. It helps the evils Venus and the wanton boy produce. It remedies the evils choler[a] can inflict on the body of a man by sympathy. Wormwood, being an herb of Mars, is a present remedy for the biting of rats and mice. Mushrooms are under the dominion of Saturn, if any have poisoned himself by eating them, Wormwood, an herb of Mars, cures him, because Mars is exalted in Capricorn. Suppose a man be bitten or stung by a martial creature, imagine a wasp, a hornet, a scorpion, Wormwood . . . gives you a present cure.[30]

Other "extravagant claims" that Culpepper makes about wormwood concern its usefulness in "freeing virgins from the scab, curing melancholy in old men, making covetous men splenetic, curing the right eye of a man and the left eye of a woman . . . curing both spleen and liver, preventing drunkenness and, most importantly, preventing the pox [syphilis]." He ends his discussion by saying, "This shall live on when I am dead."[31]

Shakespeare was most certainly familiar with the drink. According to Emboden, "[Wormwood] is the plant that is used in *A Midsummer Night's Dream*. Oberon touches Titania's eyelids with this

plant of Diana to counteract the effects of the wild pansy [pain's ease, or love-in-idleness]." Oberon chants:

> Be as thou was wont to be;
> See as thou was wont to see;
> Dian's bud o'er Cupid's flower
> Hath such force and magic power.

And in *Hamlet* when Hamlet utters "Wormwood . . . Wormwood," the expression is probably related to the practice that wet nurses had of wiping their nipples with wormwood to wean the babies they were nursing. It was a "bitter betrayal" for both Hamlet and the babies.[32]

Absinthe was alluring not only because of its narcotic and curative qualities but also because of its reputation as an aphrodisiac.[33] The erotic reputation of anise—a key ingredient in absinthe drinks—dates back to Pliny the Elder. In his *Natural History*, when Pliny discusses the medicinal powers of various spices and herbs, he includes anise as an aphrodisiac and even goes so far as to recommend its use in wedding cakes.[34] Various other accounts exist of the efficacy of anise as a sexual stimulant; King Edward IV of England was one believer in its power and was known to have ordered his sheets scented with aniseed to get the full effect of its power,[35] and, according to the 1480 Royal Wardrobe Accounts, Edward's linen closet was perfumed with "lytil bagges of fustian stuffed with ireos and anneys."[36] In her book *French Provincial Cooking*, Elizabeth David tells of a honeymoon couple in Rouen in 1855, who, after eating a huge meal and drinking three glasses of wine, topped off the feast with two glasses of absinthe, along with fruits and cheeses and coffee.[37] Marie Brizard's anisette, a popular eighteenth century liquor, contained anise. Though the drink was first used only for medicinal purposes, according to one writer, "when the fashionable Duc de Richelieu, noted for his sexual prowess, took to knocking it back, Marie's business boomed." Some people still contend that "a little dried aniseed in the linen closet makes for sweet dreams."[38] The ancients, similarly, believed that a little anise on one's pillow would ward off unpleasant dreams and would also "make the face look younger."[39]

The use of anise for its healthful and curative properties goes back to the ancient Egyptians, Greeks, and Romans. Pliny recommended anise for several ailments: burned and inhaled, it would relieve headaches; added to water it would remove cancerous growths in the nasal passages; parched anise mixed with honey would relieve

phlegm in the chest; anise, poppy, and honey—mixed and divided into bean-sized pieces—would cure "flatulence of the stomach, griping of the intestines and coeliac trouble" if taken three times a day; mixed with almonds, it would relieve pains in the joints. Advocated almost as a cure-all, among other things anise was used to induce sleep, to remedy kidney problems, to make childbirth easier, to counteract fatigue, and to provoke vomiting. Pythagoras believed that "no epileptic fit occurs while anise is held in the hand," and for this reason he advised that it "be planted near the home." Pliny contended that even smelling anise would "make for easiser childbirth" and would "stop sneezing."[40] The Romans in the first century, to avoid indigestion after a big feast, ate a piece of a spiced cake that was seasoned with anise. As late as 1305, anise was popular enough in England that King James I included it as one of the commodities to be taxed to raise money to repair London Bridge.[41] In 1491 Jacob Meydenbach wrote *Hortus Sanitatis,* ostensibly a medical guide and a copious work derived from botanists and herbalists of past centuries. Meydenbach describes anise this way:

Anise has an odor that is goodly and strong. And that which comes out of the Island of Crete is the best. And after that the sort that is from Babylon. . . . It may be employed in a fumigation of the nostrils and so will ease an aching head. For an aching of the ears it may be used with oil of roses to lessen the pains, and yet again to take away the griefs of a belly stuffed with wind.[42]

Today, anise seeds are still used to flavor foods and beverages, and medicine such as cough drops and syrups sometimes contain anise, giving the product the taste of licorice. It is still used as a carminative (to relieve the distress of gas pains); pharmacologists have substantiated that it is effective when used for that purpose.[43]

Certainly, to some people the anise in the drink produced a tantalizing taste and odor, making the drink even more appealing than other alcoholic drinks. A twentieth-century writer describes drinks flavored with anise in the following way:

There is something about the spirits laced with aniseed that suggests over-ripe fruit on a hot summer's day, when the fruit is in that highly scented state, about to burst the skin and spoil. Or a crowd of magnolia or lilac in an enclosed garden. These drinks are not, of course, made of fruit or flowers, but simply of neutral spirit distilled from grain and flavored with anise. But the direct, licorice-like taste and the smell—heady, rich, a little brazen— instantly evoke an idyllic drowsiness.[44]

The history of the drink as a narcotic began around 1790, when French refugee Pierre Ordinaire settled at Corvet, Switzerland,

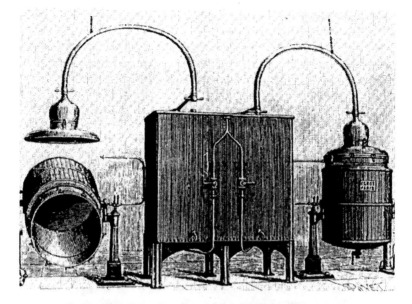

A typical nineteenth-century steam-heated still used in the production of absinthe. Illustration from L. Baudry de Saunier, *La Majesté l'Alcool.* Courtesy of the Seagram Museum, Waterloo, Ontario.

where he became known for his skills as a physician, particularly for his homemade medicines, some of which he concocted from plants in the area. One of these, an extract of wormwood, was so effective when administered as a stomach tonic to patients that it was extensively made and sold to others[45] and soon acquired the nickname "La Fée Verte (the green fairy)." Some time around the first part of the nineteenth century, probably after Ordinaire's death, a Frenchman, Major Dubied, acquired the recipe for the drink, and he and his son, along with his son-in-law Henry-Louis Pernod, began to manufacture the drink. Later, Pernod established a factory called Pernod Fils at Pontarlier, the first of its kind in France, using the recipe originated by Ordinaire.[46] According to P.E. Prestwich, at first the drink was relatively expensive, and its use was "restricted to the middle class and certain artistic groups, where its supposedly hallucinatory effects were much appreciated."[47]

Following its first production, there was a steady increase in its consumption, and in less than a century there was beginning to be great concern about Europeans' overindulgence in the drink, particularly in France and Switzerland, where absinthe was first produced

in quantity.[48] In France, even some of the monkish orders were known to manufacture absinthe, but these orders were later expelled from the country.[49] According to one report, by the 1880s absinthe drinking had grown to be "an enormous evil" in large European cities such as Geneva, Zürich, Berne, Marseilles, Lyon, and Paris, and overindulgence was especially bad among "business and professional men ... journalists, and authors. ..."[50] The greatest absinthe drinkers of all, the French consumed absinthe in epidemic proportions in the latter part of the nineteenth century; absinthe drinking continued to be one of the special marks of Paris in the 1890s,[51] causing generations afterwards to refer to absinthe as "the drink of Parisian abandon."[52]

Though Europeans were the major consumers of the drink after its first production, it was soon exported to the United States, where it quickly became popular in "the little Paris of North America," New Orleans,[53] which came to be known as "the absinthe capital of the world."[54] But United States health officials imposed a ban on the drink in 1912, following the lead of Holland, Belgium, Brazil, and other countries.[55] The drink was banned in France, when, in the face of World War I, government officials finally decided absinthe drinking was "a great evil" and prohibited its use in both the army and navy for fear that its overconsumption was undermining the military strength of the country. The ban was later extended to the entire country.[56] In banning the drink the French were probably influenced by Russia's decision to ban vodka, a ban that reportedly had a major effect on the country's health and economy.[57]

Even though the drink had been banned in most countries by 1915, the appeal of the drink was so great that it was difficult to control its sale, and as late as the 1920s and 1930s, absinthe was still being sold, sometimes in disguised form, in both Europe and the United States.[58] Today absinthe is still legal in some countries, notably Spain, where "its evils are still debated over full glasses."[59]

The leaders of the movement to ban absinthe were mainly concerned about the addictive nature of the drink, the difficulty of curing a person of absinthism, and the mental and physical deterioration that it caused in the habitual user. Calling the drink "seductive and treacherous," a reporter in the October 14, 1879, edition of the *New York Times* contended that the drink was "much more popular, as well as deleterious," than other liquors. He then went on to describe its effects:

At first there is very little reaction from it; it quickens the mental faculties, lends a glow to the health and spirits, and seems to raise man to higher

Advertisement for one of several absinthe distilleries operating in France in the nineteenth century. Courtesy of Musée de la Publicité, Paris.

power. Its encroachments are scarcely perceptible. A regular absinthe drinker seldom perceives that he is dominated by its baleful influence until it is too late. All of a sudden he breaks down; his nervous system is destroyed; his brain is inoperative; his will is paralyzed; he is a mere wretch; there is no hope for his recovery. Victims of intemperance of the common sort frequently reform, but the absinthe drinker, after he has gone to a certain length, very seldom does or can throw off the fatal fascination.[60]

So concerned was Victorian novelist Marie Corelli about the growing number of *absintheurs* in France in the 1890s that she wrote a novel on the subject entitled *Wormwood.* The main character, who is addicted to absinthe, frequently refers to the drink as "the fairy with the green eyes."[61]

This view of absinthe as a seductive and treacherous crippler of man continued for the next several decades. According to a writer of an article which appeared in the May 1915, issue of *Literary Digest,*

In the early stages [absinthe] produces an agreeable feeling of intoxication. By its continued employment, the character becomes changed. To the brightness and gaiety of the first effects succeeds a somber brutishness ... nervous agitation, insomnia, nightmares ... hallucinations ... and profound mental troubles.... Insanity exists chiefly where the consumption of this deadly spirit is highest, and what is worse, the descendants of the absinthe drinker suffers for the sins of their fathers; thus, absinthe makes mad those who suffer from it and weak-minded the next generation.[62]

And an article in the April 24, 1930 issue of the *London Times* carried a warning that "absinthe is liable to cause hallucinations and delirium and set up a craving not unlike that experienced by morphine and cocaine addicts."[63] Many horrid crimes were also attributed to overindulgence in absinthe, and, in fact, the most successful effort to ban absinthe occurred after a Swiss farmer, reputedly under the influence of absinthe, brutally murdered his wife and child.[64]

Several artists of the period were influenced by the drink, either directly or indirectly. As recently as 1981, Michael Albert-Puleo, of Case-Western Reserve University School of Medicine in Cleveland, hypothesized that absinthe had "pharmacologic influences" on Vincent van Gogh's "artistic vision" and played a significant part in van Gogh's art. According to Albert-Puleo, the absinthe drinker "would experience exaltation, auditory and visual hallucinations and excitation." He believed these hallucinations produced by absinthe, in combination with van Gogh's mental illness, certainly "played a part in the strange and wonderful visions the artist captured on canvas."[65] The French painter and lithographer Toulouse-Lautrec, two

years before his death, spent some time in a sanatorium for "nervous diseases" and "alcoholism."[66] His death has been attributed to "his passion for absinthe."[67] He was known to carry a supply of the drink in his custom-made cane for instant rejuvenation.

French painter Edgar Degas, in his 1876 painting *The Glass of Absinthe* shows a "dazed" couple under the narcotic influence of the drink. Similarly, in one of his Blue Period works, *The Glass of Absinthe*, Picasso "captured on canvas the depraved melancholy [absinthe] produced,"[68] and "the tragic danger" involved to anyone constantly under its influence."[69] Artists Rops, Lunois, and Lefebre also "put their talents to use depicting the absintheurs of Paris."[70] Several writers of the period, especially in France, were possibly addicted to absinthe. They included Maupassant, Musset, Poe, Verlaine, Baudelaire, Apollinaire, and Rimbaud among others.[71] And Oscar Wilde's death may have been caused in part by absinthe addiction. Sarah Bernhardt and her partner Coquelin did their part to help popularize the drink. They appeared in colorful advertisements with glasses in hand extolling the virtues of the drink.[72] And according to a fairly recent article in a popular men's magazine, Ernest Hemingway, who was also fond of the drink, was introduced to the Tarragona variety of the drink in 1922 in Spain. According to the writer, Hemingway "reverenced the peculiar effects of absinthe, right or wrong, on the mind and the genitals." On one occasion Hemingway said that whiskey "does not curl around inside of you the way absinthe does. There is nothing like absinthe."[73]

2

ABUSE AND PROHIBITION IN FRANCE

Let me be mad ... mad with
the madness of Absinthe,
the wildest, most luxurious
madness in the world.[1]

So stated Gaston Beauvois, the main character in Corelli's novel *Wormwood*. A passionate and emotional plea, the book was designed to focus attention on the problem of absinthism in France during the last decade of the nineteenth century. The setting of the novel is Paris; the theme is "the destruction of a good and creative man by his addiction to absinthe" (page 1). Corelli voices her concerns through the frequent emotional outbursts of the main character as he helplessly struggles with his addiction, fully aware of and disgusted by the depravity of his life. On one occasion Gaston says:

Give me the fairest youth that ever gladdened his mother's heart, — let him be hero, saint, poet, whatever you will, — let me make of him an *absintheur*! — and from hero he shall change to coward, from saint to libertine, from poet to brute! You doubt me? Come then to Paris, — study our present absinthe-drinking generation, *absintheurs*, — and then, — why then give glory to the English Darwin! For he was a wise man in his time, though in his ability to look back, he perhaps lost the power to foresee. He traced, or thought he could trace, man's ascent from the monkey, — but he could not calculate man's descent to the monkey again. He did not study the Parisians closely enough for that! [page 191].

At the end of the novel, Gaston looks on his life with repulsion.

14

And what am I my dear friends, I have told you,—an *absintheur! Absintheur, pur et simple! voilà tout!* I am a thing more abject than the lowest beggar that crawls through Paris whining for a sou!—I am a slinking, shuffling beast, half monkey, half man, whose aspect is so vile, whose body is so shaken with delirium, whose eyes are so murderous, that if you met me by chance in the day-time, you would probably shriek for sheer alarm! But you will not see me thus—daylight and I are not friends. I have become like a bat or an owl in my hatred of the sun!—... At night I live;—at night I creep out with the other obscene things of Paris, and by my very presence, add fresh pollution to the moral poisons in the air! I gain pence by the meanest errands,—I help others to vice,—and whenever I have the opportunity, I draw down weak youths.... For twenty francs, I will murder or steal,—all true *absintheurs* are purchasable! For they are the degradation of Paris,—the canker of the city—the slaves of mean insatiable madness which nothing but death can cure [page 448].

Finally, another absintheur in "a fit of rage" gives him a phial of poison in exchange for absinthe—"a mere friendly exchange of poisons"—according to Gaston—which he intends to take as soon as he has the "courage to swallow" it.

Though Corelli's novel is probably an overdramatization of the absinthe problem in France in the 1890s, to some extent it expresses the views of many concerned French citizens from about 1880 until 1915, when the drink was finally banned in France. The drink was first produced in quantity in France in the early nineteenth century, after the Swiss firm of Pernod set up a factory in Pontarlier in the Doubs region.[2] But as far as can be determined, the increased availability of the drink at that time had little impact on the drinking habits of the French, who apparently were content to drink wine, a less expensive drink than absinthe. In fact, according to Marrus, even wine was not very popular among the "menu peuple" in France before the sixteenth century. But over the decades wine drinking spread from the upper to the lower class, a trend that continued on in to the seventeenth century. By the reign of Louis XIV, there was a general consumption of wine among both the upper and lower classes, especially in areas of France where vineyards flourished.[3] It was during the French conquest of Algiers (1830–1847) that French soldiers were introduced to absinthe, which was used for fever and dysentery and for purifying water; when they returned to France, they brought their taste for the drink with them.[4] In 1908 E. Ledoux, in discussing the dangers of absinthe drinking, said "delusional insanity was common in [l'Armée de l'Afrique], and was colloquially known as "le cafard.""[5]

But even though the drink was popular among the military,

according to Michael Marrus, as late as the 1860s absinthe was "a fairly exotic drink in France."[6] But that is not to say that the drink was unknown among certain segments of French society, especially among artists and writers. In 1857 Alfred de Musset, French poet, dramatist, and novelist, reportedly died at the age of 47 from drinking absinthe.[7] Édouard Manet's first major painting, *The Absinthe Drinker* (1859), shows a standing, brooding, draped figure in a dark hat with a glass of green liquid by his side and an empty bottle nearby.[8] Manet probably got the idea for the painting while studying under Thomas Couture,[9] who, however, was shocked by the work. Unfortunately, Manet was not allowed to exhibit *The Absinthe Drinker* at the Salon, where paintings were usually exhibited by artists.[10] A few years later, French novelist Henry de Kock included the name of the drink in the title of his popular novel, *Les Buveurs d'Absinthe* (1863), but the drink is hardly mentioned at all.[11]

Though Marrus' research indicates that absinthe was not well known in France in the 1860s, some French citizens thought that it was a problem by that time, at least in some parts of France. In 1860, the same year that opium was legalized in the United States and markets all over the world were opening to opium traffic, Henri Balesta was concerned that absinthe abuse was becoming a problem in some parts of France. In a book on the subject, *Absinthe et absintheurs,* Balesta observed that even children were being introduced to the drink at an early age. "Today," he said, "it is through tobacco and absinthe that youth proves its masculinity." He then continued:

One sees children, scarcely away from maternal surveillance, at the doors of the taverns, who pipe in mouth and glass in hand, initiate themselves into life by copying the veterans of the tankard and the cigar. . . . The newcomer, yesterday timid and chaste, finds himself thrown into the center of a circle of roistering companions who want nothing better than to complete his education. They take him to the cafe, no questions about it. It is a solemn trial for the amateur. This is the moment to show himself, to take his place in the esteem of others, to gain the good opinion and respect of his contemporaries. Waiter, an absinthe "panachee." Good!!![12]

Balesta also gave a specific example of a young child's initiation into absinthe by the child's father and his drinking companions. Having lost his young wife, the father sought companionship and forgetfulness in the local cafes. Having no place to leave his six-year-old daughter, he took her with him, but she remained quiet and sad, casting a pallor over the lively party. One evening her father commanded her to drink some absinthe, a practice that was later continued with the encouragement and the assistance of his friends.

Though repulsed by the taste at first, the small child eventually became accustomed to the drink and became lively and animated after taking the drinks offered by the men. Balesta recounted the situation thus:

Whenever the child fell into a morose state for good or ill, they would have her drink absinthe. The day when, little by little, she was able to drink a full glass for the first time all by herself, it was a real triumph for the father! You'll see, you'll see, his friends kept repeating, that will cure her, the little one, because she has worms and absinthe is a vermifuge, all the doctors will tell you so. Events seemed at first to give credence to these clumsy advisors. The child took on color; her eyes shone with remarkable brilliance; she had flashes of amazing precocious intelligence, and from the somber, taciturn state that the death of her mother had reduced her to, she became laughing and talkative. [The father] ... congratulated himself on this marvellous cure; he increasingly encouraged his daughter to use the terrible remedy he had found for her.[13]

Soon she was begging for the drinks, and eventually was able to drink a full glass; unfortunately, the child soon died from the effects of the drink, and the father in self-condemnation hanged himself.[14]

Balesta also told how young people took up the practice of drinking absinthe. Usually, he said, there was a "veteran" drinker among the group of young people, whose job it became to prepare the drink and to initiate the nondrinkers. Balesta described the moment immediately after the drinks were mixed:

What a moment for a beginner! He is going to realize the dream of two years. He raises his glass slowly, looking for the last time at the contents, then raises it to his lips. He is going to drink. He drinks. He has drunk. The desire is satisfied, the dream realized. Absinthe is no longer a myth to his palate. Ugh! How awful it is, says the poor devil to himself, making a face, and yet everyone drinks it. But he is being watched. Delicious, this absinthe, very novel, I have never drunk anything like it, he exclaims with a delighted expression, which is indeed against his heart and against his stomach. The second swallow goes better. The third is better yet. The last goes altogether well. The game is played. He still doesn't like absinthe, but he is beginning to understand why one likes it, and bluffing it out, he will soon like it himself.... Little by little, under the intoxicating liqueur, he feels an unknown fire lighting his veins, and reaching his brain. His tongue, formerly thick with embarrassment, loosens with the warmth of this fire; he talks, he talks a great deal, and amazingly, he talks well; he is almost witty. His heart overflows with affection, he must love someone.... Life seems more beautiful than ever, the horizon is rosy....[15]

Balesta also wrote about the "brilliant young men on the Boulevard" who were addicted to absinthe and about some women

drinkers, who, he claimed, "assimilated the drink with remarkable facility."[16] Among those brilliant young men who succumbed to the power of the drink were Paul Verlaine, Arthur Rimbaud, and other members of the symbolist movement in France, including artists, musicians, and journalists.

Absinthe was certainly well known in France during and after the Franco-Prussian War (1870–1871); in fact, according to an 1878 article by Lucy Hooper in *Lippincott's*, Paris "was literally suffering from delirium tremens" during that period because of a major increase in the consumption of absinthe. Hooper blamed the drinking epidemic on "the horrors of the seige and the Commune," saying "this period brought about . . . overindulgence in wines and liquors for months, driving many of the people 'mad.'" She pointed out that the French, especially around Paris, drank five times more wine and liquor from October 1870 to May 1871 than they usually drank, partly because of a scarcity of food and an abundance of alcoholic drinks at that time—some people lived basically on bread and wine for weeks on end—and partly for warmth because food was scarce. "Such a regimen," Hooper said, "acting on frames enfeebled by want, on minds exasperated by defeat and sorrow, on passions inflamed by scenes of carnage might drive a whole population distracted." She attributed the increase in population of "madhouses" in the early seventies directly to "the immediate use of absinthe," contending that it certainly caused "the immediate use of absinthe," contending that it certainly caused "much of the insanity that now peoples the asylums of Paris."[17]

While the seige and the Commune may have caused an epidemic of absinthism in the early 1870s, natural and economic forces were also at work to assure that the drink would become popular during the next decades. At first, absinthe was a much more expensive drink than ordinary wine, which somewhat curtailed its consumption by the average citizens of France.[18] However, in the mid–1870s (and again in the 1880s) the vineyards in France were attacked by phylloxera (plant lice), seriously damaging them and causing a shortage of grapes.[19] Thus, manufacturers of absinthe, who had previously used wine alcohol as the basis for their drink, were forced to find a substitute. They turned to a cheaper, industrial alcohol produced from beets or grains. By using this inexpensive alcohol, which became known as *alcool d'industrie*,[20] manufacturers produced absinthe that was cheaper than wine; as a result, Frenchmen of all classes turned to absinthe and similar drinks,[21] and even though heavy taxes were levied on the new distilled spirits in an attempt to protect the

wine industry, improvements in techniques for distilling the alcohol continued to make *alcool d'industrie* cheaper than *alcool du vin*,[22] and the industry flourished. The increased sale of the spirituous alcohol caused immediate serious economic problems among the grape producers in France, problems that were to continue on in to the twentieth century.[23]

By 1879, according to a *New York Times* report, the "dangerous, often deadly habit of drinking absinthe" was steadily growing in France, not just "among foreigners" but "among the native population," and "a good many deaths ... especially in large cities" were "directly traceable to excessive use of absinthe." The "intellectual man" was "particularly susceptible to the drink." "Some of the most brilliant authors and artists of Paris have killed themselves with absinthe," the reporter said, "and many more are still doing so."[24] Again in December 1880, the *New York Times* reported that the practice of drinking absinthe had "augmented alarmingly," especially in Paris, with "officers of the army, business and professional men, and journalists and authors being especially its victims." Warned the *Times* reporter:

A French physician of eminence has recently declared that [absinthe] is ten times more pernicious than ordinary intemperance, and that it very seldom happens that the habit, once fixed, can be unloosed. The same authority says that the increase of insanity is largely due to absinthe. It exercises a deadly fascination, the source of which scientists have vainly tried to discover, although they have no trouble ascertaining its terrible effects. Its immoderate use speedily acts on the entire nervous system in general, and the brain in particular, in which it induces organic changes with accompanying derangement of all the mental powers. The habitual drinker becomes at first dull, languid, is soon completely brutalized and then goes raving mad. He is at last wholly or partially paralyzed, unless, as often happens, disordered liver and stomach brings a quicker end. The liquor is dangerously seductive because it seems, in the beginning, to help the digestive organs, when it hurts them, and very seriously. Many persons have been induced to take absinthe for indigestion, and then gradually have fallen under its baleful influence. The drinker is in most cases in seemingly good health, having no thought of his peril, until the hour when illness has declared itself. He is apt, indeed, to believe that he is remarkably well, and to consider all the stories about absinthe as mere bugaboo.[25]

Absinthism also reportedly caused a "hoarse, guttural absinthe voice," a "wandering glazed absinthe eye," and "cold and clammy hands."[26]

Besides the horrors of the seige and the Commune and the new techniques for distilling alcohol, several other occurrences in the last half of the nineteenth century helped to accelerate the sale, production,

and consumption of alcohol and wine and helped to assure a greater number of absinthe drinkers. First of all, there was a major increase in the number of *débits de boissons* [cabarets and cafes] in France during the last part of the 1860s and thereafter, mainly because of the relaxing of policies governing the opening of such establishments. After the *coup d'état* of 1851, Louis-Napoléon issued a decree which gave Prefects the right to close any cafe or cabaret, to reject applications for new establishments, and to levy fines or have proprietors cast into prison. Napoléon's intention was to curb political uprisings that could begin at these establishments, where it was usual for people to congregate to discuss important political and social issues. Napoléon's plan was partially successful; between 1851 and 1855 the number of such establishments dropped from 350,425 to 291,244.

During the 1860s, however, a more liberal period, the law was almost completely ignored by the Prefects; as a result, in 1869 there were nearly 366,000 cabarets and cafes in France and more consumption of alcoholic drinks than had ever been recorded in France's history.[27] A major increase in *débits de boissons* occurred in the 1880s, after the government "abrogated the Napoleonic law," making it easier for businessmen to set up *débits de boissons*. By the end of the century, France had more drinking establishments than any other country in the world.[28]

Besides the relaxing of laws governing the opening of drinking establishments, the rapid increase in their number can be attributed to several other things. Marrus points out that *débits* were especially important in the lives of the lower-class Frenchmen because "the *débit* was the principal, if not the sole, place in which popular sociability could take place." He explains: "Living in cramped and insalubrious quarters which were often ill-lit and poorly heated, people felt a powerful attraction to the bright, warm and crowded world of cabarets and bistros. Here (and often only here) the working man could feel *chez lui*."[29] Marrus was, most likely, familiar with the views of such writers as French novelist Émile Zola (1840–1902), who even before the Commune tried to convince the bourgeoisie that *cabarets* were popular because most working class people lived in "squalor and poverty." "It is a simple question of milieu," he said in *La Tribune* in 1868. "Workers are suffocating in cramped and miry neighborhoods ... the back alleys adjacent to the rue Saint-Antoine, the pestilential holes of the rue Mouffetard.... When Saturday comes, not knowing where to go to breathe a bit of fresh air, they install themselves in cabarets." Zola believed that the decline of the working class was "inevitable" under these circumstances because

"work requires recreation, and when money is short, when the horizon is closed, one grasps at available pleasure."[30]

During this time the *débitant* [bartender] became one of the most important people in his community. According to Marrus, he was a *personage* who "was respected as a kind of 'social confessor,'" a person "from whom one asked advice and revealed confidences." Marrus further explains:

Just at the outskirts of most large cities, moreover, just beyond the city limits within which alcohol was often subject to special taxes, there were frequently cabarets or inns to which working men would walk on Sundays in order to pass the day drinking away from the urban core. In time cities grew out to embrace these *guinguettes*, but their popularity remained high throughout the nineteenth century.[31]

According to Zola in 1872, "overwork, misery, and fatigue" pushed the laboring class into these drinking establishments, while, on the other hand, the "hypocritical rich wallowed in more sordid and expensive vices—gluttonous addiction to fine wines and absinthe, gambling, and the callous seduction of innocent young girls."[32]

Besides providing a place to socialize, the *débits* provided valuable services to the public that added to their popularity. They made available newspapers, magazines, and writing materials; they cashed checks for their customers, and, indeed, often engaged in a form of banking. "It was not unusual," said Marrus, "for the *patron* to undertake primitive banking responsibilities, taking charge of workers' or soldiers' pay, accepting deposits and withdrawals, providing credit or cashing money orders with less red tape than the postal authorities." They also served as employment agencies and provided overnight accommodations for travelers. In fact, the *débits* were an integral part of the lives of the common people from birth until death, "the places where ordinary people celebrated a birth or a wedding ... [and] to which mourners would repair after a funeral."[33]

As the *débits* increased in number and in popularity, the proprietors increased their services to the public and made them more attractive. In the 1880s and 1890s, "a new *cabaret de luxe* developed for the common people." Marrus explains:

In the capitol there remained open throughout the night in certain quarters, "bars," which were considered in the American style, appeared about the same time in Paris, Bordeaux and elsewhere, with their counters made of zinc and their wide variety of alcoholic drinks. Some of the new *débits* provided a special atmosphere to draw customers; waiters dressed up in special costumes or—an added attraction—women were hired to serve the drinks.

In the "Cafe-Brasserie de Divorce" in Paris, set up after a statute permitting divorce was passed by the French Parliament in 1884, waitresses wore regal gowns, buckle shoes, and lots of ribbon. Even for ordinary folk, the cabarets at the end of the century had new attractions. Mechanical games first made their appearance at the time, exercising their fascination for customers as they have done ever since; a less successful enterprise, but one which was apparently popular then, was the automatic dispenser of alcoholic drinks. Telephones, indoor plumbing and electric lights also helped make the "salon of the working man" more congenial.[34]

Marrus contends that "from the 1880s until the First World War was the golden age of the cabaret in France."[35]

By the 1870s, it had become common practice for both the middle and upper class in France to serve a distilled alcoholic beverage before eating. According to the *Grande Encyclopedia,* such a drink was beneficial in "opening up the appetite." There was great competition among the manufacturers to produce colorful and aromatic *apéritifs,* drinks that were at the same time cheap enough to be purchased even by the lower class.[36] According to Prestwich, "although there were over 1,500 *apéritifs* in France, absinthe rapidly became the most popular, accounting for over 90 percent of consumption and even when the [grape] shortage disappeared, customers remained faithful to the new drink." It was affectionately called *la fée verte* (the green fairy).[37] Bemoaned one writer more than three decades later: "The name of sorceress would [have been] better chosen for that awful liquor, whose witchcraft is bringing illness, ruin, and dishonor to thousands of men, especially in the French-speaking lands. When people are bound by its spell, they become enslaved as perhaps by no other alcoholic drink. Indeed, absinthiated spirits must have been the magic beverage given by Circe to the companions of Ulysses, in order to metamorphose them into beasts."[38] During this period, said Marrus, "five P.M. became known in genteel society as *l'heure de l'apéritif,* though for many people, bourgeois as well as workers, *l'heure de l'apéritif* sounded more often throughout the day." By the mid–1880s, the green fairy was "the king of aperitifs."[39]

By 1894, according to Heilig Sterling, Paris correspondent for the *Atlanta Constitution,* absinthe was "one of the special marks of Paris." "Whether you be on the boulevard or in Belleville," he said, "the green drink, at the 'green hour,' as they call it, is a special feature of the landscape." The drink was also popular in other parts of France. Heilig explained:

This coming of absinthe has been a slow and steady growth in France. . . . Absinthe has had a bad effect on the wine-growing industry. The transfor-

mation of the habits of the wine drinker into the absinthe drinker is not peculiar to Paris. Even more than Paris, the South of France gives an example of this change of ways. The people of the South of France complain, with reason, that their wine no longer brings its price.... The religion of the "aperitif" lives in more vigor in the South of France, even than in Paris. From the mouth of the Gironde to the Pyrenees, from the Pyrenees to the furtherest shore of the Mediterranean to the Alps, the drinkers of absinthe ... are innumerable.... This exaggerated consumption of absinthe prevails equally in the mining countries of the South. In the greater part of these districts, absinthe has become the current drink. It is drank [sic] even at the table—horror, as they would say at Paris—mixed with water. Thus absinthe [is] an important factor in social life.[40]

Apart from its low cost, absinthe appealed to the French for several other reasons. There was a certain amount of ritual involved in mixing and drinking absinthe, a ritual that many found both relaxing and enjoyable, especially during the summer. First, the absinthe was poured into a glass of cracked ice, over which was suspended a lump of sugar in a perforated spoon. The sugar was necessary because of the extreme bitterness of the wormwood—some claim that an ounce can be tasted in 524 gallons of water![41] Cold water was then dripped over the sugar into the glass until the sugar was almost dissolved and the absinthe, sugar, and water mixture had changed to the desired color.[42] According to Prestwich, consumers of the drink spent "many a pleasant hour ... slowly pouring ice-cold water over a sugar cube carefully balanced on a spoon and watching water, sugar, and liquor dissolve into a cloudy liquid." At the same time, they were experiencing the full effect of the drink, which was reputed to cause "euphoria without drunkenness" and an effect similar to that of opium or cocaine.[43] In 1868 the *American Journal of Pharmacy* describes the effects of the drink this way:

You seem to lose your feet, and you mount a boundless realm without horizon. You probably imagine that you are going in the direction of the infinite, whereas you are simply drifting into the incoherent. Absinthe affects the brain unlike any other stimulant; it produces neither the heavy drunkenness of beer, the furious inebriation of brandy, nor the exhilarant intoxication of wine. It is an ignoble poison, destroying life not until it has more or less brutalized its votaries, and made driveling idiots of them.[44]

In Corelli's *Wormwood*, the main character, who got drunk on absinthe the night before his wedding day, describes the feeling thus:

That night, the night before my wedding day, I drank deeply and long of my favorite nectar,—glass after glass I prepared, and drained each one off with insatiable and ever-increasing appetite—I drank till the solid walls of my

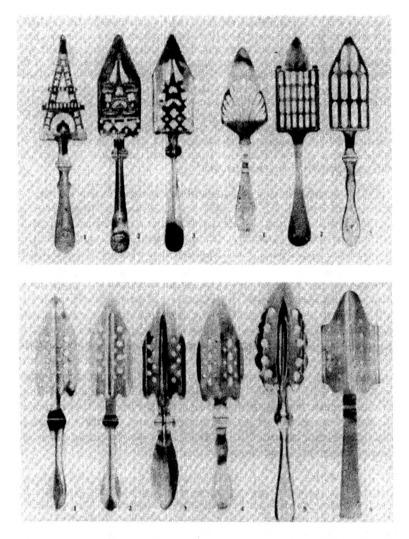

An assortment of absinthe spoons. Illustration from Marie-Claude Delahaye, *L'Absinthe: Histoire de la Fée Verte.* There was a ritual involved in mixing and drinking absinthe which many people found relaxing and enjoyable, especially during the summer. First, the absinthe was poured into a glass of cracked ice, over which was suspended a lump of sugar in a perforated spoon. Cold water was then slowly dripped over the sugar into the glass until the sugar was almost dissolved and the absinthe, sugar, and water mixture had changed to the desired color of green.

own room, when I at last found myself there, appeared to me like transparent glass shot throughout with emerald flame. Surrounded on all sides by phantoms—beautiful, hideous, angelic, devilish—I reeled to my couch in a sort of waking swoon, conscious of strange sounds everywhere, like the clanging of brazen bells, and the silver fanfaronade of the trumpets of war, conscious too of a similar double sensation—namely, as though Myself were divided into two persons, who opposed each other in deadly combat, in which neither could possibly obtain even the merest shadow—victory.[45]

It is no wonder that absinthe affected people in this way; it was much more potent than wine and other *apéritifs* with a usual alcoholic content of 50 to 75 percent, though at times the alcohol content was as high as 90 percent.[46] "Although manufacturers argued that the high alcoholic content was necessary to produce the whiting action so demanded by the consumers," said Prestwich, "the result was not only a seductive drink but a very potent one."[47]

Heilig, who claimed to be "a frequenter of the Boulevard," described the drinking scene in Paris in this way:

[In Paris] the noon hour is a little *fête*, when people try to quite forget that they are working for their living. Master and man go off their different ways. . . . All thoughts of business are put aside for a good hour and a half, or two hours even . . . from 11 to 1 at noon. They do not go immediately to eating. They sit outside upon the sidewalk, even in the winter time, look at passers-by and sip their drink. The drink is absinthe. They drink it very slowly; by slow degrees they feel their poor, tired backbones strengthen and their brains grow clearer, and they feel a touch of happiness. It is so pleasant to sit looking at the street and all the pretty ladies passing by. At great cafes, upon frequented boulevards, the price is only 10 cents. In the quarters of the working men, you may have absinthe for three cents. The proper thing is to take but one glass. In quantity this is about a Madeira glass of the green drink. Poured into your goblet by the waiter, it does not seem much. You fill the goblet up with water, watch it turn a milky sage tint, with the glittering opal tints one learns to love so well; stir up the mixture with your spoon, take one small sip and let it rest. Now that is nice. . . . In summer especially when the ice water is so agreeable, absinthe captivates the palate by its peculiar and really exquisite fragrance. This fragrance, which is that of paregoric, grows upon you.[48]

According to Prestwich, although the "strong, yet illusive odour . . . produced headaches in laboratory researchers," it produced "a passionate devotion in consumers," and "at *l'heure de l'apéritif,* or *l'heure verte* (7 P.M.), whole boulevards in Marseille and Paris were redolent with the perfume of absinthe."[49]

While Parisians who drank absinthe in moderation and only as an *apéritif* saw little harm in having one or two glasses before lunch or dinner, others feared that such drinking could eventually lead to addiction, and, in fact, was "more dangerous" because the drink was

taken on an empty stomach.[50] Heilig had observed how easily a person could become addicted to absinthe:

First the drinker is content to take his one glass [of absinthe] very weak . . . [but] after a time he takes it stronger; then he takes two glasses. The custom grows upon him, and after a year or two the occasional amateur has bloomed into a new "habitue" of the "green hour." When this drinker ends by intoxicating himself, he will impute his trouble to the bad quality of the alcohol employed in making the absinthe. . . .

According to Heilig, some people considered it a "safeguard" that most French regarded "the drinking of their absinthe out of certain hours as a gross piece of ignorance and bad taste" and that not many people would "brave the waiter's elevated eyebrows or their neighbor's looks of curious amusement which [were] sure to follow a demand for absinthe after lunch or after dinner."[51] But many drinkers "moved from one cafe to another cafe" to avoid the embarrassment of being seen "lingering over" their glasses. Said one observer: "[The absinthe drinker] takes his first drink at one cafe, his second somewhere else, and his tenth or twelfth at some tenth or twelfth other cafe." This same observer claimed to know "a very distinguished musician," who would start "at the Cafe Napolitain and finish up at the Gare du Nord. . . ."[52]

Heilig had observed that overindulgence in absinthe was quite common, not just in Paris, but all over France. "All towns have the same look before lunch time, before dinner, and even after dinner," he said. "The innkeepers of the mountains and the plains have adopted the same fashions," he continued, and "it is not one glass of absinthe which they serve to their customers—it is the bottle itself. How many take two glasses without counting the rincette—the final rinse which you take free—no one can know. The number must be very high. . . ." Heilig went on to say that some proprietors, because they were losing money, had to stop serving absinthe by the bottle, which was "cheaper," but, instead, were serving it in a small carafe that would hold two drinks. "Before this new departure," he said, "when they gave the bottle, the proprietor was ruined."[53]

One major concern of the time was the increase in the number of women who had begun to frequent the cafes and cabarets during the drinking hour. Even as early as 1860, Balesta, writing about the socialization of absinthe, claiming that it acted violently on their delicate frames and that as many women drank absinthe as men— and that addiction to the drink was as common as among men, even [among] young women of 18 to 20 years old.[54] For the most part, however, according to Marrus, prior to the 1880s, "the world of the

cabaret had ... been an almost exclusively male sanctuary." But in the late nineteenth century, even "respectable" women "with some claim to gentility" were no longer waiting forlornly outside the cabarets while their husbands drank inside, but more and more they were going inside and drinking with the men. Although in some places—Saint Sauveur, for example—special cabarets were built for women, paintings of artists Manet, Degas, Renoir, and Toulouse-Lautrec and advertisements of the period show women with glasses in hand drinking socially alongside the men.[55]

Heilig's observations support Marrus' claim that women were drinking more than ever in France in the latter part of the nineteenth century; he claimed that "the wife goes with her husband always, as an equal, to the cafe, to the saloon," and that "women of a special class ... take to absinthe [and other alcoholic drinks] as the ducks take to water." He hastened to inform his readers that this class of women was "a large and multiform class" in Paris and included "the ladies of the high world, even the creatures of the demi-monde—if this is understood it does not mean prostitutes." He continued by saying that "[women] from all the middle classes are victims of the *apéritifs*" and that "any one who takes a look during the 5 o'clock p.m. absinthe hour especially, no matter what quarter of the capital, will find that women have accustomed themselves to drinking absinthe." He described these women as "decent, sober women, self respectful, genteel, and well dressed" and said they visited the cafes and saloons "without offense" and were conducive to "the making of a good proper atmosphere." He continued by saying that "the specialists affirm" and "the liquor sellers half admit" that "their women clients take their absinthe, very often, pure (not 'pure' in the French sense, as without gum or sugar) but 'pure' pure." "They drink it neat in little glasses, without water," he said.

George Saintsbury, the English scholar and connoisseur of wine and other alcoholic drinks, writing in *Notes on a Cellar Book* in 1920, maintained that one should never drink absinthe straight. "A person who drinks absinthe neat deserves his fate whatever it may be," he said, for "the flavor is concentrated to repulsiveness," and "the spirit burns 'like a torch-light procession.'" He contended that a person must have "a preternaturally strong or fatally accustomed head if that head does not ache after it," and besides the person loses "all the ceremonial and etiquette which make the proper fashion of drinking it delightful to a [person] of taste."[56] Heilig guessed that women, who "had not been blessed with too much reasoning power," drank their absinthe pure because "they come tight in their

corsets." "Naturally they cannot take a large amount of water in," he said, "because they have to eat their dinner afterwards. They want the absinthe taste and its effects. They also want their corsets." He surmised that "when a woman wants to do two things, she does not give up either. She has the impulse to take both and make them work in some way, as God may please."[57]

What those in charge of the public welfare were most concerned about with women drinking absinthe was the belief that absinthism, especially in women, would create a special race of people with both physical and mental infirmities. By this time it was commonly held that absinthe was slowly poisoning the nation and causing the race to degenerate. According to one report, even the "stature of men [was] lessening," and "in some places soldiers up to standard height [were so] difficult to find" that "the minimum height in the army had to be lowered."[58] Heilig summarized the prevailing belief of medical authorities for his American readers.

What the doctors fear the most is from the ladies drinking. . . . [A]bsinthism, in particular, is said to create a special race, both from the point of view of the intellectual faculties and physical characteristics. This race, the doctors say, may very well continue for a limited time, with all its physical deformities and vicious tendencies, even for several generations, but, exposed in every sort to accident and malady, given over to impotence and sterility, the race soon disappears. The family dies out.[59]

Absinthe producrs, especially in the 1890s, took advantage of the public's attraction to the drink by conducting vigorous advertisement campaigns, partly to counteract the attacks of prohibitionists, who wanted to ban absinthe. Some of these advertisements, designed to appeal to a person's sense of patriotism, were colorfully decorated and inscribed with words such as "Patriotism" or "Equality"; some advertisers claimed that their product had been endorsed by the medical community and had certain hygienic advantages; some were sexually suggestive—Prestwich cites one advertisement that featured a young *demi-mondaine* who was "holding a glass of absinthe and insisting that it was one of her minor vices."[60] Many advertisements featured beautiful women with blissful expressions either holding, pouring, or serving glasses of absinthe. Bottles of absinthe from competing distilleries advertised their contents with artistically decorated labels inscribed with words suggesting superior taste, high quality, and romantic intrigue. Almost all of the labels included the words *qualité supérieure*.[61] These advertisements were a far cry from the earliest known advertisement for absinthe; in 1769 a Swiss newspaper ran a small ad for *Bon Extrait d'Absinthe*.[62]

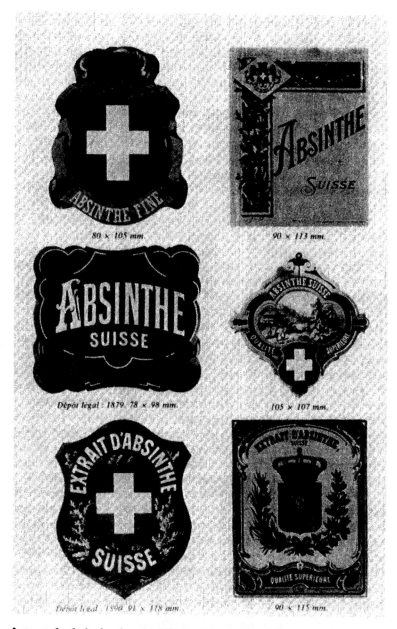

Assorted absinthe bottle labels. Illustration from Marie-Claude Delahaye, *L'Absinthe: Histoire de la Fée Verte*.

The French temperance movement picked up momentum in the last two decades of the nineteenth century, with much of its energy directed against the absinthe industry; indeed, considering the small amount of oil used in each drink, absinthe consumption by this time was considerable. According to the 1868 edition of the *American Journal of Pharmacy,* the French had imported two million gallons of Swiss wormwood oil annually since about 1850, and France was also producing some of its own.[63] Ironically, the major supporters of the temperance movement were the grape producers, whose industry was suffering because of a drop in wine sales, and members of the research community and medical profession, who were convinced that absinthe was a "poison" that was destroying the country.

In the past, temperance societies had accomplished very little in France.[64] In fact, until the Commune of 1870–1871, there had been little, if any, concern in France about wine or alcohol consumption. In 1852 French physician Maynus Huss first used the term "alcoholism" to describe the disease brought on by overindulgence in drink. Although he did receive recognition for his research, the public and the medical community paid little attention to his findings. But, according to Susanna Barrows in *Nineteenth-Century Europe,* "after the French defeat and the bloody uprising in Paris, [alcohol and drunkenness] preoccupied the medical profession, legislators, men of property, and government officials." Dr. Jean-Baptiste Barth organized the first successful temperance society in France in 1871, a few months after watching his house burn to the ground during what he called "the filthy and monstrous orgies" or the Commune. Dr. Barth was joined by others like him, who believed the "decadence" of the time was caused by drunkenness and alcoholism. Their major efforts were directed toward "the moral reform of the working classes," and within five years a law was passed against public drunkenness.[65]

But even though the supporters of the temperance movement had some successes in the 1870s, for the most part the public was unconcerned about the problem, which was believed not to be as serious as in other parts of the world. This apathy is reflected in an entry in the 1875 edition of *La Grande Dictionnaire du XIX^e siècle.* "In our country," it states, "although drunkenness is not unknown, it is far from having a character as repellent and as nefarious as in England and America." The article went on to say that Anglo-American "dipsomania" was such that temperance movements were necessary to "moderate the hereditary order of the Teutonic race and the Anglo-Saxon race for alcoholic spirits."[66] Even the medical

community was reluctant to apply the term "alcoholic" to their patients. This belief that the French did not have the propensity to become alcoholics as did most of mankind was widespread. And certainly many artists and writers of the period would have agreed in spirit with Charles Baudelaire, whose poetry seemed to say that alcohol was "the *via poetica* to the Kingdom of the unfettered imagination or the balm of the dispossessed."[67] Baudelaire may have been echoing Plato's statement centuries before that "'tis to no purpose for a sober man to knock at the door of the muses."[68] Certainly, the prevailing attitude toward alcoholism in France was such that many would have quickly agreed with the French physician who said: "There may be a good many drunkards in France, but happily there are no alcoholics."[69]

In 1877 Zola tried to awaken the consciousness of the French people with the publication of *L'Assommoir* (The Dram Shoppe), which deals with a working-class family that was totally ruined by alcohol. The main character, Gervaise, who was lame at birth, assumed that she had been conceived during one of the many violent love-making episodes between her drunken father and battered mother. She, too, was drinking anisettes by the time she was 14 but was later inspired to change her life after marrying a sober, hard-working man, who looked with disdain on "absinthe and all that sort of stuff." However, after a debilitating accident left him unable to work, he turned to alcohol for consolation, frequenting the nearby cafes joining in the drinking and the merriment. It was told that at one time an absinthe drinker "stripped himself stark naked in the rue Saint-Martin and died doing the polka." Hopelessly struggling to make a living for husband and children, Gervaise finally succumbs to drink herself; she later starves, unnoticed.[70] Though Zola's intention was to show the tragedy, the squalor, the degradation, and the hopelessness of the main characters' lives, most readers were simply shocked at what they considered the insensitivity of the language and the scenes in the book. Only later did the book become an important work, especially to temperance workers.

By the mid–1880s, temperance forces had gained the support of prominent doctors, politicians, and social workers. One of the earliest publications on the subject of alcoholism appeared in *La Croix* in 1886. At that time it was estimated that 2,000 alcohol-related deaths had occurred in France that year and that alcohol-related insanity had doubled within the last three decades.[71] But even so, temperance workers had little success because everyone in France continued to share the belief that wine, which was a national beverage,

did not contribute to alcoholism, and that, indeed, alcoholism had
not been a problem in France until the advent of industrial alcohol.
Explained Prestwich: "Wine, that sunny product of French soil and
source of considerable wealth, was sacrosanct, and was encrusted
with national myths about the glory and genius of the French race."
He went on to say that "most French doctors and temperance groups
shared this faith in wine and argued that alcoholism had developed
in France during the wine shortages ... when people turned from
grape wine, a 'natural' beverage, to alcohol made by industrial, and,
therefore, presumably unnatural, processes."

Ironically, even the temperance supporters "looked to the con-
sumption of wine as a means of curbing alcoholism" and "advised
that one litre of wine a day for a hard-working adult man was not
dangerous." But the worker was to avoid drinks made with industrial
alcohol, for they were not "pure."[72] Likewise, writers of the period
usually condemned *alcool* [distilled liquor] but praised "fermented
drinks"—wine made from grapes. "After all," said Marrus, "wine
was 'the national drink *per excellence*,' good for one's health and good
for the nation." "Even the quality of drunkenness (*ivresse*) was
different," he continued. "With wine there was an *ivresse gaie et bon
enfant, l'ivresse gauloise.* With spirits, on the other hand, there was an
unsavory kind of drunkenness, *'lourde et imfáme,'* leading to alcohol-
ism and all forms of social disorder."[73]

Since absinthe was a popular substitute for wine and was high
in industrial alcohol content, it became the major target for temper-
ance groups in the 1880s and 1890s. Furthermore, by this time, the
medical community had developed a strong scientific and medical
case against absinthe, attributing an increase in insanity and other
serious medical problems to an overindulgence in the drink. As early
as 1708, Johan Lindestolophe, in his publication *De Venenis* ("On
Poisons"), claimed that habitual use of *Artemisia absinthium* would
result in "great injury to the nervous system." His statement was
based on the "narcotic and debilitating effects" that he and a col-
league, Christianus Stenzelius, had experienced while using the
drug.[74] Other research on absinthe was conducted in 1857, when a
Dr. Motet helped treat absinthe patients at Bicetre, a leading
psychiatric hospital in Paris. In 1859 he described his work there in
his thesis "On Alcoholism and the Poisonous Effects Produced in
Man by the Liqueur Absinthe." Following Motet's study, a few other
studies were conducted at Bicetre, a hospital in Paris. One of these
by Louis Marce was published in a major journal. His short article
reported the effects of absinthe on dogs and rabbits, such as "con-

vulsions, involuntary evacuations, abnormal respiration, and foaming at the mouth." He believed that humans, too, were adversely and doubly affected by the alcohol and the thujone in absinthe.[75]

Three studies were conducted by Dr. V. Magnan, who was at one time the director of the Paris Asylum at Sainte-Anne.[76] Magnan's work on "absinthism" (addiction to absinthe) was eventually incorporated into medical textbooks and became a standard part of the training for medical practitioners. Prestwich summarizes a part of Magnan's studies on absinthism as follows:

From clinical observations and laboratory research he concluded that absinthe caused medical and psychological trouble not associated with the high consumption of alcohol. The essences of absinthe, he argued, attacked the nerves, particularly of the head and neck, before alcohol had come to act, producing progressively vertigo and hallucinations, convulsions of an epileptic nature, and finally a particularly violent form of insanity. While the child of an alcoholic might inherit a tendency to alcoholism and madness, the child of an *absinthique*, it was argued, was born with a predisposition to insanity and serious organic troubles of the nervous system.[77]

Magnan also did experiments with dogs. He found that dogs under the influence of absinthe would react as if they were confronted with their enemies, even though they were facing a blank wall and that large doses of absinthe in dogs would also cause convulsions.[78] In 1865 M.P. Emile Littre and Charles P. Robin in *Dictionnaire de Médecine* called absinthism "a variety of alcoholism," but they pointed out that "the special neurological effects were attributable to something other than alcoholism." Three years later the *Boston Medical and Surgical Journal* (*New England Journal of Medicine*) published a paper on absinthism by Rober Amony, Magnan's student. *The Lancet* carried a review of Magnan's work in 1874.[79]

By the end of the nineteenth century, temperance forces had succeeded in getting the attention of almost all of France through educational programs and public awareness campaigns. Many articles were written on the topic similar to the one that appeared in the April 1895 issue of *Cosmos*, a scientific journal. The article denounced "the increasing evils of drink in France," blaming the problem mainly on "the spiritous liquors, more or less pure, that are dealt out in the drinking saloons"; the writer, no doubt, was referring to absinthe. He went on to say that the spiritous liquors "show effects even in the descendants of the victim" and that "in the insane asylums the intellectual decadence of 16 percent of the inmates is attributable to drunkenness," an increase of five percent over the past few years. To solve the problem, he recommended, among other things,

that "a heavy tax be put on spiritous liquors," that "light drinks be free of tax," that more temperance societies be formed to "enlighten public opinion," and that any laws passed be strictly enforced. He finally pointed out that "the only countries that have made serious laws against alcoholism are those where temperance societies have proposed and prepared those laws."[80]

The occasional writer focused on the medicinal value of absinthe, notwithstanding its abuse in the "wine-shops." In an article in the January 25, 1890, issue of *Medical Record,* Dr. J. Leonard Corning said he had found absinthe effective in treating patients suffering from "depression, morbid apprehension, and acute irritability." He also contended that when inserted in the skin with a needle, it acted almost like anaesthesia and that its analgesic properties made it especially useful in treating headache, spinal problems, neuralgia, and arthritis.[81] On December 29, 1900, the Academy of Medicine was asked by the government to "determine the comparative toxicity" of "various alcoholic beverages in use." One member of the investigating committee recommended that "absinthe alone be put into the forbidden list." This recommendation probably made sense to those familiar with previous laws concerning the drink, such as an 1872 law which said "that the commerce and sale of the essence of absinthe ought to be carried on by the pharmacists according to the law on the sale of poisons."[82] That same year politically active grape producers finally pressured parliament to declare wine "an hygienic drink" and to give a tax break to the wine industry, an action that did little to curtail the sale of absinthe.[83]

Opposition to absinthe and all other spirituous liquors continued on into the twentieth century. In 1901, as if to prove the difference in the effects of fermented drinks and distilled drinks, an experiment was conducted involving two groups of soldiers at Bordeaux. Before marching, one group was given beer to drink and the other wine. The results of the experiment were not surprising. "With wine," the report stated, "our troops felt less tired and went along the road singing and chanting refrains in cadence. Under the influence of beer, by contrast, they were sluggish, marched with heavy step, and reached the finishing point worn out, exhausted, with scarcely enough energy to prepare their modest meal."[84] At temperance meetings, guinea pigs and rabbits were given pure absinthe after which they had convulsions and died terrible deaths. Pictures of deformed and mentally deranged children of absinthe users were widely distributed by temperance organizations and the scientific community, convincing many of the dangers of the drink.[85]

In the first part of the twentieth century, public debates about the dangers of absinthe continued, even at the Senate and National Assembly, during which time strong and convincing arguments were made to prohibit its sale, the most serious ones being that a person was 246 times more likely to become insane from drinking absinthe than from drinking other forms of alcohol; that the increase in tuberculosis in the working districts was the result of workers' overindulgence in absinthe; that the increase in violence and insanity was the result of absinthe; that hereditary absinthism was responsible for a decrease in population growth in France; that an increase in rejection of conscripts for military service was the result of absinthe; and that agitation and other worker problems were the result of workers' preference for absinthe over wine.

In submitting a report to the Chamber of Deputies, Henri Schmidt, a temperance leader, declared that the "real characteristic of absinthe" was that it would lead "straight to the madhouse or the courthouse." "It is truly 'madness in a bottle,'" he said, "and no habitual drinker can claim that he will not become a criminal." The drink became commonly known during this period as "*la correspondance* (for *la correspondance à Charenton,* 'the quick coach to the madhouse') or ... the 'green peril,' or 'the French disease' (*le mal français*)." It was portrayed as "a noxious green wave sweeping over France" the "maximum of poison, condensed, refined, perfumed, irresistible."[86] It was "the scourge," "the plague," "the enemy," and "the queen of poisons."[87]

On August 11, 1901, an incident occurred that focused attention on Pernod's factory in Pontarlier and that also emphasized the strength of the absinthe produced there. During a thunderstorm, lightning struck the central part of the factory, slicing into a large vat of the brew, spewing burning alcohol everywhere. Bottles and vats began exploding in the intense heat; a worker finally opened the underground faucets, allowing all of the vats of alcohol to empty into the Doubs River. Conrad claims that "one of the 51,000 liter reservoirs was still burning two days later...."[88] E.M. Fournier, a professor of geology at the University of Bescancon, made an interesting discovery after the incident. It seems that Fournier had believed for a long time that the Loue River, which was "thirteen miles away from Pontarlier, was only a branch of the Doubs, fed by an underground channel.[89] But he was unable to prove his theory until three days after the Pernod incident, when he claimed that "he saw the water turn a milky yellow green and smelled alcohol coming off the river 'like a drunkard's breath.'"[90]

In August 1905, a major tragedy occurred in Commugny, Switzerland, which gave impetus to the temperance movement both there and in France. At that time, Jean Lanfray, a peasant of French birth and a known absinthe drinker, viciously murdered his pregnant wife and two daughters after he discovered that his wife had not waxed his boots while he had been at work that day as he had commanded her to do that morning. During the investigation of the murders, officers discovered that Lanfray was accustomed to drinking about six quarts of wine every day along with various other alcoholic drinks, including absinthe. The citizens of Commugny, convinced that the crime had been precipitated by absinthe, called a meeting a few days later at which time they denounced absinthe and demanded that it be banned. Commugny's mayor labeled the drink as "the principle cause of a series of bloody crimes in our country," and 82,000 people signed a petition to ban absinthe in the canton of Vaud. Their outcry was reinforced by a group of Swiss doctors, who said that "more than all other alcoholic beverages, absinthe exercises an irresistible temptation to the drinker and compels him to drink too much." And the director of the Bel-Air Insane Asylum in Geneva confirmed that at least 40 percent of the patients there admitted to being alcoholics.

Lanfray was examined in prison by a psychiatrist from the University of Geneva, who concluded that "without a doubt, it [was] the absinthe he drank daily and for a long time that gave Lanfray the ferociousness of temper and blind rages that made him shoot his wife for nothing and his two poor children, whom he loved." When Lanfray was tried for the crime in February 1906, his defense lawyer argued that he "had been in a state of absinthe-induced delirium" when he committed the murders and, thus, could not be held accountable for them. His sentence of life imprisonment was cut short when he committed suicide a few days later by hanging himself. The immediate reaction of the Vaud legislature to the Lanfray case was that it banned the sale and production of absinthe in the commune by a vote of 126 to 44; in 1907 a special nationwide referendum was called resulting in the banning of the production and sale of absinthe throughout Switzerland, the vote being 23,062 for and 16,032 against the ban. The Lanfray case and the Swiss banning of absinthe were publicized all over Europe and helped feed the desire of the abolitionists in France to do something about the problem there.[91]

By 1906 alcoholism, especially acute absinthism, was a major issue of public debates in France, as temperance organizations mobilized their forces and launched a new campaign against absinthe,

hoping to make some headway toward total prohibition of the drink; as a result, that year the legislature imposed a surtax on absinthe and imposed regulations on the drink that reduced the amount of alcohol and absinthe in the drink. Again in 1907 antialcohol supporters made a concentrated effort to force the Chamber to ban the drink, but even with 400,000 signatures and the support of the Paris newspaper *Le Matin,* they failed to get enough votes of the members of the Hygiene Commission to prohibit the drink, mainly because there was concern about the effects on the industry and the loss of revenue from taxes. They did, however, vote in favor of a new surtax. During the debates, opponents of the proposal to ban the drink had argued that the problem was complex because there was "good absinthe"—the absinthe produced in the Daubs region that was a blend of costly distilled alcohols and "natural essences"—and there was "bad absinthe"— that made from cheap distilled alcohol. The surtax was designed to eliminate the producers of the "cheap" absinthe, whose produce was consumed by the working class, but to protect the producers of the expensive absinthe; thus, the elite could continue to buy the expensive absinthe while the government profited from the increased revenue.[92]

Immediately after the defeat of the proposal to ban absinthe, absinthe manufacturers began a campaign to counteract the arguments against the drink by distributing scientific and medical evidence that the drink was beneficial, rather than harmful. To this end, they pointed out all of the natural ingredients in the drink and emphasized its medicinal value, especially for stomach problems and loss of appetite. They also took issue with experiments that injected animals with huge doses of absinthe, saying such large doses of coffee or tobacco would have killed the animals; they challenged the reports that blamed absinthe for an increase in insanity in France, producing statistics which revealed that insanity was higher in Britain, where absinthe drinking was not a problem. One report included pictures of healthy peasants, who typically ate absinthe omelets and drank absinthe to "quench their thirst" while "tending fields of absinthe." They claimed that these peasants were healthier than the average Frenchman. The tuberculosis they attributed to the damp mountain air and the increase in crime to army regiments in various locations. They further argued that one drink could not possibly be responsible for all the social problems in France and that it should not be banned unless all other *apéritifs* were also banned.[93]

By 1907 France was consuming 90 percent of the "world's production of absinthe," some of which was produced in Switzerland,

where great plantations of wormwood flourished.[94] France's problem with "the green fairy" was not going unnoticed by the rest of the world, especially by concerned English citizens. In a letter to the *London Times,* citizen W. Soltau urged prohibiting the sale of absinthe in England to prevent its "wreaking havoc" there as it was doing in France. He pointed out that consumption in France had increased in 20 years from 1,024,850 gallons annually to 4,484,950 gallons. In building his argument, Soltau quoted several prominent French officials, among them Henri Robert, "the leading criminal barrister at the French bar," who said that alcoholism in France was "the chief cause of the increase in criminality" and that "absinthe [was] the enemy"; Dr. Ropus of the Pasteur Institute, who contended that "absinthe [was] heaping up ruin and sorrow in France and that to prevent its fabrication [was] a work of humanity and patriotism"; a professor Berthelot, who was "in agreement with all the physiologists and hygienists in the medical world in asserting that absinthe is the destroyer of the health and the intelligence of those who use it habitually"; and a Mr. Ribot, who called absinthism "the most dangerous form of alcoholism that exists."[95]

H. Anet, writing for the April 1907 issue of *Economic Review,* declared that the war against absinthe in France had "not even . . . begun and that "God, alone, [knew] when it [would] be started." "In France," he said, "the consumption of absinthiated spirits has increased fearfully during the last fifteen years." He then continued:

The French medical authorities are overwhelmed by this slow but sure poisoning of the population. The race is degenerating; the stature of men is lessening; in some places soldiers up to standard height are difficult to find; the minimum height in the army had to be lowered. Absinthism is much more pernicious than alcoholism; its influence on the brain is particularly bad. In the last thirty years the number of lunatics has increased threefold. In Paris, at the hospital where such cases are especially nursed, statistics show 9 out of 10 are due to absinthe poisoning.[96]

According to Anet, several proposals had been put forth by eminent citizens to deal with the problem of absinthe addiction. A Dr. Daremberg had proposed that "the duties on all liquors made with essences . . . be doubled." The Congress of Hygiene had voted to support a resolution that would forbid "the sale of absinthe in France and in the French colonies." And M. Jacquet, a leader in the movement to ban absinthe, had convinced the *Société Médicale des Hôpitaux de Paris* to vote for the following resolution: "The Hospital Medical Society declares once more that absinthe is one of the chief causes of decay and mortality, and urges the public authorities to

forbid the manufacture and sale of the liquor." But in spite of these actions, Anet had little hope that absinthe would be banned at that time. "Public opinion, as a whole, has not been stirred," he said, and "the distilleries and publicans are still too powerful as electoral agents." It was his opinion that the "deputies and senators would not dare to touch the revenues of these 'honest traders.'" In addition, the minister of finance had recently stated that "measures against absinthe would endanger public finances." Anet concluded by asking, "When will the days come when in France ... absinthe shall agree with its Greek etymology, *apsinthion*—'the liquor which it is impossible to drink'?"[97]

In a June 1907 letter to *The Nation*, J. Napier Brodhead, writing from Nice, France, blamed the increase in drunkenness in France on the distilled liquor being sold there, especially the kind used in making absinthe. "Till within the last 25 years," he said, "the French drank nothing but their own natural wines, and they were the most temperate people in Europe." "Today," he continued, "more alcohol is consumed in France than anywhere else." To prove his point, he provided the following statistics:

Location	Population	Liquor Sellers
New York	3,437,000	10,821
Chicago	1,698,000	5,740
London	4,536,000	5,860
Paris	2,661,000	30,000

"What has thus transformed the French nation into an alcoholic people?" he asked. The answer was *"les ennemis de l'âme Française"*—the enemy has "killed the grape" and "debauched the people with alcoholic drinks of the worst kind." He contended that "the kind of absinthe sold at popular *buvettes* is ... a most deadly sort," but that the "sale of superior kinds of absinthe has slightly diminished as the richer classes [have begun] to understand the evils it engenders."[98]

The debate continued to rage, and finally, in 1908 a bill was passed that, ironically, increased the amount of alcohol in absinthe, the argument being that "absinthe with a higher degree of alcohol was healthier and that the requirement for higher alcohol content would eliminate those producers who used artificial essences with lower standards of purity." With this bill, many small manufacturers were forced to stop production, a situation temperance leaders saw as slowly leading to prohibition; some argued, however, that it was quite foolish to believe that a drink with a higher alcohol content was not as dangerous as one with a lower content.[99]

In 1909 new efforts were made in the Senate to ban the drink, but the committee named to investigate the question was slow moving, and it was not until May 1911, that it reported to the Senate. The committee rejected arguments that favored absinthe, said the drink was "indeed a poison," and attributed the poisonous nature of the drink to an ingredient called *thujone* (a narcotic), which was impossible to isolate in any substance. During the course of the debates on the issue, the committee proposed that "all drinks containing thujone be banned." A sample product called "absintheless absinthe" was presented to the Senate Committee with the suggestion that it be made available for sampling in the bar of the National Assembly. The proposal was quickly accepted by manufacturers of absinthe, who immediately developed a "thujoneless absinthe" and advertised it as having "the endorsement of the Senate." In 1912 the Senate voted to ban "drinks containing thujone" and sent the bill on to the Chamber, where it lay dormant until the beginning of World War I.[100]

But absinthe continued to be much debated and written about. In 1913 Charles Foley's play *Absinth* caused a sensation because it focused on absinthe addiction among the aristocracy. The main incident of the play involves a baron, who murdered an Apache dancer while under the influence of absinthe. He remembers nothing of the event, which his servants apprise him of the next day, but a tell-tale handkerchief with red hair and blood on it convinces him that his servants are telling the truth. Later, in Gertrude Stein's *The Autobiography of Alice B. Toklas,* American painter Alfred Maurer describes Paris after the battle of the Marne in World War I as "pale . . . just like absinth." Said one writer, "In those early years of World War I, everyone knew what [he] meant. That absinth conveys the vacuum, peculiar light, weather, and vibrations of Paris in a state of imminent siege and reflects its hallucinatory power as symbol for the end of an era."[101]

With the coming of the war came new concerns about absinthe, and renewed efforts were made to ban the drink; as a result, on August 16, 1914, Louis Malvy, minister of the interior, banned the sale of absinthe as an emergency measure to help solve the alcohol problem that many felt was weakening the military strength of the country. But in spite of the ban, the drink continued to circulate, partly because of the large supplies that remained stored in warehouses. Also, the ban did not apply to home-made absinthe, and the drink could still be purchased for home use. Convinced by this time that alcoholism, absinthism in particular, was destroying the

country, the public, with the support of the major newspapers, demanded that the ban on absinthe be strictly enforced; as a result, in January 1915 absinthe was banned by presidential decree, though the drink could still be exported. The bill was later amended "to forbid the manufacture and exportation" of the drink.[102] Prohibition forces were jubilant. Said a Paris correspondent to the *London Times*: "It is more than ever apparent that France, with her dwindling population, still further reduced by war, has need to safeguard her citizens from a disintegrating poison.... The benefits to health that will accrue are incalculable and constitute a new source of wealth."[103]

Evidently there was not much difficulty in getting a law passed at this time. Henri Schmidt, who was deputy for the Vosges and who was largely responsible for the passage of the law, was quoted by the *London Times* as follows:

This salutary movement, being once launched, spread over France, but the prohibition, due to the action of the Prefects and military authorities, was not universally observed. Hence an Act was necessary, and it passed both Chambers and became the law of the land, enforcing not merely temporary but absolute prohibition. It is one of the most interesting manifestations of that new spirit which has arisen in France. It is significant that it excited no opposition among the public and little among the trade. The latter only stipulated that there should be allowances made for the amount paid in excise and unconsumed stock. Even in Parliament, tho the representative of the absinth industry ... challenged [the] figures which would attribute crime and lunacy to the product, there was evident a strong sympathy with the reform, which made easy the task of the introducer of the measure.[104]

In fact, according to the June 1915 issue of the *London Times*, the "French prohibition of absinthe was enforced ... with ease," and "it [seemed] probable ... that if the ban on absinthe were extended for the duration of the war to spirits generally, very little protest would emanate from Frenchmen."[105] The author of a May 1915, article in the *Literary Digest* expected France to achieve the "magnificent results" by banning absinthe that Russia had achieved by banning vodka. "Five and a half millions have been added to the savings-banks' accounts in Russia," he said, and he expected France to benefit as well. He then quoted at length from an article written by a Paris correspondent of the *London Times*, who praised those responsible for the banning: "It needed courage to attack formidable vested interests," he said. "It needed patriotism to tamper with the sacred 'liberty of the individual.' That both Chambers, after a short discussion, arrived at prohibition, is evidence that the indictment

against absinthe was fully proved. And the counts were numerous."
After calling absinthe "a poison more powerful in murderous im-
pulses than any other," saying "its victims sometimes have run
amuck in provincial France," he then continued:

In a case under my notice, a laborer, maddened by absinth and armed with
a long knife, rushed down a village street not far from Paris. The affrighted
inhabitants sheltered in their houses. A stone, flung by a youthful David,
struck the madman on the forehead. He was induced to enter a chemist's,
where he was placed under chloroform and then handed over to the gen-
darmes. Instances of the sort might be multiplied to show the effects of ab-
sinth.[106]

The journalist felt that the working classes, in particular, had "been
debauched and ruined physically" by absinthe.

Some saw the prohibition of absinthe as a part of a new religious
awakening brought on by the war, as many people were convinced
that the war was punishment from God for the sins of a degenerate
nation. Said French churchman Wilfred Monod,

Who will deny that the French people have passed, during the last months,
through one of those moral crises which can end in a radical and healing con-
version? Let us have courage to acknowledge that, in more than one respect,
our nation offered certain alarming symptoms of anemia, and even of
degeneracy. Philosophers, educators, statesmen, have remarked with horror
the progress of tuberculosis, alcoholism, gambling habits, debauchery,
lawlessness, and the spirit of faction. Besides this, the French seemed re-
signed to their own disappearance. They gave more work to the coffin-
makers than to the cradle makers.[107]

But Monod praised the French for reacting so quickly to reverse their
unhealthy condition when suddenly faced with war:

The spectacle was wonderful. How quickly and surely the finger was placed
on each sore! The prohibition of absinthe, the perfidious national poison . . .
the early closing of the drink shops, the aid to the unemployed, the increase
in public food, the suppression of sensationalism in the papers . . . the
reawakening of religious sentiment, the reflecting silence of militant free
thought. . . . Such has been the fruits of the trial.[108]

For some time after absinthe was banned, stories continued to
circulate about the drink; for example, Stoddard Dewey, in the
August 1915 issue of *The Nation*, felt compelled to refute charges that
French soldiers were given absinthe "to excite them to fight," a charge
that had been made at a peace meeting in New York. After saying
the absinthe story was "deftly put in circulation in the United States"
because of "popular prejudice," he further explained how implaus-
ible such a charge was:

Ever since the first unhappy days of war, the commander-in-chief took stringent measures to keep strong drink generally from his soldiers. The civil authorities took the occasion to forbid throughout the country both manufacture and sale of absinthe in particular. It still happens that the police in cities and towns raid some liquor shop clandestinely selling absinthe from its old stock. Such sale is much more difficult than moonshining in North Carolina, and as all manipulation of alcohol in France has to be performed under Government inspection, it is impossible there should be any clandestine fabrication of absinthe—except of stories about it. How in the world from quantities which would have to be hidden somewhere French officers could get enough to fire their men to action would be more than a mystery. Then for those soldiers who are not accustomed to this mixture of drug and alcohol—as the majority must be, since that is the case with the majority of Frenchmen in civil life—such administration of absinthe would risk making them idiotic just when they need their senses. . . . To get morally "forwarder" for battle, a soldier would have to drink so much wine he could not run![109]

He went on to say that neither soldiers "in camp or garrison" or those "enjoying a furlough at home" were allowed to buy any kind of alcohol, though they could buy medicated wines, such as quinines, which had an alcoholic content of 15 percent. And "no military man in uniform can be served at all, not even with mineral water, except from five o'clock to nine—before and after the dinner hour."[110]

One reason prohibition forces considered the banning of absinthe as a major victory was that the ban included not only absinthe but also *similaires*: that is, drinks that were similar to absinthe in taste and appearance; thus, even anise-flavored *apéritifs* were banned, a regulation that was hotly protested by the alcoholic industry, but to little avail until after the war. By April 1920 absinthe was "creeping back into the stocks of some cafes." According to a 1920 news article, "Great difficulty has been encountered in the past by those fighting the use of the liquor, which is being served under various names, no one being able to give an exact definition . . . [but] if a drink shows the presence of absinthe, all stocks of the beverage are confiscated and the vendor is arrested."[111] In October 1922 the law banning absinthe was "interpreted to cover all cloudy imitations with which the French market has been crowded since the war." More specifically, the decree stated:

All liquors considered similar to absinthe, of which the dominant taste or odour is that of anise—which become clouded by the addition of four parts of distilled water and fail to become clear with the further addition of three parts water—also all liquors of anise which, though not clouded with water, contain the essence of tansy or caraway, and also all anise liquors containing more than 40 per cent of alcohol or less than 150 grams of sugar per litre, are prohibited.[112]

In 1922 the National Assembly finally passed a bill that would allow the manufacture of drinks similar to absinthe in flavor and appearance, drinks that were high in alcohol content, flavored with anise, and appealing in color. These *pastis* and *anisette* drinks had much of the appeal of absinthe, satisfying most customers and manufacturers. Said Prestwich, "Given these postwar developments, it was clear why absinthe manufacturers never sought a repeal of the war-time legislation; it was unnecessary, for the drink had been reincarnated in a slightly less toxic but no less appealing form."[113] But even in 1925 there were those who were unhappy about the legalization of the new drinks, believing that many of the drinks being served were "far more dangerous than the old because [they were] manufauctured secretly and consequently with less care."[114]

As a matter of fact, as it turned out, the banning of absinthe was a minor victory for prohibitionists; the public was convinced by this time that banning absinthe had solved the alcoholism problem, and they took to the new drinks in such large numbers that, according to the July 23, 1925, issue of the *New York Times,* "consumption of alcohol in France [had] increased in a few years by nearly 100%." In the article, the Paris correspondent of the *Times* reported that part of the increase occurred because "drinking absinthe in disguised form [was] becoming increasingly popular in France." He further reported that, according to the Academy of Medicine, the major increase in drinking occurred among women and that "cirrhosis of [the] liver due to alcohol was considerably more frequent in women than men." The increase in women drinkers, he said, was "merely part of the general tendency of the female to imitate the male, other aspects ... being the boyish bob, the masculine cut in clothing, and the readiness with which they take to cigarettes." A Professor Achard contended that the increase in alcoholism was the result of "improvements of conditions of the working classes, particularly the increase of wages and the eight-hour working day," which gave them "more time and money to waste in drink."[115]

It is interesting to note that, though the French believed for decades that absinthe was a fairly toxic drink which was destroying the health of the population, it took the war to force them to seriously consider banning the drink. Said Prestwich,

The prohibition of absinthe ... did little to improve the health of Frenchmen because although the drink did have certain harmful characteristics, they were neither so profound nor destructive as temperance propaganda suggested and, deprived of their traditional *verte,* consumers merely switched to similar drinks. In addition, by stressing the problem of essences and

impure alcohols, temperance campaigners distracted both doctors and the public from the real cause of alcoholism, namely the excessive consumption of any type of alcoholic drink.[116]

Prestwich concluded by saying that "absinthe was less a villain than a convenient victim and its prohibition provided the satisfaction of resolute action without entailing grave economic dislocation or personal sacrifice."[117]

Even though the manufacture and sale of absinthe was banned in Switzerland in 1908, in the United States in 1912, in Italy in 1913, in France in 1915, and in Belgium in 1918, it was not banned in England; therefore, as late as the 1930s, England was still having a problem with absinthe abuse, with most of the absinthe being imported from the Netherlands, France, and Spain. It appeared that illegally produced absinthe was being shipped to Holland and to Spain, neither absinthe producing countries, after which it was imported into England. And although absinthe was prohibited in France, it was still produced there, and a goodly quantity of the drink was exported to England.[118]

3

VERLAINE, RIMBAUD, WILDE AND THE OTHERS

> For the poet, my children
> You must not delay
> To bring green-eyed absinthe
> On a golden tray.[1]

Even though the early abusers of absinthe came from the lower class, by the mid-nineteenth century the green liquor was frequently indulged in by professionals in all walks of life, particularly by poets, writers, musicians, artists, wealthy merchants and social celebrities. Part of the attraction to the drink was that it exemplified, in part, the spirit of the times; it was fashionable to be daring, different, and merry—to indulge in unconventional behavior and to experiment with new lifestyles. According to Donald Vogt, the 1850s and 1860s in France was "a parvenu period: get rich quick, show off, enjoy. Gamblers, profiteers, and demimondaines held the center of the stage.... It was then that *La Vie Parisienne,* as a play, as a magazine, as a mode of life, became a byword for meretricious gaiety." Absinthe became almost a symbol of the Bohemian spirit—absinthe that would stimulate the body and the brain, that would expand one's consciousness. Literary men and artists were particularly drawn to the drink, believing that it would inspire them with new ideas and add fuel to the creative process.[2] Not the least of the attraction to the drink was the prevailing belief that it was an aphrodisiac that would stimulate their sexual appetites and increase their sexual enjoyment.

Though many literary figures experimented with such drugs as absinthe, opium, and hashish during the nineteenth century, Paul Verlaine (1844–1896), a French poet who became well known for his

Bohemian lifestyle, perhaps suffered more than any other as a result of his addiction to absinthe; in fact, one could point to Verlaine's life, alone, to define the "absintheur." Verlaine suffered most of the classic symptoms associated with the drink, including violence, though he was not by nature a violent person.[3] In his *Confessions* (1895), written shortly before his death, Verlaine attributed most of his problems in life to his addiction to absinthe, calling it a "horrible drink ... the source of folly and crime, of idiocy and shame."[4] Verlaine's lifelong friend and biographer, Edmond Lepelletier, agreed that it was Verlaine's addiction to the "green liquid" that "undermined his moral and cerebral stamina, and eventually led to his social and even intellectual downfall."[5] It was absinthe that led Verlaine to adopt a Bohemian lifestyle, a lifestyle described by one writer as "the opposite of the life of the respectable well-to-do."[6]

In discussing Verlaine's addition to absinthe, one would of necessity have to dwell on the sordid aspects of his life; certainly, to those familiar with those details, Verlaine's name conjures up images of the poet hovering over a cafe table with a glass of absinthe in his hand. Bergen Applegate, in *Paul Verlaine: His Absinthe-Tinted Song*, reinforces this image of Verlaine:

Wandering from ... wine-shop to wine-shop, he seems to have staggered out of the pages of Petronius—some vague, indefinite creature, half beast and half man—a veritable satyr.... Let us look at this singular genius in one of his favorite haunts. It is the year 1893. A basement café, Place St. Michel, Paris. The air is fetid with tobacco smoke, mixed with the pungent, acrid odor of absinthe. It is two o'clock in the morning. Some Parisian night birds ... have dropped in to moisten their gullets and look for prey. At a table in the center of the room a group of young men are sipping *bocks* and *petits verres* and listening to the *rebelaisien* ejaculations of a drunken man.... The drunkard is Verlaine.... he is drinking absinthe. The wan, purplish light shed by the gas jets from the walls, mingled with the more ruddy glow from a large oil lamp hanging above the group, throws into his glass some rays of iridescent splendor. Half curiously, half questioningly his sunken, glowing eyes peer into the greenish opalescent liquid. The look is that of a man not altogether certain of his identity—the fixed gaze of a somnambulist taking on a puzzled expression at the moment of awakening. Well might he question, for into that devil's chalice he had poured all his youth, all his fortune, all his talent, all his happiness, all his life.[7]

An English writer describes Verlaine as he first saw him at the height of his career.

My first sight of this great, simple, beautiful poet and child was in the basement of a cafe ... where there used to be singing, and where the poets gathered. Verlaine was drunk that night and as usual was dressed in rags. He

had a false nose on his face (for it was carnival time) and he was piping on
a little tin whistle. The spectacle had the terrible comedy touch of Aris-
tophanes. It was tragedy made grotesque. The man had the head and face
of Socrates, and here we saw Socrates playing the buffoon.[8]

But there was also another side to Verlaine, a part that was never
quite suppressed in spite of the destructive turn that his life took as
a young man. The wonder of his life is that, living as he did, he still
managed to publish several collections of poems, the most critically
acclaimed being *La Bonne Chanson* (1870), *Romances sans Paroles*
(1874), and *Sagesse* (1881). Though much of his poetry was written
during periods of misery and in sordid surroundings, it reflects a
mind that was sensitive to the beauty of the world around him and
reveals a desire to love and be loved. He retained a sense of morality
and, at times, fervently sought for a spiritual rejuvenation. Because
he departed from traditional French verse forms, his contemporaries
considered him an innovator in technique, and he was embraced by
the Parnassians, the Decadents and the Symbolists. François Cop-
pée, at his death said,

Verlaine created a poetry which was his alone, an inspiration at once naive
and subtle, all made up of shades evoling the most delicate vibrations of the
nerves, the most fugitive echoes of the heart, yet very natural, a poetry fresh
from its source, sometimes even almost popular; a poetry in which the metre,
free and broken, preserves a delicious harmony, while the stanzas sway and
sing like the song of a child, and the lines, most exquisite, are full of music.
And in this inimitable poetry he has told us of all his ardors, faults, remorse,
tenderness, and dreams, showing us, meanwhile, his heart troubled, yet in-
nocent.[9]

Indeed, Verlaine's poetry was so lyrical and harmonious that several
composers of his time and since "set him to music," among them
Debussy.[10]

Born in 1844 in Metz at Rue Haute-Pierre, Verlaine was the
only child of Nicolas-Auguste Verlaine, a captain in the military, and
Elisa Dehée, both descendants of respectable and financially secure
families. Verlaine was welcomed by his parents, especially since three
earlier pregnancies had ended in miscarriages, the fetuses of which
his mother, strangely enough, had preserved in alcohol and kept
stored in the pantry. Having desired a child for years, when Verlaine
arrived, his parents gave him all of the love, attention, and physical
comforts that could be expected of parents. His mother had been
described as an exceedingly patient woman, a "saintly mother" who
"gave anything" to Verlaine and "forgave everything." She ended up
as a martyr to her son.[11]

As a child, Verlaine was loving and affectionate, and he had a very close relationship with his parents. Actually, Verlaine's parents may have been over indulgent. In *Confessions,* he told about his first experience at a boarding school, the Institution Landry, in Paris, where his father had enrolled him when he was nine years old. Even though he had asked his parents to let him attend the school, he was very unhappy after he got there, hating the students, the teachers, and especially the food; thus, at the end of the first day he ran away, returning to his parents, unconcerned about how they would react. "I was sure in my heart," he said, "of the prompt forgiveness of my parents." And, indeed, he was promptly "forgiven" after falling into their arms out of breath and weeping. Said Verlaine, "In their eyes, which showed no real surprise, in their arms which were held out almost in advance and thrown so quickly round my neck, in the long sweet kisses of my mother and ... the quick bearded kisses of my father ... I soon saw that there was every indulgence if not some secret approbation." His father would not allow him to drop out of the school, however, and promptly returned him next morning. But, thereafter, his father visited him daily, bringing him some delicacy to eat or a small gift.[12] Thirty years later, remembering this event, Verlaine wrote: "Exceptional parents—an excellent father—a charming mother—I was spoiled as an only son."[13]

When he returned to the school, Verlaine readily adjusted and actually came to enjoy the companionship of the other children, most of whom came from "bourgeois families" and were well-behaved. Rather innocent, idealistic, and good during his school years, he regularly attended mass and recited the catechism; early on he accepted the teachings of Christianity and the Catholic doctrine; in fact, as a youngster, he developed a high moral sense, becoming very fastidious and scrupulous about his day-to-day life, confessing to his priest with childish innocence even the most minor infractions. At home he was lovingly called "the little chap"—a practice that continued until he was almost a grown man.[14] So loved and accepted was Verlaine at home that he may have been unaware that he was not a handsome lad; in fact, his biographers have described him as downright ugly and even monstrous looking, a condition that he became more aware of as he got older and that caused him some trouble in his later life, especially in his relationships with women.

Verlaine's character began to change at the beginning of his teenage years. In *The Art of Paul Verlaine,* Antoine Adam describes Verlaine at 14 as a "skeptical and derisive schoolboy," who "spent his time reading obscene books and perhaps writing filthy verses." His

grades also began to suffer at this time. Though Verlaine had never been attractive, in his adolescent years his appearance changed for the worse. According to Adam, school photographs of Verlaine at about the age of 15 reveal "a cynical-looking and unpleasantly ugly school boy." One of his junior high school teachers described him as having "a hideous mug that reminded one of a hardened criminal" and as being "the most slovenly pupil in person and dress at the Lycée Bonaparte," where he attended school as a teenager.[15] But in spite of his physical appearance, a certificate from the headmaster of the Institution Landry placed "him among the school's most distinguished pupils" and "enumerated the scholastic triumphs."[16] Lepelletier described him as an above average student who liked Latin and who had "a real appreciation for the classics." He also recounted how his mother reacted to Verlaine the first time she met him. "When he was first introduced to my parents," he said, "his close-cropped head, beardless chin, deep-set eyes, thick straight eyebrows, Mongolian cheek-bones and flat nose, so took my mother aback that she uttered an ejaculation of terror," later explaining that Verlaine made her "think of an orangutan escaped from the Jardin des Plantes."[17] According to Verlaine in *Confessions*, it was during these early teen-age years that "sensuality took possession of [him]."[18]

Verlaine's "passion and mania" for drinking began when he was about 17 or 18 years old, and he first began overindulging while spending his summer vacation with his cousin, Eliza Dujardins.[19] It was at about that time that he also became obsessed with women and sex and began to spend part of his small allowance his parents sent him each month to indulge his passions with women beckoning from dimly lit street corners. Years later Verlaine would say that, before he was twenty, he "was [already] going to the bad."[20] By this time, too, Verlaine was aware that women found him unattractive. Two lines from a poem in *Sagesse*, a collection of religious poetry, suggest a sensitivity to his condition. "At twenty," he said, "a trouble not known before, called amorous desire, caused me to find women beautiful; but they did not find me so...."[21]

After he left the Lycée Bonaparte, Verlaine went to law school for a while, but he didn't apply himself to his studies, preferring, instead, according to Lepelletier, to "[devote] himself to the study of drinking shops on the left bank of the Seine, and the examination of the ale-houses in the Quartier Latin, where twenty years later he was to submerge will, talent, strength, and health."[22] Paris's old Latin Quarter appealed to the youthful poet for several reasons. R. Rudorff, in his 1972 publication *Belle Epoque*, described the Latin Quarter as

a colorful and exciting place, where one could express himself freely. "Ever since the early Middle Ages," he said, "poets had been living among the students on the left bank of the Seine, near Notre Dame." He then continued:

Victor Hugo, Theophile Gautier and Baudelaire had been there earlier in the 19th century.... [T]he spirit of the Latin Quarter was still the same: free, anti-authoritarian, rebellious, comradely, and always lively.... Eccentricity, exaggeration and flamboyance were part of the normal pattern of life amid the Bohemians of the Latin Quarter. This life also had its darker side. Absinthe was cheap and dangerous; drug taking was already a [social] problem and ether addiction, morphinomania and opium smoking made their ravages among many young men who sought for new sensations in the name of Art. The district claimed its toll of victims and more than one provincial family mourned a son who had succumbed to the lure of the quarter and there disappeared, after becoming a human wreck from drink and drugs, who would haunt cafes and scrounge a miserable living until illness or suicide ended his life.[23]

Unhappy with the direction his son's life was taking, Verlaine's father finally got him a job at the Hôtel de Ville de Paris (town hall). His work there was dull and monotonous, and, perhaps, to add some color to his life, Verlaine began to go even more frequently to the cafes, especially those frequented by poets and other literary men.

It was in 1863 that he first became associated with the Parnassians, a group of poets who were in revolt against the Romanticism of previous decades and whose ranks included such men as Leconte de Lisle, Albert Glatigny, and François Coppée, among others. They "emphasized the supreme importance of technical perfection" in their poetry that was published in the magazine *Le Parnasse contemporain*.[24] Verlaine sometimes stayed all night at cafes such as De Ricard's, Mendes' or Nina's, joining in the discussions and the general gaiety.[25] Richardson describes the Parnassians as both serious and fun-loving. "They could be gay in the Bohemian salon of Nina de Callias." He explained that "Nina was the daughter of a Lyons barrister [who] had inherited a fortune, and married a journalist, Hector de Callias." But, "unfortunately Callias was addicted to absinthe, and she was obliged to separate from him," and "she consoled herself by entertaining talented young men." Verlaine not only wrote poems and recited them for the group at Nina's; he also sang, accompanied on the piano by Nina, whose life was reportedly lived so intensely that she died, insane, at 38. She was buried, as she had earlier requested, "in a kimono, pink stockings and silk slippers," a costume that appropriately "symbolized her life."[26]

When Verlaine was in his early twenties, two devastating events occurred in his life. In December 1865 his father died, causing him to go through a period of grief and despondency and causing an increase in his drinking. Less than two years later, his much beloved cousin, Eliza, died. Eliza had believed in him as a poet and, in fact, was financially responsible for the publication of his first collection of poetry, *Poems saturniens,* in 1866. Unable to deal with the tragedy, Verlaine drank steadily for three days.[27] In March 1869 after his favorite aunt died, he again reacted by going on a drinking spree.[28] This pattern of heavy drinking during and after periods of great emotional stress was to continue throughout Verlaine's life.

Verlaine was only 23 when his cousin died, but he was already on the road to his destruction. His drinking continued after he returned to Paris; however, the beer was bad in Paris, and absinthe was plentiful, so Verlaine drank absinthe. Verlaine later wrote to a friend, "It was upon absinthe that I threw myself, absinthe day and night."[29] It was Glatigny and DeSivry who first convinced Verlaine to drink absinthe instead of beer. Lawrence and Olivia Hanson believe that "from that moment Verlaine was in trouble." "Beer merely dulled the senses," they said, "[but] the 'vile sorceress' raised the devil after killing every resistance to it." The Hansons explained further:

Until he began to drink absinthe none suspected that the mild, good-natured Verlaine had a devil; it was not easy to imagine. His mother protested feebly, his better friends forcibly, he listened, promised, reformed, then fell again. He would quarrel, become violent, was actually thrown out of one cafe, but though repenting a thousand times he drank on, for the sorceress promised forgetfulness of grief, of incessant trouble with his chief, or lack of notice for his poems, of every trouble great or petty.[30]

Thirty years later, Verlaine would look with horror on this period of his life. "Absinthe! How horrible it is to think of those days," he said in *Confessions.* "A single draught of the vile sorceress (What fool exalted it into a fairy or green muse?): one draught was still amusing; but then my drinking was followed by more dramatic consequences." He lamented that he had spent "hour after hour in That House of Ill Fame ... with friends ... to be swallowed up in the taverns of the night where absinthe flowed like Styx and Cocytus." He called absinthe "the green and terrible drink" and himself "bestial" for drinking it.[31]

It was one of Lepelletier's friends, Charles de Sivry, who introduced him to his half-sister, Mathilde Mauté de Fleurville. By this time his drinking was completely out of hand. One researcher estimated

from bills that Verlaine bought around a hundred drinks in two and a half days in a local tavern.[32] According to the Hansons,

...he would sit at a cafe and tell anybody, everybody who would listen, about his latest infatuation, his inability to control his passion for absinthe, anything and everything dearest to his heart or burdening his mind at that particular moment, and especially the ever growing longing for a stable influence to rescue him from debauchery; and how if that influence could take the shape of a beautiful young bed companion in the world would be perfect indeed.[33]

He thought that he had found such a girl in Mathilde. A pretty, musically talented girl, Mathilde was only 16 when he met her; so struck was he by her innocence and purity that, according to Lepelletier, "when he went to the Cafe du Delta for his usual absinthe, he quite forgot to drink it! Love overcame his desire for the green liquid: a miracle not to be repeated."[34] But his abstinence was short-lived, and his major craving by now was for absinthe. The next day he left work, and, according to one account, "drank himself silly in the bars of Arras."[35]

Shortly after meeting Mathilde, Verlaine began to show signs of the debilitating effects of overindulging in absinthe. On July 4, coming home at five o'clock in the morning after a night of drinking, he attacked his mother in a maniacal rage. A friend of the family, Victoire Bertrand, who was a visitor in the home at the time, described the scene thus:

Verlaine came [home] at five o'clock in the morning. I heard his mother get up; then I heard a commotion in her room; then Mme. Verlaine came in and cried: "get up, quick, he wants to kill me!" I rushed in at once and saw the wretch: he was holding a dagger, a saber and a big knife, and saying he wanted to kill his mother and then kill himself. . . . He was in a terrible state, his mother said to me: "He's ill, and he sometimes gets very excited." But he was excited by drink.

On July 10 a similar incident occurred as Verlaine was returning home with a friend after a night of drinking. Said the same young visitor, "I didn't dare get up for fear of annoying him; but suddenly there was a cry. I rushed into his room, and there I saw him with his saber. He wanted to throw himself on his mother; but the young man who was with him seized hold of him, and Mme. Verlaine and I snatched the saber from him." On this occasion he opened the cupboard and smashed the fetuses kept there. Later, "he knocked his mother over and grasped her by the throat and said he was going to kill her and then himself." All in all, the struggles with Verlaine lasted

for about seven hours. Verlaine's mother later sorrowfully buried the fetuses in the courtyard in front of the residence.[36] This kind of violence extended to more than his family. In 1869, for example, on one occasion Verlaine drew a weapon on Lepelletier because Lepelletier tried to keep him from returning to a cafe for a drink; and Lepelletier had to run for his life.[37]

His mother certainly seemed incapable of exerting any influence on her son by this time. Said Lepelletier,

> She adored Paul, spoilt him, and forgave him everything. . . . She dared not chide him when he came home drunk, which happened rather often. She would help him to bed, bring him *eau sucrée* [sugar-water] and *tisane* [herb tea] and then, retiring to her own room, burst into tears. But the next day she was always ready with excuses for the dear drunkard, throwing the blame on his comrades—of whom I was one—for the excesses to which Verlaine spontaneously abandoned himself without even the example of friends, for we were far from drinking as deeply as he did.

Indeed, Lepelletier claimed that some of Verlaine's friends at that time were "excessively sober," and "went to the cafes [only] to meet their friends and talk."[38] Marcel Coulon believes that in the beginning Verlaine drank because "he was thirsty, and he found it pleasant to drink" but that later in life he sought "oblivion . . . in accursed liquors" and "drowned . . . many troubles . . . in his absinthe."[39]

Verlaine may have been looking for a savior in Mathilde, whose life appeared to him to be pure, chaste, and uncorrupted. At any rate, it was shortly after these violent episodes that he decided to ask for Mathilde's hand in marriage. After participating in a night that was full of corruption and depravity, drinking at the bars and indulging in sexual orgies at the brothels, Verlaine wrote to Charles de Sivry, asking if he could become betrothed to Mathilde. Though he was somewhat taken aback by Verlaine's request, Charles broached the request to his mother and father, who, after making it clear that Mathilde could not marry for several more years, agreed to, at least, entertain the idea of an engagement beetween the two. So elated was Verlaine that he immediately wrote a poem to Mathilde, one that was later included in *La Bonne Chanson*. Mathilde, who was unaware that Verlaine had a problem with drinking and violence, was flattered by the adoration and love that was tenderly and beautifully expressed in the poems he wrote for her. The 25-year-old Verlaine was no more emotionally mature than his teenaged sweetheart; they both idealized a love relationship that was pure, ethereal, and perfect—a relationship that was hardly to be realized.[40] And this great love he felt

caused Verlaine to struggle to overcome his addiction to absinthe. He was a changed man according to Hanson: he "abandoned absinthe, brothels and all harmful companionships."[41] Lepelletier later remembered that during his courtship with Mathilde, Verlaine "almost entirely neglected his cafe companions, and his best friends only saw him for a few minutes at intervals." He, furthermore, improved in other areas of his life. He was more punctual at work, spent time with his writing, and, to the delight of his mother, for a while became a dutiful and loving son.[42] But there were occasional lapses, which Verlaine was apparently able to conceal from Mathilde and her parents. On one occasion prior to his marriage, Verlaine wrote to Lepelletier concerning an approaching luncheon engagement with Mathilde's parents. "Abominable drunkard," he said. "I am waiting for you. Don't make any allusion to my being canned yesterday. I think I have managed, by some miracle of hypocrisy, to conceal how lit up I was after all yesterday's absinthes, bitters, and bocks."[43] Mathilde and Verlaine were married in August 1870. Mathilde later said that for two years after they got married, Verlaine "did not once get drunk." "I think," she said, "he must have made a very commendable effort for love of me."[44]

Indeed, during the first few months of their marriage, Verlaine continued to write poems to and about Mathilde, and he soon completed *La Bonne Chanson*, the group of poems that was inspired by his love for her. Various lines from the poems in this collection suggested that Verlaine expected a great deal out of his relationship with Mathilde. In *La Bonne Chanson* it is evident that he expects happiness and freedom from his addiction to drink. "Since dawn is breaking, since sunrise is here," he writes, "since after having fled from me for so long, hope again bends its flight towards me, calling and imploring it . . . all this happiness chooses to be mine. . . ." Concerning his vices, he says, "We have done, now, with dreadful thoughts, we have done with evil dreams . . . and put away from us the oblivion sought in accursed liquors. . . ." "Yes," he said, "I desire to walk upright and calmly through my life . . . led by you." Not the least of his happiness was that Mathilde "was beautiful" and "accepted him." Years later, while serving time in prison, he would still remember his happiness at being loved by a pretty woman. "Once I who was thought very ugly, saw a really beautiful woman go by. . . ." Observed Coulon, "She was the angel of freshness and purity, and she was his! His, the drunkard and the heresiarch of love!"[45]

The honeymoon was shortlived, however. Within six months, Mathilde was pregnant, a situation that Verlaine did not adjust to

very well. Verlaine had also joined the National Guard at the height of the Franco-Prussian War, a move that he felt was very patriotic. But, unfortunately for Verlaine, this new activity "developed [in him] the habit of taverns, wine shops, and wetting [his] whistle." The newlyweds quarrelled for the first time, according to Verlaine in *Confessions,* when he came home late one night "quite soden with . . . absinthe." The next evening he hit Mathilde simply because the evening meal was not to his liking. Remembering these two incidents nearly thirty years later, Verlaine would say: "Damn it all, it seemed unending. He who has drunk will drink, and is it not true, O Lord, that he who has struck a blow will die from a blow, according to Thy word?"[46] Other problems soon developed. After the siege of Paris by the Commune, Verlaine became associated with the insurgents, a move that cost him his job.[47] So only a few months into his marriage, Verlaine was without a job, had started drinking in excess once more, and his passion for Mathilde had diminished to the point that he was abusing her and was even entertaining the notion of having an affair with the maid, whom he called "a darling" and a "secondary fancy."[48]

When Mathilde was eight months pregnant, a new chapter began in the life of Verlaine. It was at that time that he met Arthur Rimbaud (1854–1891), a promising young poet, who had been drawn to Paris by Verlaine's poetry. Only 16 at the time, Rimbaud was disenchanted with his life in Charleville (in the Ardennes), in northeastern France, where he lived under the domination of a stern and thrifty mother who emphasized living the respectable life. For several years he was a model son and student, earning top grades in school and attending religious services each Sunday with his family.[49] But some time after his fifteenth birthday, he began to revolt against all forms of respectability; he stopped attending classes at school, preferring to frequent cafes, where he was sometimes given tobacco and drinks for entertaining listeners with obscene language or blasphemy. He refused to bathe, changed clothes infrequently, and uttered derisive comments about everything; he was fond of claiming that he had "no principles" whatsoever.[50]

Finally, Rimbaud, who had been writing poetry since he was 15, sent a few poems with a letter of introduction to Verlaine, who by this time had already published two volumes of poetry—*Poèmes saturniens* and *Fêtes galantes.* The youth desired greatly to go to Paris, having already run away from home three times to go there, each time being returned to his mother by the authorities because of his age. So struck were Verlaine and his friends by the quality of Rimbaud's

poetry that Verlaine immediately invited Rimbaud to Paris, sending him the train fare[51] and saying, "Come, dear great soul, we call you, we wait you."[52] He later welcomed him into the home of Mathilde's parents, where the couple were living because of financial difficulties. Rimbaud's appearance marked the beginning of the end for the already shaky marriage between Verlaine and Mathilde. The poet ends his *Confessions* with: "And everything went on so in this household ... until the arrival in Paris, about October 1871, of Arthur Rimbaud. ... My wife immediately became jealous of him, and her jealousy was quite unjust, at the time! in the wickedly unkind sense in which she understood it." Verlaine claimed that at that time it was "not even a question of affection, of some sympathy or other, between the two natures so widely different as those of [Rimbaud] and my own, but it was certainly a question of extreme admiration and astonishment when I was faced with this youngster of sixteen who ... had already written things 'perhaps above literature.'"[53]

Verlaine's life was to become inextricably entwined with Rimbaud's. Verlaine introduced Rimbaud to several of his poet friends, mainly the Parnassians, and for a short while Rimbaud was regarded as a new poetic genius, a new creator of verse. But Rimbaud, a sulky, insolent, and ill-mannered boy, soon alienated himself from everyone except Verlaine,[54] who was captivated by him. "A sort of sweetness shone and smiled in those cruel blue eyes and on that strong red mouth with its bitter pucker," he would later say. "What mysticism and what sensuality!"[55] One of Verlaine's poet friends, six months after meeting Rimbaud, described him as having "large hands, large feet, and an absolutely child-like face suitable to a boy of thirteen, with deep blue eyes and a nature that is not so much timid as wild [with an] imagination, rich in unprecedented powers and perversities...."[56] Lepelletier said he was "taciturn, with a sneering solemnity," and "very impressed with his own importance." "He conscientiously played the part of sublime child and infant prodigy," he said, "[and] although Verlaine was more than ten years older ... he allowed his despotic companion to lead him like a child."[57]

Indeed, Mathilde had reason to be uncomfortable about the relationship that was developing between Verlaine and Rimbaud. Shortly after Verlaine became acquainted with Rimbaud, he began drinking heavily again and staying out late at night with the boy.[58] Verlaine had probably always been a latent, if not a practicing, homosexual, and Rimbaud had homosexual tendencies also. The youthful and rebellious Rimbaud was looking for new experiences,

believing that the poet must "degrade himself" and experience love
in all its forms in order to capture their essence. Writing to Paul
Demeny some months after taking up with Verlaine, Rimbaud ex-
plained that the poet becomes a "seer" by experiencing "every form
of love, of suffering, of madness," thus becoming "the great criminal,
the great sick, the utterly damned...!"[59] "The quickest way [for
Rimbaud] to achieve degradation," said Richardson, "was to get
drunk on absinthe; and early in 1872 ... [he and Verlaine] spent
much of the day in the cafes of the Boul' Mich,' spending Verlaine's
inheritance on absinthe, living in a more or less continual state of in-
toxication. When the cafes finally closed, they used to go to the rue
Campagne-Premiere." So disgraceful was their life style that even
Verlaine's most Bohemian friends refused to associate with them.[60]
Though Mathilde later said that "Rimbaud got Verlaine drinking ab-
sinthe," and "thereby unchained his worst instincts," Verlaine had
been drinking absinthe for some time before he met Rimbaud and,
indeed, may have introduced Rimbaud to the drink.[61] But young as
he was, Rimbaud had already read Gautier's *Club des haschischins*
(1847) and Baudelaire's *Paradis artificiels* (1860), both of which
describe their experiences with hashish, opium, and other drugs.
Rimbaud was "looking for escape," and "the experiences of these
two distinguished poets offered him not only an easy route but the
promise of insights and visions heretofore not experienced, an ir-
resistible glimpse into the unknown." Hashish was too expensive for
the two to indulge in; but absinthe "could be had for fifteen to twenty
centimes a shot in the sort of cafe that Rimbaud, Verlaine, and their
friends frequented."[62]

Very early in the relationship between the two, Verlaine began
to display vicious behavior at home, one of the effects of overin-
dulgence in absinthe. At one time he tried to choke Mathilde, and
on another occasion he beat her. Shortly before the baby was born,
she made a comment about Rimbaud that Verlaine did not like,
whereupon he "pulled her out of bed and threw her on the floor."[63]
Later, he reportedly nearly killed Mathilde and the baby, this time
attempting to set fire to her hair. On another occasion, when
Mathilde and Verlaine were having dinner with a friend, without
provocation, Verlaine started arguing and threatened to kill his wife
with his knife. He was also self-destructive—he slashed his wrist and
thigh with a knife. Usually he was apologetic after these violent
episodes, promising that there would not be a recurrence of the
behavior.[64]

Rimbaud, like Verlaine, was also prone to violence when under

the influence of absinthe. They fed on each other's appetites and set out on a road of hedonism and depravity—at times fighting each other with knives.[65] During this period, according to one of Verlaine's acquaintances, Rimbaud was "strange, fantastic, disturbing," a "genius of perversity," who "spent his life inventing acts of ruthless malice." On one occasion, at a formal dinner he attacked a photographer; on another occasion, after asking Verlaine to put his hands on the table, for no apparent reason, he viciously cut his wrists. One of Verlaine's acquaintances, a Dr. Cros, later told Mathilde that he thought both were "unbalanced by their abuse of absinthe." Rimbaud also made an attempt on Dr. Cros' life, at one time putting sulfuric acid in his glass of beer while he was away from the table.[66]

Before long, almost none of Verlaine's friends wanted to keep company with the two of them; as a result, Verlaine and Rimbaud were left alone, according to Carter, "in a frenzied world of their own, where drink, sex, and poetry—'a long, immense and logical disorder of all the senses'—were all that counted."[67] Verlaine spent less and less time at home, and when he was there he was usually drunk and unruly. Interestingly enough, during this time of cruelty to Mathilde and rowdy living, Verlaine wrote some of his most beautiful and moving poetry, published in his 1874 collection *Romances sans paroles* (Songs Without Words).[68]

Finally in 1872, Mathilde, no longer able to deal with her marital situation, applied for and was granted a legal separation from her husband—a separation that eventually ended in divorce—and Verlaine and Rimbaud left for London.[69] The document of application for the separation expressed regret that the marriage, begun "under the most favorable auspices," was in serious trouble because Verlaine had "altered his behavior, associating with bad companions and giving way to drink and to absinthe," causing him to get in "a state of over-excitation resembling delirium tremens" and to indulge in behavior that "endangered his wife and child." In addition, it stated that "the acquaintance he had made with an Arthur Rimbaud ... had exercised a most pernicious influence on him," resulting in "the most monstrous immorality." It further charged that Verlaine spent more and more of his time at the cafe, "often passing whole days there and part of the night, drinking alcoholic liquors and absinthe principally."[70]

It is difficult to imagine the kind of life the two poets lived for the next several months. "[Rimbaud had] left a number of mortified fools behind in Paris," Verlaine later said, "and I a certain Princess Bitch." Rejoicing in their new freedom, they travelled about like

vagabonds. But drunken and violent scenes were frequent, and soon
the relationship began to deteriorate, partly because of differences in
temperament. Verlaine sometimes went through periods of intense
regret and self-condemnation about the way he had treated Mathilde.
Rimbaud was disgusted that Verlaine could become so emotional
about his family and also about Rimbaud. Ten years younger than
Verlaine, Rimbaud let it be known that he would some day leave
him. "One day I must go away, very far. . ., he said once when he
became disgusted with Verlaine's sentimental behavior. In looking
back over that period of time many years later, Verlaine said that,
toward the end of their relationship, "their life together became one
long scene."[71] Rimbaud's poem "Morning of Drunkenness" (1875),
from *Illuminations,* was most certainly inspired by such drinking
rounds as the two indulged in.

> Little drunken vigil holy! If only because of
> the mask you have bestowed on us. We
> pronounce you, method! We shall not
> forget that yesterday you glorified each one
> of our ages. We have faith in the poison.
> We know how to give our whole life every day.
> Now is the time of the Assassins.[72]

Between April and July of 1873, Verlaine and Rimbaud sep-
arated several times, with the last separation culminating in extreme
violence. Verlaine and Rimbaud had been living together in London,
but after a quarrel, Verlaine left for Brussels, writing to Mathilde and
threatening to kill himself if she did not meet him there and, at the
same time, writing to Rimbaud and telling him that he was return-
ing to Mathilde and threatening suicide if things did not work
out.

As it turned out, only his mother met him in Brussels; after a few
days, however, Rimbaud arrived on the scene, insisting that he still
cared for Verlaine. But Rimbaud wanted to go to Paris; Verlaine did
not. One day Verlaine came home drunk with a gun, declaring to
Rimbaud that he had bought it "for you, me and everyone." Later,
when Rimbaud insisted that he was leaving for Paris, and Verlaine
begged him to stay to no avail, Verlaine pulled out his revolver and
shot at Rimbaud twice, hitting him in the wrist. At that time
Verlaine, distraught and upset at his actions, begged forgiveness, and
Verlaine and his mother tended to Rimbaud's wound.

A few hours later, however, while still attempting to leave, Rim-
baud became fearful for his life. "[Verlaine] was like a madman," he
said. "He did all he could to keep me [and] he also had his hand

constantly in his pocket, where he kept his revolver." He hastily left, and called the police, after which Verlaine was arrested and charged with attempted murder. Even though Rimbaud later withdrew his charges, claiming that the shooting was an accident, the court still charged Verlaine with criminal assault; added to this was the prison doctor's report that Verlaine showed evidence of "recent and active sodomy." Verlaine was sentenced "to a fine of two hundred francs, and to two years' hard labor."[73]

If Verlaine had been confined to prison for more years of his life, he might have been a more productive person. Deprived of the absinthe that drove him crazy, he began to study and write, and, indeed, did some of his best writing while in prison. The poems were later published in his 1881 collection, *Sagesse*.[74] In spite of having lived the life of a degenerate, deep down Verlaine still had a strong sense of morality. he never doubted that he deserved to be punihsed for the things he did. In a poem written while in Mons, the prison where he served part of his time, he said: "And why, Society, since I have offended your rigid laws, why should you pamper me?" And in a poem in *Sagesse,* Verlaine may have been describing himself in the following lines:

> Wretch! Every good gift, the glory of baptism, your
> Christian upbringing, a mother's love, strength and health
> like bread and water and lastly that future which was as
> surely announced in the picture of that past as the
> succession of the tides . . . you ravage and waste it all. . . .[75]

Verlaine also turned to religion while in prison, hung a crucifix in his cell, and claimed he was a converted man. In January 1875, he was released from prison, having served 18 months of his sentence. He immediately sought out Rimbaud, who was teaching French at Stuttgart.[76]

This was to be his last meeting with Rimbaud, a meeting that quickly turned into a heated argument about which little is known. Delahaye, who knew both poets and who apparently was told some details of the meeting, said that they began arguing in "many public houses," later ending up in the woods outside of Stuttgart. Delahaye describes what happened then:

All arguments [were] exhausted in a battle in which fists replaced words, on the very bank of the Neckar, whose moonlit water seemed to offer these two madmen an only too natural epilogue to their fantastic story. They were in complete solitude, there was no witness of struggle, only the phantom mass of the pines of the Black Forest on the horizon. . . . Very luckily the combatants had neither knives nor revolvers, not even a stick. Though he was

the taller and more robust, Rimbaud soon realized that the other's delirium was dangerous. Verlaine, supple, sinewy, overexcited with drink, was mad with rage, humiliation and despair, believing himself irretrievably relapsed after eighteen months of virtue and conquered by Satan in spite of it all. He wanted to strike, to be struck, to go on struggling there forever.... He fell exhausted at last and lay fainting on the bank, whilst Rimbaud, damaged himself, made his way back to the town as best he could.[77]

Some peasants found Verlaine the next day still unconscious. This was the last time Verlaine attempted reconciliation with Rimbaud, though Verlaine always remembered Rimbaud with pain and was instrumental in gaining recognition for Rimbaud as a poet.

Actually, it was during these months with Verlaine and immediately afterwards that Rimbaud did most of his best writing, including *A Season in Hell* (1873). "Deliriums I" in this work dramatizes and analyses the relationship between the two lovers. In analyzing his poetry, Enid Rhodes Peschel says in his work *Four French Symbolist Poets*:

Violence and vision inhere equally in Rimbaud's art.... [H]is poetry is full of visceral fury, anger and desire to shock.... [V]iolence signals his method of creation itself: a personal and total, physical and psychic deranging that ... will lead the poet to illuminating rearrangements: of perceptions, of language, and of knowledge.

Rimbaud's poetry is important to the period mainly because he was an innovator; rebel that he was, he freed himself from the rules of French versification, making it easier for those who dared to follow. It is unfortunate that most of Rimbaud's poetic genius was spent "creating an aesthetics of ugliness," partly because of, according to Germaine Bree in the Preface to Peschel's book, "a predilection for perversity and perversion"—a condition that was made worse by Verlaine and "the green fairy." Rimbaud gave up writing poetry by the time he was 20; he spent the remainder of his years travelling around Europe engaged in various occupations. He never knew that he would someday be acclaimed as one who "helped revolutionize and revitalize the language, style, form and visionary content of French poetry." He died when he was 37 from complications that resulted when a leg with a cancerous tumor was amputated, unaware that Verlaine had edited much of his poetry, was making it available to the public, and was, himself, acclaiming that Rimbaud was a great poet.[78]

After Verlaine's final encounter with Rimbaud, he spent a period of time teaching, mainly in England; he changed jobs frequently, returning to Paris to live with his mother during periods of

unemployment.[79] Apparently, his drinking was still a problem. One of his students at Rethel, after describing Verlaine as an excellent teacher in the mornings, said that he "got into the habit of going down into the town, after the morning classes at 10:30 to a small bar...." While there "he imbibed so many absinthes that he was often incapable of getting back to the school without assistance" and was, thus, unable to teach in the afternoon; as a result, his headmaster finally dismissed him.[80]

In July 1883 Verlaine's mother purchased a small farm in Coulommes and, to the astonishment of Verlaine's acquaintances, in September of that year Verlaine left Paris and went to live with his mother on the farm, an arrangement that was to last not quite two years. It was during this time, according to Antoine Adam, in *The Art of Paul Verlaine,* that Verlaine gave up all attempts to live a respectable life and gave in to what he called "the fast life." "In Coulommes," Adam said, "he [made] hardly any further effort at dissemblance," and "he even [had] ... a number of alarming types come from Paris. Circulating about him [were] a number of "young rascals with lesbian eyes," and "La Dernière Fête galante" (The Last of Love's Revels) announced, in a gesture of defiance, "L'embarquement pour Sodome et Gomorrhe." Verlaine later claimed that at one time during this period he spent 7,000 francs in a week. He was also beaten and robbed on one occasion.[81] Edgar Saltusm, who saw Verlaine some time after his imprisonment, said:

I can see him now, Socrates and Anacreon in one, hiccoughing down the laurel lanes, paying with enigmatic songs the food which young poets provided, distilling a mysterious music from the absinthe offered by them, and presenting at last a spectacle unique in literature, that of a singer applauded in a charity bed and rising from it to become one of the glories of France— though not of the French Academy.[82]

Verlaine's mother, probably despairing of helping Verlaine, finally turned over the little farm to him. But he was forced to sell the property in March 1885 because of increasing debts.[83] Then, penniless, he took a job writing for Lepelletier's paper. For a while after that, he was accepted back into the society of men; since he was a talented man, other writers came to him for advice, and it appeared for awhile that he was going to straighten out and become a success. When he finally had a relapse, according to Martin Wolf in his Preface to *Confessions,* it was awe-inspiring. "His drinking was renewed with a zest that left observers aghast," he said, and "debts and cabaret bills swamped him in flood proportion; his orgies were

fantasies in debauchery." He also "bled his mother for funds, and she indulged him then as before, finally turning over to him all she possessed, and she sought shelter under the roof of . . . family friends."

Finally, in a drunken rage Verlaine attacked his then 75-year-old mother, threatening to kill her with a knife after she refused to give him more money. She was saved only by the intervention of her friends. Verlaine was sentenced to one month in jail, in spite of his mother's protests that he was "a good boy." After his stay in jail, Verlaine was worse than ever. Said Wolf:

Now his decline was obvious. He was rarely sober; the filthiest of out-worn slatterns embraced, then robbed him; most of his friends avoided him; no publisher would accept his works; he rummaged through every cranny for scraps containing earlier-written verses, hoping for the price of a drink; innkeepers, refusing him credit, allowed him to sleep at a corner table. Verlaine was a dead man alive, alternating with regularity between hospital and bar.[84]

In January 1886 Verlaine's mother died, shortly after exhausting herself while nursing Verlaine through a period of illness. To make matters worse, he was not with her when she died because he was confined to his bed with rheumatism, his legs in splints; for the same reason, neither did he attend the funeral. In spite of his poor treatment of her over the years, he loved her deeply and suffered with regret after her death. "I dream constantly of her," he said in *Confessions*. "We quarrel, and I want to admit that I'm in the wrong, to beg her forgiveness and bury my head in her lap. I am deeply sorry to have saddened her, and full of affection all for her and her alone...."[85] She left Verlaine only some bonds that were hidden under her mattress. At this time Mathilde's family demanded that Verlaine pay the child support that he was delinquent in; as a result, Verlaine turned over most of the money to the sheriff who came to collect the money. After Verlaine paid for his mother's funeral and some of his own debts, he had only 800 francs left.[86]

In the months that followed, Verlaine was totally destitute, living behind a combination brothel and wine-shop in a one-room dwelling with a dirt floor. Even so, at times he still thought of himself as "at bottom, a very honorable man, reduced to poverty through an excess of delicacy and good-nature, but at every point a gentleman and a hidalgo."[87] His high opinion of himself may have been colored by the fact that he was becoming well-known in the literary world by this time, and younger poets were mimicking his works. According to Philip Steven in *Paul Verlaine and the Decadence*, "when Verlaine's

influence on younger poets [such as Jean Moreas and Charles Vignier] first became apparent in the season 1883-84 his style, language, and themes were imitated so closely as to resemble parody."[88]

Verlaine was not, however, receiving much money from his works, and such money as he had was needed to help him through his illnesses. A big part of the next two years was spent in and out of hospitals, battling problems with his legs and various diseases, among them syphilis and diabetes. He would go in to a hospital, sober up for awhile and get partially well. Then he was back out on the streets, and "at once began to undo the cure by over liberal doses of the green sorceress" and by "indulging too often in women."[89] In fact, according to one writer, he "frequented homosexual prostitutes" and "female prostitutes."[90] Actually, so terrible were his living conditions that he came to enjoy his visits to the hospital, where his every need was taken care of, leaving him with plenty of time to read and write. His poet friends sometimes assembled there to hear him read, and would bring him the forbidden brandy, cigars, and absinthe, which he craved so much and which he hid. Even the doctors and nurses became fond of Verlaine, who was cheerful, good-natured and entertaining when not intoxicated. Upon returning to one hospital, after an absence of some time, Verlaine wrote to a friend. "Received back here like a prodigal son. Mild reproaches, that's all. And arrived in very good shape in spite of all the absinthes."[91]

In the 1890s Verlaine made one last attempt to reform; he even gave some lectures in Holland and Belgium, for which he was paid. By this time he had begun to receive recognition as a poet of some note; his books were selling, furnishing him with money that he desperately needed. But, according to Wolf, Verlaine could never quite leave "his life of absinthe and back alleys."[92] And though his living conditions were better after his books began to sell, he spent most of his money on drunken sprees and prostitutes, and his friends still had to help take care of him. The painter F.A. Cazals, for example, frequently befriended him. He often took meals with the Cazalses, and Cazals' wife tended his bad leg.[93]

The last six years of Verlaine's life revolved mainly around "bars ... hospitals ... and ... prostitutes."[94] Much of that time he spent in the Latin Quarter, over which he was "the unchallenged sovereign." His appearances there have been amply described by biographers. Louis Roseyre, in *Au temps du quartier*, vividly describes seeing Verlaine enter a café in the rue Soufflot with Bibi-la-Purée, a homeless, desolate thief and vagabond:

Bibi-la-Puree came first, clearing a way through the crowd, so that the reeling poet ... could find a seat. Verlaine followed, painfully, dragging his leg, and leaning on a stout stick.... He collapsed on to a chair.... Suddenly my heart, the heart of a boy of eighteen, bled with grief and fear at the sight of this old man, whining and infirm, demanding another absinthe. I knew the legend; but really Verlaine, this man who was trembling all over, this man with a dirty beard, his face half hidden by a filthy muffler, ... Verlaine collapsing on Bibi-la-Puree, with that horrible, grinning face, and a mouth slit to the ears, Bibi smelling of rat, old rotting rat! ... I have never been able to forget that sinister and pitiful vision.[95]

The bars and cafés on the Left Bank were favorite spots for Verlaine to meet with those who still desired to see him. According to Richardson, Verlaine "made the fortune of the [café] François Ier, in the boulevard Rambosson." She explains:

Between his rustications in hospital, Paul Verlaine long found himself at home [there]. Sitting in front of "the humble ephemeral absinthe," a scarf the colour of dregs worn anyhow over a shirt that was probably flannel, a short pipe held in a gloriously threatening or insistent fist, a jeer in his damp, limp moustache, a good-humour in his faun's eyes, he used to talk, sometimes in gentleness, sometimes with trembling and rebellion, in a voice that was slightly husky and dull.[96]

Adam records the reactions of several of Verlaine's contemporaries.

Some people, who did not approach him but only crossed his path in the Latin Quarter, retain a terrible recollection of him. ... Andrew Gide saw him, drunk and in a rage, surrounded by jeering urchins, holding up his suspenderless trousers with both hands. Valery had retained impressions of the same kind. Jules Renard saw him at a *Plume* dinner on March 8, 1892. "The appalling Verlaine," he wrote, "a mournful Socrates and a befouled Diogenes—dog- and hyena-like."[97]

Remy de Gourmont said that Verlaine was "encouraged to his misfortune and to their shame, by young men ... whose only glory will have been that they drank with Verlaine."[98] Verlaine would say, though, "I have ruined my life and I know very well that all the blame is going to be put on me. To that I can only answer that I truly was born under Saturn...."[99]

It was during this time that poet F.A. Cazals drew a picture of Verlaine "hobbling through the streets, dressed in a pastiche of worn and floppy garments, his shuffling gait and costume both proclaiming his uncertain and problematic relationship to society. It is interesting to note that Verlaine, even in his condition, was recognized as "a poet of great talent" and was "the inspiration" for younger poets.

And according to Jerrold Seigel in *Bohemian Paris,* as Verlaine "camped among whores and pimps in one of the worst corners of the Latin Quarter, scourging for money, in and out of the hospital," he was protected and sheltered by the public and the police; "The Paris police commissioner gave orders to his officers that Verlaine was never to be arrested, no matter what he did," and two community groups and the Ministry of Education contributed money toward his support.[100]

Verlaine paid the price for living a degenerate and depraved life. His body was ravaged by two of his vices—absinthism, which destroyed and weakened his vital organs, and promiscuous sex, which resulted in his contracting syphilis. In his last months, he suffered from several diseases, among them diabetes, crippling rheumatism, heart disease, cirrhosis of the liver, and the last stages of syphilis. Toward the end of his life he could no longer drink of "la fée verte"; he lived on milk and mineral water. When he died, from pneumonia, on January 8, 1896, he was living with a former prostitute, Eugenie Krantz, whom he finally settled down with after alternately living for brief periods of time with her and two other retired prostitutes named Philomene and Caroline.[101]

Newspaper accounts of Verlaine's death described him as "living 'a truly Bohemian life,'" as "falling into 'the most obscure Bohemia,'" and "'launched in a life of Bohemia and poverty,'" and as "living out his Bohemian existence 'through to the end.'"[102] Richardson records that the day of Verlaine's funeral, "On the threshold of the squalid house in the Rue Descartes, the most famous poets and men of letters in France waited to accompany the body of Verlaine," and that "the humble *quartier* was stupefied by the distinction of the mourners."[103] According to another account of the funeral, "seven literary men delivered seven magnificent orations." And Philomene and Eugenie "were both present, bathed in tears," but Caroline "was unavoidably detained." She was found "stark naked in front of Verlaine's house in the Rue Descartes, shrieking that she was his muse."[104] The "green fairy" had done its part in destroying a talented man of genius before his time.

In 1968 British playwright Christopher Hampton wrote a play about the tragic relationship between Verlaine and Rimbaud. Called *Total Eclipse,* the play was performed at the Brooklyn Academy of Music by the permanent resident company in the Chelsea Theater Center. According to one critic, "Michael Finn and Christopher Lloyd as Rimbaud and Verlaine [were] not convincing geniuses, but they [suggested] the destructiveness latent in creative energy."[105]

Other poets besides Verlaine and Rimbaud were also well acquainted with absinthe. One of these was Oscar Wilde (1854–1900), the Irish poet and dramatist, one of whose best-known works is the epic poem *The Ballad of Reading Gaol*. A versatile writer, his other critically acclaimed works include *The Happy Prince and Other Tales* (1891), a group of fairy stories; *The Importance of Being Earnest* (1895), a stage comedy; *The Picture of Dorian Gray* (1891), a novel; and *Lady Windermere's Fan*, a comedy of manners. He was also known as a brilliant and witty conversationalist who usually dressed flamboyantly and preached the doctrine of "art-for-art's sake."[106] According to Conrad, in spite of their differences, Verlaine and Wilde "drank absinthe with a passion...."

When Wilde met Verlaine in Paris in 1883, he was somewhat surprised at his appearance; Wilde was at that time at the height of his popularity in Engand and America, having just the year before toured America. Even though he wore flashy clothing, he was usually well dressed, and his rakish appearance contrasted sharply with the appearance of the older poet. Journalist Marcel Schwob claimed that Wilde was "a terrible absinthe drinker" and got his "visions" from it.[107]

Wilde was sentenced to prison for his homosexuality after he was charged with practicing "indecent acts" with Lord Alfred Douglas. At the trial, his writings, which some considered indecent and "decadent," were also used as evidence against him, resulting in a two-year prison sentence.[108] After he got out of Reading Gaol in 1897, he found himself friendless in both England and France. He never regained his former stature. The story is told that some time after Wilde was released from prison, André Gide reluctantly visited with Wilde in a café one day. Wilde, who was poorly dressed in a wrinkled coat with a worn shirt beneath it and who realized that Gide was not comfortable with him, said: "When in times gone by I used to meet Verlaine, I didn't blush for him. I was rich, joyful, covered with glory, but I felt that to be near him did me honor, even when Verlaine was drunk." As they got up to leave the café, Wilde insisted that he would pay the bill, but then admitted that he "was absolutely without resources" at that time.[109] Finally, friendless and destitute, in desperation Wilde took another name—Sebastian Melmoth— from a character who had traded his soul to the devil for a longer life in the novel *Melmoth the Wanderer*; as a result, he had to wander the earth for a hundred years as a vampire.[110]

As Wilde wandered, he drank more and more absinthe and became more destitute. In explaining to a friend how it felt to drink

Studio portrait of Oscar Wilde taken in 1882 by N. Sarony. Library of Congress.

absinthe, he said: "After the first glass you see things as you wish they were. After the second, you see things as they are not. Finally you see things as they really are, and that is the most horrible thing in the world." His last major piece of writing was *The Ballad of Reading Gaol.* Like Verlaine, Wilde finally succumbed to the effects of his drinking and to syphilis, which he had picked up from some other unfortunate soul along the way. As a result of the syphilis, he developed an ear infection that required surgery. He continued drinking and while still sick insisted on going to a café to drink absinthe and on taking a carriage ride through the Bois du Boulogne; possibly as a result of this activity, Wilde's ear abscessed and meningitis set in. Nothing could be done for his condition. On November 30 he died after being given conditional baptism by a priest.[111]

One of Wilde's companions for a while was the poet Ernest Christopher Dowson (1867–1900), with whom he became acquainted in 1897 while Dowson was spending some time in England. Wilde was romantically attracted to Dowson, but Dowson did not share the feeling. He did, however, share Wilde's passion for absinthe, and took advantage of the friendship by borrowing money that he was a long time repaying. One day someone said of Dowson: "It's a pity he drinks so much." But "if he didn't drink," said Wilde, "he would be somebody else."[112] Dowson seemed to enjoy the disorientation he experienced when he drank absinthe. "The absinthe which I have consumed between nine and seven of the morning on Friday seems to have conquered my neuralgia, though at some cost to my general health yesterday," he once said in a letter to a friend. He continued with, "The curious bewilderment of one's mind after much absinthe! One's ineffectual endeavors to compass a busy crossing! The unreality of London to me! How wonderful it is!"[113] At another time he said, "Whiskey and beer are for fools; absinthe for poets; absinthe has the power of the magicians; it can wipe out or renew the past, and annul or foretell the future."[114] But he was also cognizant of the menace the drink posed to his general health. In a letter to a friend, he said:

On the whole it is a mistake to get binged on the verdant fluid. As a steady drink it is inferior to the homely scotch ... woke this morning with jingling nerves and pestilential mouth on.... I understand absinthe makes the tart grow fonder. It is extremely detrimental to the complexion.... I never ... presented a more deboshed [sic] appearance than I do this morning.

In 1897, after a period of excessive drinking, Dowson wrote a poem entitled "Absinthia Taetra," which describes the absinthe

drinker's futile attempt to escape the pain and humiliation of past memories and to experience some degree of peace:

Green changed to white, emerald to opal: nothing was changed.
 The man let the water trickle gently into his glass,
 and as the green clouded, a mist fell from his mind.
 Then he drank opaline.
Memories and terrors beset him. The past tore after him like a
 panther and through the blackness of the present he saw the
 luminous tiger eyes of things to be.
 But he drank opaline.
And the obscure night of the soul, and the valley of
 humiliation, through which he stumbled, were forgotten.
 He saw blue vistas of undiscovered countries, high prospects
 and a quiet, caressing sea. The past shed its perfume over him,
 to-day held his hand as if it were a little child, and to-morrow
 shone like a white star; nothing was changed.
 He drank opaline.
The man had known the obscure night of the soul, and lay
 even now in the valley of humiliation; and the tiger menace
 of the things to be was red in the skies. But for a little while
 he had forgotten.
 Green changed to white, emerald to opal; nothing was changed.[115]

Thomas Swann, in his 1964 publication *Ernest Dowson*, says that "Absinthia Taetra," like De Quincy's *Confessions of an Opium-Eater*, "invokes the forgetfulness of absinthe" and that it

...is distinguished by two kinds of imagery, both much prized by the Decadents with their love of exoticism: jewels and savage beasts. ... When mixed with water, the speaker tells us, absinthe changes color, flows from emerald to opal, and offers oblivion from past, present, and future. "The past tore after him like a panther and through the blackness of the present he saw the luminous tiger eyes of things to be." He drinks opaline and for a little while forgets, but nothing is changed—the "tiger menace" is still "red in the skies." An escape more permanent is needed.[116]

In commenting on the poem, Mark Longaker says, "It is impossible to see in these lines only their dark beauty. One cannot help feeling that this is the voice of a man who had lived in the obscure night of the soul and the valley of humiliation, who had for a little while forgotten."[117]

Robert H. Sherard, who was touched by Dowson's loyalty to Wilde, knew Dowson "most intimately," according to Longaker, "when Dowson's body and spirit were entirely crushed, when absinthe was his only escape from suffering,"[118] and although he had a warm feeling for him for a while, he was soon repulsed by his behavior.

On one occasion he found him in a dirty cafe inebriated with absinthe, and feeling sympathy for him, he carried him to his own apartment. Once there, Dowson refused to leave, mainly because he was beset with fears of the outer world. "[Dowson's] most harassing thought," said Longaker, "was that he was about to be paralyzed, or fall into an epileptic fit, as he had heard that confirmed absinthe drinkers sometimes did. But from absinthe he would not desist, even with the menace of paralysis before him. On the mornings that he stayed with Sherard in Paris, he would have the attendant go out for absinthe, which taken on an empty stomach had prompt effect."[119] After Dowson died in February 1900, Wilde grieved for him. He wrote to Leonard Smithers, his publisher, "I hope bay-leaves will be laid on his tomb, and rue, and myrtle too, for he knew what love is."[120]

French poet Raoul Ponchon wrote of his "adoration" for absinthe, saying "it seems when I drink you/I inhale the young forest's soul/ During the beautiful green season."[121]

Poet Gustave Kahn (1859–1936) of the Netherlands also wrote a poem in free verse about absinthe, calling the drink the "mother of all happiness,"[122] and Charles Cros praised the verdant drink in a poem entitled "With Flowers and Women," saying flowers and women can be a wonderful diversion for a time, but "Absinthe, on a winter evening/ Lights up in green the sooty soul and when, later, 'kisses lose their charm' and there have been 'mutual betrayals,' still there is absinthe."[123]

Other writers besides poets also drank from the bitter absinthe cup. French dramatist Alfred-Henry Jarry (1873–1907), author of *Ubu Roi,* an avant-garde play of murder and intrigue about a man's attempt to become king of Poland, was also addicted to absinthe. When he was 17 years old, Jarry went to Paris and shortly thereafter became a part of the group of symbolist writers that gathered regularly at the home of Stéphane Mallarmé and became acquainted with some of the leading members of the movement: Remy de Gourmont, Gustave Kahn, Paul Valéry, André Gide, and Maurice Ravel.[124] A skeptical, vulgar, and irreverent person, Jarry's life has been described as "one of unremitting challenge to convention and tradition." He wrote *Ubu Roi* when he was 23, modelling the main character, King Ubu, on an eccentric physics professor, Felix Hebert. The play deals with the King's desire for power and money, for which he resorts to treachery and murder. The Parisian public loved the play, which was "hilarious and unrestrained, full of slapstick irreverence, and outrage," and Jarry was suddenly famous, "forever after to be identified with the art of provocation and insult."[125]

Jarry was probably the most eccentric of his group and was more in love with absinthe than the others. He referred to absinthe as "holy water," "essence of life," and "sacred herb." He drank absinthe full strength, believing that even "a drop of water, added to a clear liquid like absinthe, muddies it." He also inhaled ether at times, and between absinthe and ether he usually walked around in a dreamlike state. So enamored was he of absinthe that he once painted his hands and his face green in honor of the green goddess. He must have created quite a sensation riding around Paris on his bicycle, which he loved, with tight-fitting, rather bedraggled clothes on and a tie painted on his paper shirt, his green face and hands shining. He attended Mallarmé's funeral wearing filthy pants and a pair of Rachilde's yellow high-heeled shoes. As he made the rounds of the cafés drinking absinthe, he often carried a pistol, which was a danger to others at times. On one occasion a man smoking in a cafe was quite startled when Jarry attempted to shoot his cigar from his mouth; on another occasion, he pulled his pistol on a man who simply asked him for directions, informing him that he had to be six feet away from him before he would give him information.[126] According to Robert Shattuck in *The Banquet Years*, Jarry, who often visited Montmartre, "exercised a special fascination over Picasso," who "adopted his eccentric, pistol-carrying habits and later acquired a valuable collection of Jarry's manuscript."[127] Jarry, who hated "every aspect of contemporary society—its bourgeois pretensions, sham, and hypocrisy—"and spent most of his life attempting to destroy those things, was himself destroyed in the process. He apparently thought Picasso would follow him as destroyer, and Picasso's shocked fellow artists and friends thought that he had when they first viewed Picasso's *Les Demoiselles d'Avignon,* an intensely compelling painting of five ugly prostitutes. "It made me feel as if someone was drinking gasoline and spitting fire," said Georges Braque after viewing the painting.[128]

Jarry generally hated women, but he became quite close to the wife of Alfred Vallette, who was responsible for having Jarry's works published in *Mercure de France.* Vallette's wife, Rachilde, in *Alfred Jarry: Supermale of Letters,* describes Jarry's preoccupation with drinking:

Jarry began the day by imbibing two liters of white wine, three absinthes spaced between 10:00 A.M. and noon; then, at lunch, he washed down his fish or his steak with red or white wine, alternating with more absinthes. In the afternoon, a few cups of coffee fortified with brandy or other spirits of which I forget the names; then, at dinner, after, of course, other aperitifs, he

could still tolerate at least two bottles of any vintage, of good or bad quality. However, I never saw him really drunk except once when I aimed at him with his own revolver, which sobered him up immediately. Personally drinking nothing but absolutely pure water, it was I whom Jarry considered a frightful phenomenon: "You're poisoning yourself, Ma-da-me," he explained to me, as seriously as could be. "Water contains, in suspension, all the bacteria of heaven and earth, and your sweets, which form your main nourishment, are spirits in a rudimentary state that intoxicate in a completely different way than do spirits expediently purged of all their harmfulness by fermentation."[129]

Rachilde said Jarry was aware that he was "killing himself" but seemed to get some special pleasure out of being a "martyr" to the cause.[130]

Jarry died of meningeal tuberculosis in 1907 when he was only 34. According to Stillman, "his death ... was precipitated by a determined course of exhaustion, malnutrition, and drink."[131] Shattuck calls his death "suicide by hallucination," and Rachilde said "he was the victim of a cruel mirage in his brain, the desire to fit his existence to his literary program. He refused 'to take the road of real life.'"[132] Paul Chaveau, who wrote Jarry's biography, said that Jarry's romance with absinthe and other intoxicants was partly an attempt to fuse life and art, to become as one with the world of his imagination.[133] The first volume of Jarry's complete works was published in 1972 by Gallimard, making his writings more accessible to scholars. In May 1980, Peter Brook staged *Ubu Roi* [King Ubi] in New York, an indication that, even for a twentieth century audience, the play still has appeal.[134]

4

FROM VAN GOGH
TO PICASSO

When day is done and night is a lyric ecstasy with a million stars; when the lust for life flames like red wine in the heart of man; when out of the tortuous darkness temptation strides with fawning hips and painted face, do you remember Vincent van Gogh, the satyric figure of a dwarf with enormous head, huge fleshy nose, repulsive scarlet lips, black bushy beard, myopic malevolent eyes? He leans for support on a tiny cane. He stands by a dust bin polluting the night with its hideousness—symbol of filth and putrescence. He sits down at a marble table, eagerly welcomed by those who have wasted life, and now life wastes them: drinking absinthe with hopeless hopefulness. The fairy with the green eyes has enslaved their brains, has stolen their souls.[1]

No doubt W.R. Bett succeeded in capturing the attention of his audience as he read this dramatic passage to the Society for the Study of Addiction in the rooms of the Medical Society of London on April 21, 1953. The paper, entitled "Vincent Van Gogh (1853–90): Artist and Addict," is basically a clinical examination of the relationship between Dutch artist Vincent van Gogh's art and his addictions. Several studies before and since Bett's paper have attributed various aspects of van Gogh's art to both physiological problems and addition to various substances, one of which was absinthe. Though many art critics reject the notion that van Gogh's art was influenced to a great extent by his "illness," others believe "his productivity, his choice of subjects, and some technical details" of his art were influenced by his "disease."[2] Almost all agree that van Gogh's last paintings, especially *Crows Over the Wheat Field* and *The Starry Night*, reflect his inner turmoil during the final months of his life.

Van Gogh is perhaps the most fascinating artist of the absinthe

Vincent van Gogh. *Self-Portrait Dedicated to Paul Gauguin* (1888). Oil on canvas, 60.3×49.4 cm. Fogg Art Museum, Harvard University. Bequest: Collection of Maurice Wertheim, Class of 1906 (1951.65).

era; his tormented and pathetic life, during which he suffered both mentally and physically, rivals Verlaine's in its tragedy. Van Gogh was introduced to both religion and art at an early age. His father and grandfather were ministers who preached and lived by the strong moral code of the Calvinists. Three of his uncles were art dealers. As a child van Gogh was sensitive, unattractive, awkward, temperamental, and difficult to get along with. His family did not understand his

strange ways and his independent way of thinking and usually left him alone. Feeling rejected by his family, van Gogh frequently sought seclusion, causing him to become more withdrawn and more unsociable. In his study of the life and work of van Gogh, Frank Elgar presents a sympathetic view of the artist as a child, saying he was "a frustrated and misunderstood child" and no one "appreciated his virtues and needs...." Elgar believes van Gogh's lonely and frustrated childhood had a major impact on the remainder of his life.[3]

When he was 16, van Gogh began working at Goupil and Company at the Hague, a chain store that sold and distributed art productions among other things and that had branches in New York and all over Europe, including Paris and London. Van Gogh got the job through his Uncle Vincent, who first introduced him to the world of art and who had been instrumental in the development and the expansion of Goupil and Company. Van Gogh's early years with the company were without incident. In 1873 he was transferred to London, where he met and fell in love with Ursular Loyer, his landlady's daughter. After admiring her from afar for several months, he finally confessed his love and proposed marriage; but unfortunately for van Gogh, Ursular was already engaged and, in spite of his persistence, turned down his proposal of marriage. According to van Gogh's sister-in-law, J. van Gogh–Bonger in her memoirs of van Gogh, "With this first great sorrow, [van Gogh's] character changed," and "when he came home for the holidays, he was thin, silent, dejected—a different being."[4] Van Gogh was later to admit that the whole experience caused him "many years of humiliation."

During the next few years, van Gogh became more solitary and secluded, and his work with the company became less than satisfactory. He became argumentative, exhibited odd behavior at times, and was increasingly unhappy with his work, claiming that he sold "worthless pictures to unsuspecting customers." He was transferred to Paris for a while, but his problems with the company got worse, and he was finally dismissed from his job in 1876.[5]

Distraught and depressed, van Gogh turned to religion and the ministry, but, although he gave himself wholeheartedly to his mission, he failed miserably.[6] Because of the influence of his father and his grandfather, van Gogh had long been a student of the Bible; only 23 years old at the time, he approached religion with all the enthusiasm and idealism of youth. "There has always been someone in our family who preached the Gospel," he said, and "it is my fervent prayer and earnest desire that the spirit of my father and grandfather

may also rest upon me . . . and that my life may resemble more and more [their] lives." After only six months of study, however, van Gogh became disenchanted with formal religion, mainly because he failed to see any connection between the Greek and Latin he was required to study and ministering to the poor, the needy, and the sick, as he felt called to do.

It was at this time that he decided to become an evangelist. He was given a trial appointment to the coal mining districts in southwest Belgium, where, according to Albert J. Lubin in *Strangers on the Earth,* he quickly became "the nurse and teacher of the miners and their families, and was accepted by them." "In caring for these mistreated men and women," Lubin said, "[van Gogh] gave away his possessions, his money, and his clothes and became sick and emaciated himself"; he lived in a "dirty hovel," and "his face was usually dirtier than that of the miners." Dismayed, church officials charged van Gogh with exhibiting "an excess of zeal bordering on the scandalous." He was later dismissed from the service of the church, ostensibly for "lacking a talent for speaking." His evangelistic work ended shortly thereafter.[7]

Van Gogh turned to art around 1880. Immediately following his resolve to become an artist, he began studying furiously and, assisted financially by his brother Theo, the only family member to remain really close to him during his lifetime, even took some art lessons. Unfortunately, in 1881 van Gogh fell in love again, this time with a widowed cousin, who also refused his offer of marriage. So insistent was van Gogh in pursuing the young lady that she left for home in Amsterdam and the protection of her father. Still hoping to win her hand, a few weeks later van Gogh appeared at her home, but she refused to see him. After two days of pleading to see her to no avail, in a final act of insane desperation, van Gogh approached her parents again; upon being refused, he placed his hand in the flame of a lamp, his flesh visibly burning, threatening to leave it there until their daughter appeared. The horrified parents still refused, whereupon van Gogh fainted.[8] This incident is only one of many that reveals the mental and emotional instability that plagued van Gogh for most of his life. He was to experience similar episodes of violent passions coupled with self-destructive behavior throughout his life, the culmination of which was the taking of his own life.

Following this episode, van Gogh became "irritable and nervous," and "his relations with his parents became strained," resulting finally in "a violent altercation with his father."[9] It was probably both pity and loneliness that prompted van Gogh to take in

a prostitute and her children a few months later, to the dismay of his parents. Years later, van Gogh's sister-in-law said: "Vincent could not be alone; he wanted to live for somebody, he wanted a wife and children, and as the woman he loved had rejected him, he took the first unhappy woman who crossed his path, with children that were not his own."[10] Though he lavished great love and care on the woman and her children, unfortunately the woman was "slovenly," "coarse," "vulgar," and an alcoholic, and she little appreciated what van Gogh did for her. In 1883, he reluctantly "let the woman go her own way" after Theo convinced him that the woman "was not able to live an ordered life."[11]

In the next few years, van Gogh lived in a variety of places in both Belgium and Holland, during which time he mingled with other artists and continued to work at his art. In 1886, he moved to Paris and for two years lived with Theo, who was an art dealer with Goupil and Company.[12] It was fortunate for van Gogh that his brother was willing to take him in. Shortly after his arrival in Paris, Theo wrote to his mother, telling her that she "would not recognize Vincent" because "he has changed so much." "The doctor says that he has now quite recovered his health," and "he makes great progress in his work and has begun to have some success.... If we can continue to live together like this, I think the most difficult period is past, and he will find his way."[13] Unfortunately, Theo was not able to use his position to advance van Gogh's painting career, because the Goupils regarded van Gogh's paintings as "impudent monstrosities" and would not allow them to be shown at their gallery.[14] But Theo gave van Gogh both financial and emotional support at that time and, indeed, for the remainder of his most productive and creative years.

Theo was also on good terms with other artists whom he supported, and it was he who first introduced van Gogh to such artists as Camille Pissarro, Claude Monet, Jean-François Raffaelli, Edgar Degas, Auguste Renoir, Paul Signac and Henri Toulouse-Lautrec, all of whom were associated in one way or another with the school of Impressionism.[15] The term *impressionist,* which originated from the title of Monet's work *Impression, Sunrise* (1872), refers to the artists' attempts "to capture in paint the fleeting effects—or impressions—of light, shade, and color on natural forms."[16] Although there are similarities in their art, these artists had "no formal theory" and "abandoned any fixed program." They "diminished the importance of subject matter, denied the importance of genre, and subjected everything to the stamp of their own personalities and sensibilities." The term today is loosely used to "describe almost all the painters

who, in the second half of the 19th century, took a stand against tradition and . . . led art back to the concrete problems of vision."[17] Although Impressionism was viewed as "a radical and revolutionary form of art, both in technique and subject matter," these artists did not necessarily hold "revolutionary political views."[18]

Though van Gogh never became "a formal Impressionist," he was greatly influenced by the theories of the school of Impressionism, especially in his use of color,[19] and, along with Theo, supported their right to paint as they chose. It was customary for these artists, who at first were misunderstood and ridiculed by other artists and the public, to gather at cafés to discuss art and to give support to each other. It is believed that van Gogh, who undoubtedly met regularly with these artists, became a heavy drinker during his years in Paris, and no doubt he drank his share of absinthe, which was the rage in Paris at that time. That he was very familiar with the drink by this time is certain. In 1887 he did a still life painting entitled *Absinthe,* which features a decanter of absinthe on a table with a full glass of absinthe nearby. Lautrec, who may have introduced van Gogh to absinthe, "did a pastel of van Gogh with a glass of absinthe that same year."[20] Several months later, after leaving Paris, van Gogh admitted to Theo that he "was certainly going the right way for a stroke" while he was in Paris because of his drinking and his smoking,[21] and he told an artist friend that he was "seriously sick at heart and in body and nearly an alcoholic" when he left Paris.[22]

For a while, things went well for van Gogh and his brother, but, according to van Gogh's sister-in-law, "after the first excitement of all the new attractions had passed," van Gogh became irritable and argumentative, driving his brother to distraction, sometimes urging him for hours at a time to leave Goupil and open his own art gallery. In a letter to his sister, Theo admitted that his "home life" had become "almost unbearable." "No one wants to come and see me any more because it always ends in quarrels," he said, and "besides, he is so untidy that the room looks far from attractive. I wish he would go and live by himself."[23] At another time he said that van Gogh seemed to be "two persons; one, marvelously gifted, tender and refined, the other, egoistic and hard-hearted." The "two persons . . . present themselves in turns," he said, "so that one hears him talk first in one way, then in the other, and always with arguments on both sides." "It is a pity," he lamented, "that he is his own enemy, for he makes life hard not only for others but for himself." But in spite of Theo's difficulties with van Gogh, when his sister advised him "to leave Vincent for God's sake," Theo did not take the advice,

saying that van Gogh was "certainly an artist" and that he might produce "sublime" work some day.[24]

Acting on the advice of Lautrec,[25] in February 1888, van Gogh left Paris and went to Arles in southern France, where during the next fifteen months, he was to experience the most disturbed period of his life, suffering both from severe psychological and physiological problems. But it was also one of his most productive periods, during which many of his masterpieces were created; in all he did more than 200 paintings and numerous drawings and watercolors.[26] But in spite of this spurt of creativity, his move to Arles was the beginning of the end for van Gogh. He was unbearably lonely during his first months there; he complained to his brother that he had days when he suffered "from unaccountable, involuntary fits of excitement or else utter sluggishness." He explained to Theo that the only way a person could "bring ease and distraction" for the condition was "to stun oneself with a lot of drinking or heavy smoking," and he admitted that "if the storm within gets too loud, I take a glass too much to stun myself." In fact, he "drank a great deal."[27]

If he drank too much, van Gogh was not unlike many of his contemporaries, some of whose overindulgence he was quick to excuse. Van Gogh was captivated by the art work of Adolphe Joseph Thomas Monticelli (1824–1886), who died while van Gogh was living in Paris of what was rumored to be "absinthe consumption." Even though "by most accounts [Monticelli] was a heavy consumer," van Gogh came to his defense, refusing to believe that he drank so much and excusing him for the amount he did drink. Writing to Theo, he said he questioned the rumors that Monticelli drank "such enormous quantities of absinthe" because "when I look at his work, I can't think that a man who was flabby with drink could have done that."[28]

He obviously gave Monticelli's situation serious thought, for again he wrote,

I so often think of Monticelli, and when my mind dwells on the stories going around about his death, it seems to me that not only must you exclude the idea of his dying a drunkard in the sense of being besotted by drink, but you must realize that here as a matter of course one spends one's time in the open air and in cafes far more than in the North. My friend, the postman, for instance, lives a great deal in cafes, and is certainly more or less of a drinker, and has been so all his life. But he is so much the reverse of a sot, his exaltation is so natural, so intelligent, and he argues with such sweep, in the style of Garibaldi, that I gladly reduce the legend of Monticelli the drunkard on absinthe to exactly the same proportions as my postman's.[29]

But from all accounts, Monticelli, in spite of his creativity, had a major drinking problem. Monticelli's favorite place to drink was the Cafe de l'Univers in Marseilles, where the owner not only bought his work but also kept his glass filled. One of his biographers, describing Monticelli's late-night drinking habits, said he would "tip-toe furtively onto the street" and would suddenly "duck" into a café, where he "would slip onto a bench in a dark corner . . . head back, eyes ecstatic, sip in little mouthfuls of his Ambrosia," (i.e., absinthe). In 1884 Jules Monge did a portrait of Monticelli entitled *L'Absinthe*; the portrait shows a heavily bearded Monticelli seated at a small table with a decanter of absinthe in his hand. He is in the process of filling a glass on the table before him.[30] Van Gogh's excusing Monticelli's proclivity to drink absinthe may have indicated that he, himself, was partaking of the drink far too frequently.

Perhaps because of his loneliness, van Gogh began to envision a "community of painters," who would live and work together and share the proceeds from their paintings. To this end he rented the now famous "yellow house" at Arles, which he hoped would "mark the beginning of the community of painters."[31] And, indeed, his plan seemed to be working at first. In October 1888, van Gogh was joined by post–Impressionist painter Paul Gauguin (1848–1903).[32] A Parisian by birth, Gauguin spent some time in Peru as a child, after which he again lived in France. After serving in the merchant marines for six years, Gauguin became a successful stockbroker, married a Danish woman, and became the father of five children. At first painting was simply a hobby for Gauguin, but his hobby eventually took over his life. In 1883 he quit his job to devote his full time to painting, but he was unable to earn a living for his family. As a result, his wife took the five children and returned to her family in Denmark, a separation that became permanent.

At the time Gauguin went to live with van Gogh, he was 40 and had been working seriously at his art for some time and to some extent had "already begun to establish his style of painting. . . ."[33] Gauguin, who was experiencing financial difficulty and who hoped Theo would help sell his paintings, reluctantly accepted van Gogh's invitation to go to Arles after Theo, looking out for the welfare of van Gogh, made him a financial offer he could not refuse. Van Gogh ws delirious with happiness. In anticipation of his friend's arrival, he decorated the little yellow house and prepared the best room in the house for Gauguin.[34] Apparently van Gogh and Gaugin believed they could develop a reciprocal relationship sharing their passion for painting and exchanging ideas about form, color and subject. But

such was not to be the case, mainly because the two were so totally different in temperament and in their perception of and approach to life. But the two-month period when the two artists worked together "produced some of the greatest paintings of the century."[35]

Upon arriving in Arles in the early morning hours, Gauguin went first to an all night café frequented by van Gogh and was somewhat disturbed by "the company he found himself in." Later he walked to the edge of town and found van Gogh's yellow house, where van Gogh customarily "drank his cognac and absinthe with his only friend, Roulin the postman." After showing Gauguin his bedroom, which was decorated with studies van Gogh had painted and hung in anticipation of Gauguin's arrival, van Gogh took Gauguin to his studio. Gauguin was shocked. "Everything was in the most appalling disorder," he later said. "His box of paints was crammed with tubes and the lid could never be closed." He afterward discovered that van Gogh spent money he needed for food to buy paints and brushes that he already had but could not find because of the clutter in his studio. Gauguin, an organized and authoritative person, quickly took command of the house. "I find your brother somewhat nervous," he later wrote to Theo, "but I hope to calm him down." Gauguin cleaned the house, bought new clothes for van Gogh, cooked regular meals, and took control of the little money that van Gogh had. "We kept a box," he said. "So much for tobacco, so much for incidentals, so much for rent. On top of the box we kept a pencil and piece of paper so that each could write down what he had taken out of it. In another box we kept the rest of the money to buy our food; we divided it into four parts, one for each week." And he also took control of van Gogh, who was delighted to have someone to take an interest in him and to alleviate his loneliness.[36]

Prior to this time, van Gogh had depended on models for his painting; but Gauguin advised him to give up models and to use his memory and his imagination." "Sit in front of nature," he said, "...then dream about it ... let it be absorbed in the crucible of your eye and mind," and "serve it up stark and simplified on your canvas, a synthesis of what you have seen and what you have felt."[37] Van Gogh accepted this advice readily, surprising even Gauguin with his amenability. Shortly after Gauguin's arrival, the two began making the rounds of the cafés and brothels in Arles; Gauguin, who found Arles a delightful place, became popular immediately, but van Gogh was befriended by only one lonely girl.[38] Van Gogh took Gauguin to the Café de la Gare, where he lived from May until September and

which was the subject for his painting *The (All) Night Café*, which he did a few weeks prior to Gauguin's arrival.[39] He explained to Theo that he usually ate at that cafe "by gaslight, in the evening." "It is what they call here a 'cafe de nuit' (they are fairly common here), staying open all night," he said. "Night prowlers can take refuge there when they have no money to pay for a lodging or are too tight to be taken in."[40]

Writing to Theo about *Night Café*, van Gogh explained that since he "was always bowled under" by having to pay his landlord so much rent for such a poor place to live, he informed the landlord—whom he really liked—that he had decided to "revenge" himself by painting what he called "the whole of his rotten joint." To the delight of the landlord and the "night prowler" patrons, he did just that, staying up three nights straight and sleeping during the day to complete the work, which he said was "one of the ugliest I have done ... the equivalent, though different, of the *Potato Eaters*." "I have tried to express the terrible passions of humanity by means of red and green," he continued.

The room is blood red and dark yellow, with a green billiard table in the middle; there are four citron-yellow lamps with a glow of orange and green. Everywhere there is a clash and contrast of the most disparate reds and greens in the figures of little sleeping hooligans, in the empty, dreary room, in violet and blue. The blood red and the yellow-green of the billiard table, for instance, contrast with the soft tender Louis XV green of the counter, on which there is a pink nosegay. The white coat of the landlord, awake in a corner of that furnace, turns citron-yellow, or a pale luminous green.[41]

In another letter he explained that he had "tried to express the idea that the cafe is a place where one can ruin oneself, go mad or commit a crime." "So I have tried to express, as it were, the powers of darkness in a low public house by soft Louis XV green and malachite, contrasting with yellow-green and harsh blue-greens, and all this in an atmosphere like a devil's furnace, of pale sulphur," he said.[42]

Says David Wilkins and Bernard Schultz in *Art Past, Art Present*, "The ugliness of which he writes is intentional, for in this painting color is used arbitrarily, allowing him to express personal meanings and emotions through the 'clash and contrast' of glaring yellow, bright green, and 'blood' red." In expressing "the mood" of the cafe, they say, van Gogh "reveals some of his feelings about his own

Opposite: **Vincent van Gogh.** *Night Café* **(1888). Oil on canvas, 28½"×36¼". Yale University Art Gallery: Bequest of Stephen Carlton Clark, B.A. 1903 (1961.18.34).**

alienation."[43] In commenting on "the oddly exaggerated perspective of the painting," Wilkins and Schultz mention the Japanese influence on van Gogh's art, but they also suggest that van Gogh "may have been influenced by the visions he experienced during the beginning of a seizure" or by "absinthe, one of the artist's common indulgences [which] is known to affect the occipital lobe, which controls vision."[44] Writing to a younger artist, Emile Bernard, in October 1888, thanking him for a group of sketches entitled *At the Brothel*, he reminded him, ". . . my cafe is not a brothel; it is a cafe where night prowlers cease to be night prowlers, because they flop down at a table and spend the whole night thus without prowling at all." Indeed, he said, sometimes "it may happen that a whore brings her fellow along."[45]

The manager of the cafe, Madame Ginoux, later posed for both van Gogh and Gauguin. Van Gogh's *L'Arlésienne* shows Madame Ginoux seated at a table with her arms crossed.[46] In Gauguin's painting, also titled *At the Café*, the manager of the café sits at a table on which rests a glass partially filled with absinthe, a water siphon, and sugar cubes. In the background three prostitutes sit at a table with van Gogh's postman friend; at a nearby table a man is slumped over on the table with his head resting on his arm: he is asleep or passed out from drinking.[47] Apparently van Gogh liked Gauguin's painting. "I've . . . done a cafe which Vincent likes very much and I like rather less," wrote Gauguin after finishing the painting. "Basically, it isn't my cup of tea," he said.[48]

Even if all seemed well in the beginning, the two artists began almost immediately to have problems. According to Robert Wernick in an article in the May 1988 issue of *Smithsonian*, Gauguin was a strong, egotistical individual, whose "years at sea . . . gave him a taste for exotic places, complaisant women, and hard liquor—along with a physique to enjoy them." An "enthusiastic boxer and fencer," he had "an ingrained disrespect for authority and respectability." Said Wernick, "Nothing in Gauguin's life was ever allowed to get in the way of his central conviction that he was a genius and that to a genius all things are permitted." "Gauguin's favorite subject for portraiture was himself," he continued, and "on occasion he could paint himself as he must have appeared to his pals around the absinthe bottle, rough-hewn and sardonic, Barnacle Bill the Sailor." His wife, Mette, described him as "wholly absorbed in contemplating his own magnificence."[49] It was inevitable that the two artists' personalities should clash. As explained by Gauguin, "Between the two of us, he like a Vulcan, and I boiling too, a kind of struggle was preparing itself. . . ."[50]

Only three weeks after moving in with van Gogh, Gauguin was complaining that he and Vincent didn't "see eye to eye very often about anything and still less about painting." Even though almost every conversation between the two artists ended with a disagreement, van Gogh did not want Gauguin to leave him. It was about this time that van Gogh began to experience severe mental and emotional problems that would eventually culminate in what some have called a "mental breakdown." He began acting in a strange way. Some days he would remain silent all day; other days he would become almost violent, throwing things around in the house. Some nights Gauguin would awake and find van Gogh near his bed, only to have him leave silently when he discovered him there. Disturbed by van Gogh's behavior, Gauguin wrote to Theo, asking him for money to go to Paris. "I respect your brother's intelligence," he said, "but our temperaments don't mix," and "we can't live here together in peace."

The final explosion between the two came the day Gauguin finished painting a portrait of van Gogh, a portrait in which van Gogh appeared to be mad. That night when the two were drinking absinthe, van Gogh "suddenly flung his glass of absinthe at Gauguin." The next day, fearing the situation would get worse, Gauguin started packing his belongings as a contrite and disturbed van Gogh watched. Tired of his packing, Gauguin walked outside; shortly afterwards he was shocked to see van Gogh coming toward him with a razor. He rebuked him with a stare, whereupon van Gogh went back inside the house, and Gauguin went elsewhere to spend the night. He later discovered that van Gogh had turned the razor on himself and had cut off part of his ear, severing an artery and causing a great deal of bleeding. Nearly faint, he took his ear to the girl at the brothel who had been kind to him, causing a great commotion. Gauguin, in spite of van Gogh's pleading, refused to see him again, saying he would only "excite him again" and "the sight of me might prove fatal."[51]

Van Gogh later did a self portrait with a bandage covering the injured ear. Said Wilkins and Schultz of *Self-Portrait,* "The placement of the green coat against the red background and the blue cap against orange demonstrates his interest in using complementary colors to achieve rich coloristic and dramatic effects. The violent juxtaposition of the red and orange draws attention to Van Gogh's solemn eyes," which reflect the hurt and sorrow of his life at that time. He, himself, wrote that he was filled with "a certain undercurrent of vague sadness," which he found "difficult to define." "My

God," he said, "those anxieties—who can live in the modern world without catching his share of them?"[52]

Gauguin later went to Tahiti, where he "went native . . . lived in a grass hut and took as his . . . woman a thirteen-year-old Tahitian girl, who gave birth to his son." In 1893, needing money to live on, Gauguin went to Paris, where he made an unsuccessful attempt to sell his paintings. In 1895 he returned to Tahiti and lived there for the remainder of his life.[53] It is clear now that his years in Tahiti— during which he was sick with syphilis, was disliked by the natives and the French civilians, and was not too successful with his art—were not the ecstasy he thought they would be, but, then on January 18, 1897, after receiving a check from Paris for some of his art, he wrote a friend: "I sit at my door, smoking a cigarette and sipping my absinthe . . . without a care in the world."[54]

Following the ear incident, van Gogh was admitted to the mental hospital at Arles, where he was put under the care of the house surgeon, Felix Rey, who "considered his condition serious." While visiting with him, Theo wrote to his wife: "There were moments when I was with him when he was well; but very soon after he fell back into his worries about philosophy and theology. It was painfully sad to witness, for at times all his suffering overwhelmed him, and he tried to weep but could not; poor fighter and poor, poor sufferer; for the moment nobody can do anything to relieve his sorrow and yet he feels deeply and strongly."[55]

In January 1889, van Gogh left the hospital apparently "completely sane" and energetically resumed his work, completing in the next few weeks among other works two self portraits—*Man with Severed Ear* and *Man with Pipe*—both of which show the artist with a bandage over his injured ear. But by early February he was experiencing "delirium and hallucinations" and had to return to the hospital. Released once more, he continued to paint, but by this time the people of Arles had turned on him. Because of his red hair, they called him "Fou-roux"—the "red madman." A petition was circulated and presented to the mayor demanding that van Gogh be institutionalized permanently. As a result, his house was locked up, and he returned to the hospital, where he stayed until he was transferred to a hospital in the nearby town of St.-Rémy in May. By this time he, too, was almost convinced that he should remain in an institution, that there was, indeed, something wrong with his mind. In May 1890 he left St.-Rémy, spent some time with Theo in Paris, and then went to Auvers-sur-Oise, where he was closely observed by Dr. Paul Gachet, who had been highly recommended by Pissaro because

of his interest in art as well as his experience in working with emotionally disturbed patients. Even though Dr. Gachet quickly became van Gogh's good friend and staunch supporter, his work with van Gogh was unsuccessful, and van Gogh shot himself on July 29, 1890, and died two days later.[56]

About a year before his death, van Gogh painted *The Starry Night,* generally seen as expressing "his philosophies of life and death and their connection to nature." He had earlier written to Theo:

For my own part, I declare I know nothing whatever about it, but to look at the stars always makes me dream, *as simply* as I dream over the black dots of a map representing towns and villages. Why, I ask myself, should the shining dots of the sky not be as accessible as the black dots on the map of France? If we take the train to get to Tarascon or Rouen, we take death to reach a star. One thing undoubtedly true in this reasoning is this, that while we are *alive* we *cannot* get to a star, any more than when we are dead we can take the train."[57]

Van Gogh hinted at the possibility of ending his life in an April 1889 letter to his brother concerning the reaction of the townspeople of Arles to him after his release from the sanatorium; not only did the adults laugh at him, even the children made fun of him and threw rocks at him. "Without your friendship," he said, "they would . . . drive me to suicide. . . ."[58]

Several years later Gauguin, sick, almost penniless, and despondent, also attempted suicide by taking arsenic. Though he failed, in the agonizing months prior to the attempt, he painted the masterpiece *Where do we come from? What are we? Where are we going?* (1898).[59] He was to live five more miserable years after this, most of the time sick and in pain. According to the records of a merchant from Hivaoa, an island of the Marquesas group, Gauguin bought "202 liters of red wine, 25 liters of absinthe and assorted spirits and 80 bottles of beer in the last four months of his life."[60] Ironically, after his death his paintings suddenly became very valuable, giving support for his wife and family that he was unable to provide while he was living.

It is difficult to understand the artist's compelling urge to paint, to give his whole life—as both van Gogh and Gauguin did—to pursue at any cost what sometimes seems to be both illusive and unattainable. Gauguin tried to explain in the following words written in a notebook for his daughter several years before his death:

I believe in the sanctity of the soul and in the truth of Art, one and indivisible. . . . I believe that this Art has a divine source and lives in the hearts of all men who have been touched by the heavenly light; I believe that having tasted the delights of this great Art one is inescapably and forever dedicated

to it and can never renounce it; I believe that everyone, by means of it, can achieve bliss.

I believe in a Last Judgment at which terrible punishments will be meted out to all who have dared to traffic in sublime and pure Art and all who have soiled and degraded it by their vulgarity and vile lust after material pleasures. I believe that, conversely, the faithful disciples of great Art will be blessed and, wrapped in a perfumed and heavenly garment of sweet harmonies, they will return to the heart of the divine source of all harmony, to be identified and dwell with it there forever.[61]

Van Gogh's letters to his brother Theo and other family members and friends have been published in a three volume work entitled *The Complete Letters of Vincent van Gogh.* In the words of Bennett Schiff, writing in the October 1984 issue of the *Smithsonian,* the letters "form an anatomy of a man's life which, through the description of everyday events, becomes both heartbreaking and profound, a testament to a singular genius who barely had a single day of plain joy in his tortured life, except when he was painting."[62] In a letter written while at Arles, van Gogh said: ". . .loneliness, worries, difficulties, the unsatisfied need for kindness and sympathy— that is what is hard to bear, the mental suffering of sadness or disappointment undermines us more than dissipation—us, I say, who find ourselves the happy possessors of disordered hearts."[63] Van Gogh worked hard at his painting; in fact, he almost "never didn't work." His more than 800 paintings in a 10 year period can attest to his industry.[64] But as far as can be determined, not one of van Gogh's paintings sold while he was living. Now, a century after his death, his works are invaluable. As recently as May 1990, Japanese art dealer Kideto Kobayashi paid $82.5 million for van Gogh's *Portrait of Dr. Gachet,* setting the record for a single painting; the previous record for a painting was van Gogh's *Irises,* which sold for $53.9 million in November 1987.[65]

Only a few weeks before his death, van Gogh said of his painting of Dr. Gachet,

What impassions me most—much, much more than all the rest of my metier—is the portrait, the modern portrait. I seek it in color, and surely I am not the only one to seek in this direction. . . . I should like to paint portraits which would appear after a century to the people living then as apparitions. By which I mean that I do not endeavor to achieve this by a photographic resemblance, but by means of our impassioned expressions— that is to say, using our knowledge of and our modern taste for color as a means of arriving at the expression and the intensification of the character.[66]

Many scholars have attempted to analyze Van Gogh's "illness," which was most severe during the last two years of his life. Evidence

of his attacks is available in both his letters and hospital records. Of varying intensity and accompanied by dizziness, anxiety, disorientation, delirium, visual and auditory halluciantions, delusions, and occasional violent behavior, the attacks came on suddenly and lasted from one to two weeks to as long as two months. He had several such severe attacks while at Arles and St.-Rémy.[67] In the 1922 work *Strindberg und Van Gogh,* German psychiatrist Karl Jaspers contended that van Gogh had schizophrenia; he attributes changes in van Gogh's art after 1888 to the illness, pointing to his excessive concern with technique during that time and evidence of great "tension" and "emotional excitement," which resulted in "impoverishment and unsureness" in his drawings. At times like this, says Jaspers, "the lack of discipline virtually [extended] to smearing without a sense of form. This represents energy without content, or doubt and terror without expression."[68]

Others have attributed van Gogh's problems to epilepsy, and, indeed, two physicians who attended van Gogh during his illness, Dr. Peyron at St. Rémy, and Dr. Filex Rey at the Arles hospital, diagnosed van Gogh's illness as epilepsy.[69] In a 1925 publication, German doctor Walter Riese takes issue with Jaspers because he "did not admit that [van Gogh's] psychosis might have had an epileptic base." But Reise admits that "a number of works from the artist's final years ... suffer from a certain degree of weakness and from a visible tendency towards ornamentation, which recalls the work of the alienated," a term commonly used for schizophrenics.[70] In 1932 Françoise Minkowska makes a further case for epilepsy in *L'Évolution psychiatrique,* saying van Gogh's condition resembled a "psychic [form] of epilepsy" about which little was known at the time of Jaspers' study.[71]

In his 1972 psychological biography of van Gogh, *Stranger on the Earth,* Albert J. Lubin includes "absinthe poisoning" as a "diagnostic possibility" for van Gogh's problems after first dismissing the likelihood that his illness was the result of delirium tremens caused by excessive drinking. "To the clinician," he says, "the presence of delirium accompanied by disorientation, hallucinations, delusions, terror, and violent behavior suggests a syndrome commonly called a 'toxic psychosis,'" a condition "caused by various toxic or other organic disturbances of the brain." He points out that delirium tremens, which occurs when an alcoholic suddenly stops drinking, is the "best known toxic psychosis" and that there is some evidence to suggest that at least some of van Gogh's attacks occurred immediately after he had visited Arles, where he may have drunk heavily. But

"other factors," he says, "[argue] against the diagnosis of delirium tremens." He continues: "While visual hallucinations are typical, auditory hallucinations are unusual; fainting spells are not observed; and the characteristic tremor of the hands that contributes to its name does not appear in the descriptions of Vincent's attacks." Besides that, some of the attacks occurred during periods when alcohol would not have been available to him for some time, and, furthermore, his physicians, who would have been familiar with delirium tremens, did not diagnosis his problem as such.[72]

Lubin makes the case for absinthe poisoning by first pointing out the artist's fondness for the drink. "Vincent was no stranger to absinthe," he said. "According to Gauguin," he continued, "he was drinking it during their nightly visit to a bar when he threw the glass at Gauguin's head." Further, "In denying that [Monticelli's] death was due to absinthe, Vincent may have hinted at his own reason for using it: '. . .he would drink it, not solely for pleasure, but because, being ill already, he needed it to keep him going.'" Lubin points out that "from descriptions in the French medical literature, the typical manifestations of absinthe poisoning were epileptic convulsions and recurrent attacks of delirium," but "unlike delirium tremens," he said, "the attacks were said to persist after the victim stopped drinking it and to be commonly accompanied by auditory hallucinations." Robin points to the popularity of absinthe drinking in Arles when van Gogh lived there, saying that in all of France, "[absinthe] consumption was highest in the Bouches-du-Rhône, the *département* in which Arles is located; compared with a national average of 0.60 liters, the average consumption there was 2.45," he said.[73]

In an article in the November 25, 1988 issue of *Journal of the American Medical Association,* Wilfred Niels Arnold, a member of the Department of Biochemistry at the University of Kansas Medical Center, supports the theory that absinthe played a major role in van Gogh's illness. Arnold is "convinced" that "during his last decade van Gogh developed an affinity for chemicals of the terpene class [one of which is the *thujone* found in absinthe] and that they contributed to his early demise." Arnold refers to a 1961 study by R.E. Hemphill, who concludes that van Gogh "was a manic-depressive who developed confusional episodes and fits due to his addiction to absinthe. The toxic agent in absinthe was thujone." He also points to some comments by Anton Kerssemakers, van Gogh's frequent companion in 1884, who claimed that van Gogh usually had alcohol with him when he was painting and, to make matters worse, ate very little. Arnold refers to the Lautrec portrait of van Gogh sipping his

absinthe and to van Gogh's still-life portrait of himself with absinthe in hand. "It is clear," said Arnold, "that van Gogh started drinking heavily after his arrival in Paris in 1886" and that "there are numerous anecdotes along these lines from relatives and friends." Arnold contends that those such as van Gogh's nephew who view his uncle's drinking as only possibly "contributing" to van Gogh's poor health have "confused the literature by missing or under estimating his proclivity for absinthe" and "its damaging components in addition to alcohol."[74]

According to Arnold, van Gogh's letters in the last years of his life indicate that he suffered from many of the symptoms of absinthism—two of which were severe stomach problems and a marked deterioration of the nervous system. In an April 1888 letter to another painter, Emile Bernard, for example, van Gogh "complained of a major stomach disorder," and in a later letter to his brother he "admitted to drinking and smoking too much during the preceding period and to 'certainly going the right way for a stroke when I left Paris.'" Later correspondence indicates that his "digestion was greatly improved" and his "stomach ... stronger." He was constantly warning Theo to beware of "smoking, drinking, and sex," since they were fraught with danger. Even so, he continued to overindulge, if not in the company of Gauguin then with others of his friends. Said artist Paul Signac, "Though he [van Gogh] ate hardly anything, what he drank was always too much ... after spending all day in the sun [painting] ... the absinthes and the brandies would follow each other in quick succession."[75]

Like the absintheur, van Gogh also suffered from hallucinations and convulsions. Arnold believes that the "hallucinations might possibly have given van Gogh a different perception of color and relationships between colors." "You can see some of that in his choice of palette in his final period," he said. Furthermore,

In the last 18 months of his life, when van Gogh experienced at least four fits with hallucinations resembling those described by absinthe drinkers, he was exposing himself to increasing amounts of thujone. Even when he was given leave from the hospital at Arles or the asylum at Saint Remy there are good indications that he drank absinthe (thanks in part to the unwitting assistance of his well-wishing friends) and that he relapsed accordingly.

In fact, Arnold says, "In a letter from Saint Remy to Theo, van Gogh writes about visiting old friends and neighbors in Arles and then in the next letter of another attack." Arnold also points out that van Gogh's "fits and confusion" were controlled by bromides (a compound

to ameliorate convulsions) and withholding alcoholic beverages, which would be indicated for absinthe addiction ... but not likely to be effective in temporal lobe epilepsy, one of the alternate diagnoses with some adherents."[76]

In addition to the thujone in absinthe, van Gogh may have developed an affinity for two other ketone-terpene compounds—camphor and pinene. Shortly after the ear incident, van Gogh wrote to his brother that his remedy for insomnia was "a very, very strong dose of camphor in my pillow and mattress," saying he would "recommend" it to his brother "if ever you can't sleep."[77]

According to Arnold, "the margin between convulsant and fatal doses is even smaller for camphor than for thujone, but, otherwise, the effects on mammals are similar." Arnold also recounts how Signac at one time had to restrain van Gogh from drinking "about a quart of essence of turpentine from the bottle." Says Arnold, although the attempt to drink the turpentine "has usually been regarded as demented," there "is a chemical connection." Arnold explains that "turpentine is extruded from the sapwood of firs, pines, and conifers," and "the essential oil is separated from the rosin by steam distillation as an oily, colorless liquid with a penetrating odor and a characteristic taste" and that "it contains a large proportion of pinene and other terpenes." Says Arnold, "I believe that van Gogh had developed an affinity for terpenes, the documented examples being thujone, camphor, and pinene." He went on to say that it was "perhaps ... not too strong to even suggest that he had a pica; that is, a craving for unnatural articles of food...." "The pica theory," he says, "would help to resolve some of the strangest of van Gogh's acts during the last two years—his attempts to eat his paints and so on—that were previously regarded as absurdities and unrelated."[78]

It is somewhat ironic that a Thuja tree—another source of thujone—grew over van Gogh's grave for 15 years after his death, at which time his casket was disinterred for reburial on a larger plot. At the time of the disinterment it was discovered that the roots of the tree had completely wrapped around the casket "as though they held him in a strong embrace." The Thuja tree was replanted in Dr. Gachet's garden and, according to Arnold, is still growing on the beautifully landscaped grounds around the well-preserved three-story house that was once the home of Dr. Gachet.[79]

Other theories have been put forth by the medical community in the last few decades attempting to diagnose van Gogh's case. Frederick W. Maire, writing in the August 16, 1971 issue of the *Journal of the American Medical Association*, thinks that van Gogh may

have had glaucoma and that his suicide may have been the result of a sudden belief that he was going blind—a terrible situation for an artist. According to Maire, "There is some reason to postulate that van Gogh suffered a possible chronic type of glaucoma known to be painless, insidious, and capable of causing intermittent elevations of intraocular pressure." "Symptoms may only have been an intermittent appearance of colored halos seen around lights and a slowly progressive diminution of vision," he says, but "this diminution induces the glaucoma sufferer to seek a compensatory and steadily increasing brightness of light in order to see more acutely."

Maire bases his belief that van Gogh had glaucoma on three reasons: "the halo of rainbow tints seen around light in some of van Gogh's later paintings, his preference for brightly sunny southern France, and the apparent relative absence of obvious depression preceding his death in contrast to his previous behavioral patterns." Maire points to the rainbow colored halos around the ceiling lights in *The Night Café* in September 1888, saying similar lights in an earlier painting, *The Potato Eaters* (1885), did not have the halo effects. He also points to *Sidewalk Cafe at Night* (September 1888), *Starry Night* (June 1889), and *Road with Cypresses* (May 1890) as having lights with a halo effect. He suggests that van Gogh decided to stay in Arles because of the "more intense sunlight," which would have helped his vision by making colors clearer and would have alleviated the pain suffered by some victims of glaucoma by constricting the pupils of his eyes. Maire mentions a letter van Gogh wrote to Gauguin at one time in which he said that he "eyesight was strangely tired" one day and that he had to rest his eyes for two and a half days. Maire claims that "van Gogh's self-portraits, when magnified, show the pupil of one of his eyes to be slightly larger than the other"; dilated pupils are frequently associated with glaucoma.[80] Though Maire's article makes for interesting reading, shortly after it appeared in the *Journal of the American Medical Association*, there was a deluge of letters to the editor that questioned the validity of Maire's findings.[81]

Another interesting theory was put forth by Thomas Courtney Lee in the February 20, 1981 issue of the *Journal of the American Medical Association*. Pointing to van Gogh's propensity for the color yellow in the last years of his life and his use of halos in his paintings, he suggests that van Gogh suffered from digitalis intoxication. Digitalis was a common treatment for epilepsy during the time van Gogh lived; in fact, both of van Gogh's portraits of Dr. Gachet include a foxglove flower—*Digitalis purpurea*. Along with dizziness,

confusion, stomach problems, and delirium, digitalis intoxication, which occurs in about one-fifth of the patients taking the substance, also causes one's visual perceptions to change, with many reporting the dominant visual impression as yellow, while others report seeing halos or swirls of light. "Symptoms of depression were common with van Gogh from 1874 to 1886," says Lee. He continues:

Psychoanalysts have established that sense of color is negligible in melancholia. Van Gogh's dominant palette of black, brown, and amber supports this observation. It was in 1888, when he moved to the South of France, that his psychotic symptoms became more acute. It was during this time that his paintings became overtly yellow and his epilepsy manifest. It was also the time that digitalis may have been prescribed for him to relieve his acute maniacal symptoms.

Lee admits that "it is not reasonable to assume that van Gogh was continually under the effects of digitalis and its yellow fog during the last years of his life." But he thinks that "during his acute maniacal or epileptic periods, he may have been treated with this medicine for a short period, noticed the golden and coronal toxic symptoms, was impressed with them, and, when these side effects disappeared, purposefully continued to paint with a yellow dominance."[82]

Van Gogh's sister-in-law in her *Memoir of Vincent van Gogh* supports the opinion of Professor G. Kraus in his 1941 publication, in which he "denied that [van Gogh's] sickness had any appreciable influence on Vincent's work, with the exception perhaps of his last painting" (*Crows Over the Wheat Field*). Like Kraus, she believes "his art has all the characteristics of 'healthy art' because of its straightness, its spontaneity, and his hard work," that "none of the numerous and different diagnoses can be sustained in view of the facts, and that "in his art as well as in his 'malady,' Vincent was an individualist...." She mentions his absinthe drinking but does not go as far as the later diagnosis—"namely that of alcohol poisoning from drinking absinthe of bad quality."[83]

Most art critics would probably agree with Ronald Pickvance, curator of the 1987 exhibition of van Gogh's art at the New York Metropolitan Museum of Art, who contends that "van Gogh's paintings are neither 'graphs of his so-called madness nor primarily indicators of his mental state.'" Like the artist himself, Pickvance believes his paintings were the result of "sheer work and calculation." According to Pickvance, "[Van Gogh] described color, handling and design in terms that respond far more to internal artistic necessity than to psychological quirks or medical abnormalities," and "he conceived of process, purpose and function with a quite

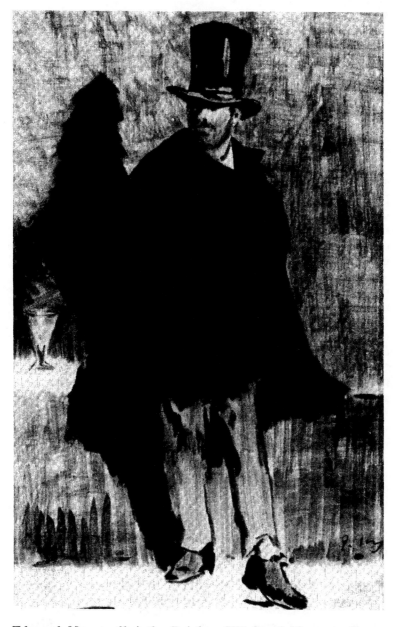

Edouard Manet. *Absinthe Drinker*. Hill-Stead Museum, Farm-
ington, Connecticut.

deliberate and almost programmatic intent." Pickvance points out that "in the last 70 days of his life, [van Gogh] produced no fewer than 70 canvases."[84] In light of all the evidence, it would be unreasonable to claim that van Gogh's art resulted chiefly because of his "illness" or any addiction he may have had; but it is not unreasonable to believe that van Gogh's "illness"—whether schizophrenia, epilepsy or other—was exacerbated by absinthe drinking and that at least some of van Gogh's psychological and physiological problems were the direct result of overindulging in the drink.

While of all the major artists of the period, van Gogh is the one most frequently associated with absinthe, he was by no means the first or the only artist to deal with the subject. As early as 1858, French painter Édouard Manet (1832–1883) became interested in the subject while studying under Thomas Couture (1815–1879). His first major painting, *The Absinthe Drinker* (1858–59), shows a brooding, draped figure in a dark hat with a glass of green liquid by his side and an empty bottle nearby. His model for the work was an alcoholic "rag-picker" named Collardet, who frequented the area near the Louvre.[85]

It is not known whether Manet, who has been described as a "gentleman" who was "one of the most civilized, elegant figures in the history of art,"[86] had any personal acquaintance to speak of with absinthe, but his poet friend, Charles Baudelaire, who advised others to "Be drunk always" was not ashamed to admit that absinthe drinking was one of his "vices."[87] The idea for the work may have been suggested by some lines from Baudelaire's *Fleurs du Mal.*[88] At any rate, the idea began to take form while Manet was studying under Couture, during which time he copied Adrian Brouwer's painting of a person insane from drinking absinthe.[89] So pleased was Manet with his completed work that he invited Couture to his studio to view the painting. If he expected praise, he was disappointed. Couture was shocked at the painting. "An absinthe drinker!" he said. "And they paint abominations like that! My poor friend, you are the absinthe drinker. It is you who have lost your moral faculty."[90]

Undaunted by this criticism, in 1859 Manet submitted the painting to the French Salon, but unfortunately, the painting was rejected, as were many paintings that Manet submitted later. According to one writer, "Manet never got over his surprise at the public's contempt for his art, nor his bitterness about the rejection." Manet's rejection by the jury of the Salon was made even more painful by the fact that he had great respect for the Salon, believing it was "the only true 'field of battle' for an artist."[91]

And, indeed, the French Salon was a revered institution, having been the proving ground for artists since its establishment by the Royal Academy of Painting and Sculpture in 1663, providing for either annual or biennial exhibitions by artists and sculptors. The first exhibition was held in 1673, but only members of the Academy could exhibit their works, a situation that continued until 1791, at which time the National Assembly opened the exhibition not only to French artists but to foreign artists as well. During the nineteenth century, the Salon flourished and "was transformed into a vast public spectacle wherein large numbers of artists sought public as well as private favor, with a few asserting their right to paint as they chose regardless of official or popular approval." In the beginning, a government-appointed jury selected the paintings to be exhibited at the Salon; later in 1848 and 1849, there was a trial period of a free Salon, resulting in a deluge of artistic works, many of which were of inferior quality. Thereafter, some control was exercised over the selection of the art that was exhibited at the Salon.[92]

During Manet's lifetime, exhibitions at the Salon in France were world famous. To be exhibited there was certain to bring success to an artist; to be repeatedly rejected, failure.[93] Those artists who refused to submit to the standards of the Salon and chose to follow their own inclinations, as Manet frequently did, found it difficult, if not impossible, to have their works accepted by the jury for the Salon. During Manet's most productive years, the exhibitions at the Salon were dominated by conservatives, who had preconceived notions of what constituted good art[94] and who obviously felt that an absinthe drinker was not a fit subject for serious art.

In an article in the November 1983 issue of *Art in America*, which deals with Manet's revisions of some of his paintings, Charles F. Stuckey puts forth an interesting theory as to why "the extraordinary *Absinthe Drinker*" was "received so poorly" at the 1859 Salon exhibition. He believes that its rejection was partly because "the unpopular original version" was quite different from the one known today. Stuckey contends that the painting went through some significant changes in the years following its rejection. According to Stuckey, Manet's stepson, Leon Leenhoff, claimed that in the original painting the central figure had no legs and the absinthe glass was missing. Leenhoff's statement is corroborated in a 1945 study by Jens Thiis, who says that the bottom sixteen inches "of the present painting is a separate piece of canvas that was sewn on as an addition." Leenhoff believes Manet added the man's legs and the absinthe glass in 1863, but Stuckey thinks there is some question about

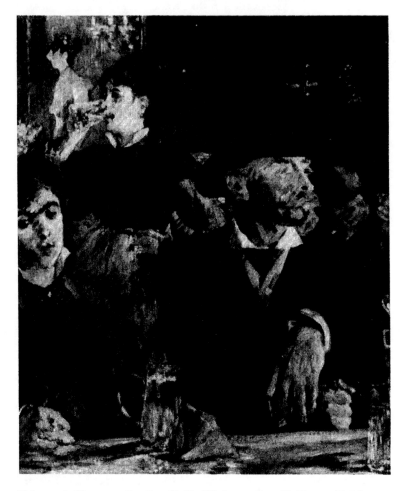

Edouard Manet. *At the Café.* **Walters Art Gallery, Baltimore (37.893).**

when the changes were made, the only certainty being that the paint-
ing was completed by 1872, "for early that year Manet sold it to the
dealer Durand-Ruel as one of the four related works referred to as
'philosophers.'" Indeed, Stuckey believes Manet may have made the
changes "because he wanted this painting to become part of an
ensemble consisting of full-length images of beggars."[95] Manet, who
always insisted that "he painted objects as he saw them and not as
others would like to see them," continued to submit paintings to the

Salon but with little success.[96] It seems that the rejection of *The Absinthe Drinker* almost prophesied Manet's experiences with the public.

Following the rejection of Manet's *The Absinthe Drinker,* an increasing number of paintings by innovative artists of the period were systematically rejected by the Salon; as a result, in 1863, after "numerous complaints" from the rejected artists, the government established the Salon des Réfusés for them "to let the public judge the legitimacy of [their] complaints."[97] Many of these rejected artists, who were later called Impressionists, discovered that they had a great deal in common, and they gathered around Manet, seeing him as their leader.[98] But even after the Salon des Réfusés was established, Manet continued to shock the public with some of his creations. In 1863, after his painting *Le Dejeuner sur l'Herbe* (Luncheon on the Grass) was rejected by the Salon and hung in the Salon des Réfusés, the critics, the public, and the French emperor reacted with horror, mainly because the painting included a nude woman reclining on the grass with two fully dressed gentlemen, but partly because no one understood the painting. It was later discovered that the painting was modelled after an engraving by Raphael that included "a group of classical deities."[99] Manet simply put Raphael's idea into a contemporary setting.

Manet and his followers gathered at the Café de Bade, "a fashionable establishment in the center of Paris," until 1866, at which time they moved to the Café Guerbois, where the atmosphere was more conducive to conversations and debates by the artists who gathered there, among them Degas, Renoir, Monet, Pissarro, and others. At 37, Manet was the oldest of the group and "the intellectual leader." According to one account, Manet was "overflowing with vivacity, always bringing himself forward, but with a gaiety, an enthusiasm, a hope, a desire to throw light on what was new, which made him very attractive." Zola described him as "of medium size, small rather than large, with light hair, a somewhat pink complexion, a quick and intelligent eye, a mobile mouth, at moments a little mocking . . . a man of greatest modesty and kindness." But others saw him as "ambitious" and "impetuous" and "naturally ironical in his conversation and frequently cruel . . . [with] an inclination for punches, cutting and slashing with a single blow." He could get furiously angry, and on one occasion took part in a duel. Manet also had an argument with Degas, the end result being that they each returned paintings that they had previous given to each other.[100]

Manet's fascination with street scenes and café life in Paris was most obvious in the last 13 years of his life from about 1870 to 1883, when absinthe drinking was becoming fashionable. During these years, according to Novelene Ross in the book *Manet's Bar at the Folies-Bergère,* Manet "sketched and painted more than 150 images of fashionable Parisian women, *demi mondaines,* and lower-class women," and "the latter two categories appeared prominently in Manet's studies of Parisian entertainment genre—cafe, cabarets and beer halls." His last major work (188182) dealing with this theme was *Un Bar aux Folies-Bergère* (A Bar at the Folies-Bergère), which was exhibited at the Salon in 1882.[101] Such paintings as *A Bar* were influenced by Claude Monet (1840–1926), particularly in its bright lights and mirror images.[102]

The scene in *A Bar at the Folies-Bergère* is not unlike the scenes in many of the cafés and bars in Paris where absinthe was in vogue. In the painting, a barmaid with a wistful, contemplative expression on her face, stands before a marble counter arrayed with various liquor bottles, a small vase of flowers, and a bowl of oranges—prepared to serve the patrons of the evening. A moustached gentleman in a top hat stands in front of the bar, and a gymnast performs in the background. The gay crowd and the brilliance of the evening—made brighter by a large chandelier and globe lights—are reflected in a long mirror back of the counter. According to Ross, "Mirrors were then (and still are) a ubiquitous feature of Parisian interior decorations," and "any study of contemporary leisure activities in the city would inevitably have included a mirrored background...."

Ross says that the painting "offers the veracity of sensation—the evocation of citrus fruit, sweet liquors, roses, and cigar smoke; the sensation of sexual tension played against the inebriated backdrop of flickering light, animated banter, and aerial acrobatics," and "the clearly focused frontal view of the barmaid dominates this worldly kingdom of the senses." Ross continues,

She wears the house uniform of dark bodice trimmed with lace over a gray dress. Added to this regulation *toilette* are the personal touches of a ribbon necklace with oval medallion, a simple bracelet, earrings, and a corsage of roses between her breasts. She leans forward slightly, palms resting against the counter, as immobile as the objects which surround her. Separate from, and yet enveloped in multiple dimensions of pleasure, the barmaid's sensuous face with large features and heavy-lidded eyes betrays no expression.[103]

Larry L. Ligo, in a January 1988 article in *Arts Magazine,* contends that the oranges in the painting help to identify the woman as a

prostitute; he points to other paintings in which Manet used oranges, all of which include pictures of prostitutes. He also refers to a 1984 publication by Manet scholar T.J. Clark, in which evidence is presented

that the Folies-Bergère was a recognized "haunt" for prostitutes . . . [and] had been firmly established as a "permanent fair for prostitutes" by the mid 1870s, a reputation still "enjoyed" in 1889 when it was listed in a guidebook of Parisian brothels as a place ". . . famous for its *promenoirs*, its garden, its constantly changing attractions, and the public of pretty women."

Clark believes the barmaid in Manet's bar "is intended to represent one of the prostitutes for which the Folies-Bergère was well-known," and "he sees the barmaid as both a salesperson and a commodity— something to be purchased along with a drink."[104] Most certainly, as William Feaver says in the December 1983 issue of *ARTnews*, the painting is "a feast of sensations" from "the bottles . . . [of liquor] on the marble slab to the rookery mob on the far balcony, the icy chandeliers overhead, the black velvet of her bodice and the oranges. . . ."[105]

John House, in a November 1983 article in *Art in America*, says such paintings as *A Bar at the Folies-Bergère* would have made them less likely to be accepted by the Salon.

In the art of the past where a figure looks out toward the viewer, our relationship to the figure in question, and thence to the whole subject, is clearly determined; Manet's paintings permit us no such certainties. By denying the viewer either a clearly defined relationship to the figures in his paintings or the means of constructing a coherent narrative from them, Manet was creating structures which challenged the conventions of narrative painting current in the 19th-century Salon.

House refers to the "impossible" reflections behind the barmaid in *A Bar at the Folies-Bergère* and the difficulty of coming up with a "precise reading" that will "explain every detail and form more and more comprehensively."[106] House thinks that

to identify the barmaid in *A Bar at the Folies-Bergere* as a prostitute destroys the ambivalence of our relationship to her. . . . Manet's paintings themselves contain no answers to these uncertainties, nor are they the sort of questions which any detailed analysis of the historical context can resolve; they must be left as questions.[107]

Manet was an admirer of French graphic artist Honoré Daumier (1808–1879), the sharp-witted political cartoonist of the 1830s. Shortly after lithography was invented by German actor and playwright Alois Senefelder, many artists tried it out, with one of the

most successful being Daumier. In fact, Daumier was so successful that he frequently got in trouble for criticizing and ridiculing politicians and the government,[108] especially while he was on the staff of *Caricature,* which was known for its political satire. The illustrated weekly magazine was constantly under the surveillance of the government, and was "seized by government officials twenty-seven times" by 1834, finally succumbing to the repression of the press that occurred after there was an attempt to assassinate the king.[109] In 1832, Daumier was sentenced to five years in prison for a caricature of King Louis-Philippe as Gargantua.

In spite of this, Daumier continued to use his talent to speak out against social injustices and other aspects of life. Because of the criticism of the government and its officials by Daumier and others, a law was passed in 1835 forbidding criticism by "drawings." According to the law, "Frenchmen have the right to circulate their opinions in published form," but drawings were such an "incitement to action" that complete liberty in this realm was no longer permitted. Thereafter, Daumier's prints became "more humorous and less political."[110] Among his other work, in 1863 Daumier published some lithographs on absinthe in *Le Charivari* that were "social commentaries" on the subject. The lithographs had such titles as "Beer—never . . . it takes absinthe to revive a man" and "Absinthe . . the first glass . . . the sixth glass."[111] Though in his time Daumier was valued most for his lithographs, he was also a painter. His paintings are perhaps as valuable today as his lithographs.[112]

Like Manet, Impressionist painter Edgar Degas (1834–1917) was also enchanted with café life and street scenes; according to Sue Welsh Reed in a December 1984 issue of *ARTnews,* "Degas made high art of the lowly *cafe-chantant,* where Parisians flocked on summer nights to sit under the stars and hear performers sing of the unrequited love of a hippopotamus for a rose." These café-concerts, which appeared in Paris as early as 1840, "achieved wide popularity during the 1867 International Exposition and continued into the 1880s." "By the 1890s," said Reed, "the scene had shifted to Montmartre" to "nightspots such as Le Moulin Rouge" and "entertainers such as Jane Avril." Though they were lacking in "sophistication" with a "certain naivete to their programs," these café-concerts were appealing to the public because of "a relaxed casualness to the setting, not unlike a small-town band concert."[113] American Mary S. Bouligny, who in 1871 published "a memoir of her years in Paris" entitled *Bubbles and Ballast,* describes the atmosphere of these places of entertainment.

Tonight being warm enough to favor out-door strolls, we repaired to a *cafe-chantant,* on the Champs Elysées.... An orderly crowd, the *bourgeoisie,* had gathered at this place, and no noise was heard, save the murmur of conversation, half lost in space and air, on some animated applause, occasionally called forth by the eccentricities of the performers. What a melange of entertainment did the brilliant kiosk afford! Singing, skating, dancing, recitations and dialogue. The duet, with a male and a female voice, in imitation of fighting cats, was inimitable.... All the world is not so privileged as to be able to lounge at a *cafe-chantant,* in the beautiful month of June, with stars overhead, and music in the air.[114]

In her 1896 publication *Sunny Memories of Foreign Lands,* Harriet Beecher Stowe describes an outdoor concert and dance that she attended at the Jardin Mabille:

It was so illuminated by jets of gas sprinkled among the foliage as to give it the effect of enchantment. It was neither moonlight nor daylight, but a kind of spectral aurora, that made everything seem unearthly.... But it is a scene ... perfectly Parisian, and just as earthly as possible ... where earthliness is worked up into a style of sublimation the most exquisite conceivable.[115]

While the café-chantant was appealing to those who sought escape from the hum-drum affairs of life, in Degas' *L'Absinthe* (1876; nowadays most frequently referred to as *Dans un café* [In a Café]; see frontispiece to the present work), the mood of the absinthe drinkers, who are alone in the café, is neither festive nor enchanting. The dazed and despondent couple languish over a glass of absinthe in the Café de la Nouvelle-Athènes in Place Pigalle, a "regular haunt in the 1870s of the Parisian literary and artistic avant-garde."[116] Two nearby tables are occupied only by an empty whisky decanter, creating a mood of isolation and loneliness—of being cut off from the human family, their "brooding loneliness" being reflected in the mirror on the wall. Art critic H.W. Janson says Degas

makes us look steadily at the disenchanted pair in his cafe scene ... but, so to speak, out of the corner of our eye. The design of this picture at first seems as unstudied as a snapshot, yet a longer look shows us that everything here dovetails precisely—that the zigzag of empty tables between us and the luckless couple reinforces their brooding loneliness.

He says that "compositions as boldly calculated as this set Degas apart from his fellow Impressionists." Though Degas did not care much for doing portraiture, his keen eye for human character is obvious even in *L'Absinthe (Dans un café).*[117]

Writing in the May 1963 edition of *Apollo,* Ronald Pickvance discusses the controversy that developed when *L'Absinthe* was first

exhibited at the Grafton Gallery in 1893. The press and the public were outraged. According to Pickvance, it was the only "rumpus of any magnitude" to shake "the London art world" between

Whistler's libel case against Ruskin and Roger Fry's Post-Impressionist Exhibition of 1910. . . . Indulgently, we may look back with some amusement and regard it as just another example of the Victorian conscience being outraged by a piece of low—and French—subject matter, as essentially a moral objection on the part of English Puritanism. Yet this would be too simple a view. The controversy was not merely a storm in a wine-glass, an isolated outburst that was quickly forgotten. The issues it raised had important repercussions on English painting and English art criticism, and have their place in the broader pattern of Anglo-French cultural scene.[118]

Prior to *L'Absinthe*, Degas' work had been widely accepted and praised by the critics in England, partly because he had many friends there. English critic Frederick Wedmore at one time called him "the master of the Impressionist School, the man of genius, the inspirer of the whole party." And in 1876 the best collection of Degas' work—among them *L'Absinthe*—was owned by an Englishman, Henry Hill. Pickvance believes *L'Absinthe* may be the same picture—with the title *Dans un Café* (In a Café)—that Degas exhibited in 1876 at the second Impressionist Exhibition. The sitters for *L'Absinthe* were Marcellin Desboutin, Coulture's former student and Degas' friend, and Ellen Andrée, an actress who frequently modeled for artists[119] and who was later a model for Manet for two 1879 paintings of café scenes—*Au Café* and *Chez le Père Latuille*.[120] Pickvance says Degas "represented Desboutin in the familiar environment of La Nouvelle Athenes, a cafe in the Place Pigalle, the regular haunt in the 1870s of the Parisian literary and artistic *avant-garde*." Desboutin was also a friend of Hill, the collector, which may have been one reason Degas' work was in his private collection. Or Hill may have bought the picture at the 1876 exhibition or even from Degas himself. At any rate, in September 1876 the picture, entered in the catalogue as *A Sketch at a French Cafe*, was shown in Brighton at the Third Annual Winter Exhibition of Modern Pictures, apparently with the permission of the Hill family.[121]

A writer for the *Brighton Gazette* was sharply critical.

The perfection of ugliness; undoubtedly a clever painting, though treated in a slap-dash manner, amounting to affectation. The colour is as repulsive as the figures; a brutal, sensual-looking French workman and a sickly-looking grisette; a most unlovely couple. The very disgusting novelty of the subject arrests attention. What there is to admire in it is the skill of the artist, not the subject itself.[122]

This criticism was, according to Pickvance, a "faint promise of what was to come in 1893: a hint of a moral objection to the subject—the 'ugly,' 'repulsive' figures, not the absinthe, which hasn't yet been spotted—and some slight unease about the manner of painting."[123]

Following the showing in September 1876, the picture did not surface again until 1892, this time at a second sale of the Hill collection. Entitled *Figures at a Cafe,* the picture was "hissed on the easel." "Was the absinthe now spotted, and the decadence of the French race proclaimed?" asks Pickvance. In spite of the art world's reaction to the picture, Alexander Reid, a Glasgow art dealer, bought the painting, which he soon sold to Arthur Kay, also from Glasgow.[124] Said Kay,

It was hung in a position where I could see it constantly. Every day I grew to like it better. After frequent requests to sell, and worried by the questions of those incapable of understanding it, I exchanged it in part payment for another picture. It had not been away for 48 hours before I went back to the dealer, and in order to recover it, bought another work by Degas, a *Repetition.*[125]

Both of these paintings by Degas, and another entitled *The Little Student,* were among the 370 works at the opening of a new art gallery—the Grafton Gallery—on February 18, 1893, with the controversial one—No. 258—now named *L'Absinthe.*[126] The exhibition, entitled "Paintings and Sculpture by British and Foreign Artists of the Present Day," included works by Whistler and Raffaelli among others, all "artists who belonged, broadly speaking, to the second generation of Impressionists," and whose "work, mildly *avant-garde,* could be seen at most contemporary exhibitions in London, Paris, Berlin, and Munich." Said Pickvance, "There was nothing vastly new . . . not even a catalogue manifesto, in this long-awaited opening exhibition—except the presence of No. 258, now at last entitled *L'Absinthe.* "[127]

Though the picture was hung in an inconspicuous place away from the central room, surprisingly, it got some attention, and the reviews of the picture were not bad. An art critic for the *Times* said,

It is not half a lifetime since M. Degas was denounced as a monstrosity by half the art world, and now his *L'Absinthe* appears as though, in conception, design, and execution, it was the permanent and inevitable type of how a pair of topers in a *cabaret* must be painted. Evolution in art is rapid in these days, but evolution in opinion about art is much more so.[128]

The *Glasgow Herald* described the picture as "showing great power of rendering character and a superb use of material"; the *Star* called

it "grim in its realism, incomparable in its art," while the *Pall Mall Gazette* said it was "a veritable triumph of observation.... The awkward spread feet of the woman, the type of the man; are surely rendered as they were actually seen, and the composition is daringly original." The *Pall Mall Budget* declared that "every tone and touch breathes the sentiment of absinthe."[129]

Even more important, the *Art Journal,* a conservative magazine, had praise for the painting:

Nominally a study of low life it is really a representation of a well-known French painter M. Desboutin, and a *modèle d'atelier,* Mdlle Jeanne Andree, painted with extraordinary vividness and with absolute freedom. The characterization is complete, and what there is of story is set down with an absence of circumlocution that is almost painful.

D.S. MacColl, writing in the February issue of the *Spectator* described *L'Absinthe (Dans un café)* as

the inexhaustible picture, the one that draws you back, and back again. It sets a standard by which too many of the would-be "decorative" inventions in the exhibition are cruelly judged.... The subject, if you like, was repulsive as you would have seen it, *before Degas made it his.* If it appears so still, you may make up your mind that the confusion and affliction from which you suffer are incurable.[130]

MacColl's article did not go unnoticed by the art world. Said J.A. Spender (pseud. "The Philistine") in *Westminster Gazette,* MacColl

is not a critic so much as an advocate—the frankly partisan advocate of the young English imitators of French impressionists who call themselves the New English Art Club. To [MacColl], the subject is nothing; the use of paint, the handling, everything. ... If you have been taught to think that dignity and the endeavor to portray a thing of beauty are of the essence of art, you will never be induced to consider *L'Absinthe* a work of art, however "incurable" your "affliction and confusion" may be.

Other art critics quickly joined in the debate with letters to both the *Westminster Gazette* and the *Spectator.* Sir William Blake Richmond called Degas' painting nothing more than "a literary performance" and "not a painting at all." "It is a novelette—a treatise against drink. Everything valuable about it could have been done, and has been done, by Zola," he said. Walter Crane, in responding to the painting, said it was "an illustrated tract in the temperance propaganda, a study of human degradation, male and female," while another responder said "much too much has been made of 'drink,' and 'lessons,' and 'sodden,' and 'boozing' in relation to the picture,

and that the title ought simply to read *Un homme et une femme assis dans un café.*"

The critics' dialogue ended with the April 15 issue of the *Spectator,* in which MacColl reviewed the main points of the argument: "There was a patriotic view of the question ('French poison'), and "there was a teetotal view of it ('temperance tract')." According to MacColl, the argument was mainly the result of "the nationalist, 'Keep Britain Clean' mentality" that was "part of a long-standing bourgeois abhorrence of anything French." MacColl referred to English writers Swinburne and George Moore, both of whom had been "attacked" and "vilified" because of their French connection." He saw the attack on Degas' painting as part of "a warning against the establishment of a French base in London" and the fear that English art would be "infected by the disease of this French School" of iniquitous realism."[131]

It is possible that much of the controversy surrounding *L'Absinthe* would not have occurred if it had been catalogued as *Au Cafe* as was intended. Degas, who was later described as "fuming because he had been written about in the papers," was especially concerned that Desboutin and Ellen Andrée, who only posed for the painting, were labelled as "vulgar, boozy, sottish, loathsome, revolting, ugly, and besotted." Desboutin's biographer later pointed out that Desboutin was not an absinthe drinker, and that, indeed, the decanter on the table was filled with only "black coffee."[132]

Pickvance concludes his article on Degas' *L'Absinthe* by saying that "MacColl, as critic-propagandist, was the object of the Philistine's attack, rather than Degas as painter-moralist. *L'Absinthe* happened to be an exemplar of the 'New Art Criticism,' and acted as a catalyst to a long smoldering body of resentment." "The fundamental issue was the artist's freedom in his choice of subject," he said. Pickvance contends that after the *L'Absinthe* controversy, it became "more permissible for English artists to choose their subjects from material long tabooed" and influenced the coming generation of art critics, among them Roger Fry, Frank Rutter, and Charles Marriott.[133]

Unlike some of his contemporaries, Degas lived to see his work appreciated. In fact, one of his paintings sold for $95,700, considerably more than any painting prior to that time, but, unfortunately, Degas received only $100 for the painting when he sold it. "I'm like the horse that wins the Grand Prix and is given a bag of oats," he said.[134]

Jean-François Raffaelli (1850–1924), graphic artist, sculptor,

and painter, exhibited paintings at the Salon in the 1870s; but in 1880 and 1881 he exhibited with the Impressionists, probably because he was one of Degas' friends. The Impressionists were enthusiastic about his subject matter—scenes of Paris that included "landscapes," the "miserable population of the surroundings of [Paris], and of its quays, and of its crowded districts." He frequently met with members of the avant-garde at the Café Duerbois to participate in their lively discussions about art. Though he was influenced by the Impressionists, he continued to paint with dark, somber colors until near the end of his painting career, when he lightened his palette. He is best known for his oil paintings and prints that feature scenes of Paris.[135] In 1881, Raffaelli painted a portrait called *Absinthe Drinkers.* The subjects—two men at a table on which sit a decanter and two glasses of "truly opalescent" absinthe—have been described as "more mellow than depressed."[136]

French painter and lithographer Henri de Toulouse-Lautrec (1864–1901) is best known for his depiction of scenes of Paris in the 1880s and 1890s—its cafés, cabarets, circuses, theaters, and entertainers. His paintings immortalized Le Moulin Rouge, a gathering place for artists at that time. Born into a wealthy, aristocratic family, Lautrec spent his early years on one of the family estates near Albi enjoying the benefits of his family's good fortune. Unfortunately, as a young teenager Lautrec broke both his thighs, and, as a result of a severe calcium deficiency, his legs stopped growing, causing him to become a cripple and to suffer a lifetime of pain.[137] Only a little over five feet tall as an adult, he frequently made fun of himself in photographs showing the body of a fully developed man supported by shrunken, undeveloped legs.[138] Lautrec's talent for art was obvious from the time he was a child; later during the long period of convalescence while his legs were healing, Lautrec passed the time by practicing his painting. Although his mother and his friends encouraged him to develop his art, his father never appreciated his work, even after Lautrec's death. Indeed, so disappointed was Lautrec's father that his son was sickly and handicapped that he separated from the family and never developed a close relationship with Lautrec.[139]

When he was 17, Lautrec went to Paris. In 1882 he began formal art lessons under both Léon Bonnat and Fernand Cormon, under whom he quickly learned the fundamentals of art.[140] Finally disillusioned and bored with formal art lessons, Lautrec moved to Montmartre, "the rather seedy part of [Paris] where writers, painters, and students congregated; where the brothels were located; and where

soon would open the famed cabaret, the Moulin Rouge."[141] Lautrec was fascinated with what he saw there, and he soon got caught up in Montmartre's social life. In a letter to his grandmother, he admitted: "I am against my will leading a truly Bohemian life and am finding it difficult to accustom myself to this milieu."[142] It was during this time and shortly afterwards that Lautrec became acquainted with some of the "maverick" artists in Paris, namely Manet, Degas, and Renoir, who chose to ignore "inflexible Academic standards of compositional organization, finish, and elevated subject matter." He learned a great deal from these artists, and "became convinced that the finest art was based upon principles unacknowledged in art schools."[143]

He also met van Gogh during this period. The Lautrec–van Gogh friendship was an unusual one to say the least. John Rewald in *Post-Impressionism* describes Toulouse-Lautrec as "fascinating, sharp-witted, arrogant, tender, loyal, full of incongruous ideas, always casting a curious eye on his surroundings like a hound on the scent of game," and certainly "not a personality which could form an intimate friendship with van Gogh." According to Suzanne Valadon, who modeled for Lautrec, van Gogh "made regular appearances at Lautrec's studio" but was paid little attention by Lautrec or his friends. She describes a typical visit:

He arrived, carrying a heavy canvas which he stood in a corner where it got a good light and then waited for some attention to be shown. But no one bothered. He sat opposite his picture, scrutinizing the others' glances, taking little part in the conversation, and finally he left wearied, taking his work with him. But the next week he came back and began the same pantomime all over again.[144]

Rewald says that although van Gogh "simply did not belong" in "the carefree atmosphere of Lautrec's studio," the two artists still had "esteem for each other's sincerity." They also socialized in cafés at times. According to Rewald, Lautrec's 1887 sketch of van Gogh drinking absinthe shows van Gogh "in a rather brooding mood and charged with that tension which struck all those who met him in Paris."[145]

If at first Lautrec had difficulty adjusting to life in Paris, he quickly became a part of the night life after the Moulin Rouge opened in 1889. According to Gilbert and McCarter, "Singers and dancers, prostitutes and poets, the highborn and the lowborn who came to the Moulin Rouge—Lautrec drew them all, with a style and originality that captured the essence of Paris night life." When the Moulin Rouge

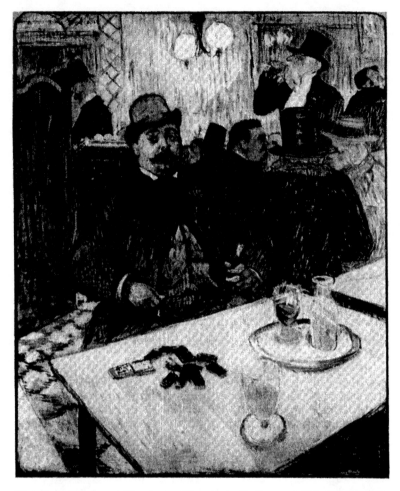

Henri de Toulouse-Lautrec. *Monsieur Boileau at the Café* (1893).
Gouache on cardboard, 31½"×25½". Cleveland Museum of Art:
Hinman B. Hurlbut Collection (394.25).

faltered and almost failed, Lautrec helped to revive it with a huge
poster "unlike any Paris had ever seen."[146] The poster made such a
big hit that Lautrec followed it with thirty more posters and, thus,
"laid the foundations of the modern poster."[147] Says Jerrold Seigel
in *Bohemian Paris,* Lautrec "seems to have recognized immediately
that the medium of advertising posters and lithographs was appropriate
to the qualities of modern life he found represented in Montmartre."[148]

The last ten years of Toulouse-Lautrec's life were the most successful of his career. According to Jan Polasek, Lautrec "had his permanent table at the Moulin Rouge and enthusiastically followed every movement of the dancers, the faces of the visitors, and continued to draw on whatever he had at hand," leaving "most of the drawings on the table" or giving them "to his women visitors in the studio."[149] According to one account "from early manhood" Lautrec was "a heavy drinker, often of fantastic, self-concocted mixtures."[150] He became an alcoholic—or more accurately, an *absintheur*—since his favorite drink was absinthe. He served his own "home-made concoctions" to his friends; his specialty was an absinthe and cognac drink called "tremblement de terre (earthquake)."[151] Rumor had it that he carried a hollow cane with a supply of absinthe readily available.[152]

Much of Lautrec's life was spent in the cafés and brothels. According to D.C. Rich in the February 1929 issue of the *Bulletin of the Art Institute of Chicago,* the scene of Lautrec's *At the Moulin Rouge* (1892–1895) is "the old cafe in the Place Blanche," which was "renovated in 1892 by Lautrec's friend, Oller." Rich describes the painting in detail:

In a corner, near the windows which shimmer with the green of plate glass and the blurred orange of the lamps, a little party is seated, consisting of Edouard Dujardin, Paul Sescau, Maurice Guibert, Mlle. Nelly C. ... and the dancer La Macarona, the last recognizable from her famous "psyche" of orange hair. Behind her are Dr. Tapie de Celeyran, a cousin of the artist, and Lautrec himself, and staring after them, the dancer, Jane Avril. To her right, looking out of the window, is "La Goulue" (the Greedy One) who earned her name from drinking up the "heel-taps" left in glasses. In the right foreground looms the enormous powdered mask of May Milton, an English dancer.[153]

Rich claims that Lautrec "loathed" the "night birds" that he associated with, and "though he railed and joked with these parasites and ... mixed cocktails for them and gave fantastic dinners in their honor, in reality he was passionately devoted to one thing only—his art." They "became his scape-goats, and perversely he delighted in exposing their squalor and ugliness." In *At the Moulin Rouge,* Rich says, Lautrec "[seized] on the eccentricities of behavior ... which sets one human being off from another. The shambling walk of Dr. Tapie, Jane Avril's wide stare and May Milton's yellow curls and puffy eyes are all recorded with an unholy accuracy."[154] Janson also refers to Lautrec's ability to see beneath the surface of a scene: Even though

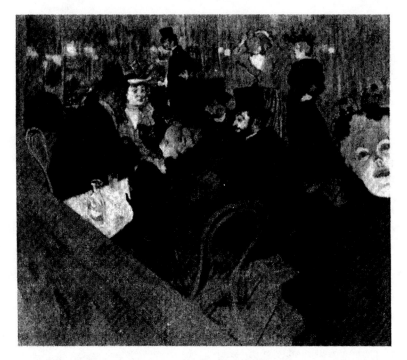

Henri de Toulouse-Lautrec. *At the Moulin Rouge* (1892–95). Oil on canvas, 123 cm.×141 cm. Art Institute of Chicago: Helen Birch Bartlett Collection (1928.610). Photograph c 1992, The Art Institute of Chicago. All rights reserved.

this view of the well-known nightclub is no Impressionist "slice of life," Toulouse-Lautrec sees through the gay surface of the scene, viewing performers and customers with a piteously sharp eye for their character ... [and] although Toulouse-Lautrec was no symbolist, the Moulin Rouge that he shows here has an atmosphere so joyless and oppressive that we cannot but regard it as a place of evil.[155]

Though his favorite haunt was the Moulin Rouge, Lautrec also frequented other night spots, among them the Café Weber and a nearby Irish and American bar where "hardened" drinkers gathered to drink "Night Cups" or "Rainbow Cups." He usually stayed late at the bars, possibly because he often had no place to spend the night.[156] During some of the times when Lautrec was homeless, he even lived in the brothels with the prostitutes—"some of the women were his lovers, many were his friends, and all were potential subjects," and he painted them with "sympathy and warmth."[157] In 1894

he lived for several months at 24 rue des Moulins, a brothel which has been described as "one of the most luxurious and well equipped establishments of its kind." He used the prostitutes there as models for his paintings. His favorite subject was a redhead named Rolande, whom he painted or drew at least 13 times during his stay there.[158]

Toulouse-Lautrec's dissipated life was a short one. He lived only 37 years. Symbolist painter Gustave Moreau said that he painted "entirely ... in absinthe."[159]

Lautrec is remembered most as a graphic artist—for "his graphic illustrations ... the size of wall paintings, not without unusual decorative mastery." This "combination of exciting subject matter and modern technique brought Lautrec into extraordinary popular esteem in the years just after 1950." Said Sheldon Cheney, Lautrec "ventured into the places of most lurid excitement in Paris, the cafes and dives, the law courts and dance-halls, the revue theatres and circuses," and "he turned out records of hothouse metropolitan life that are still exciting."[160] Besides *At the Moulin Rouge,* some of Lautrec's paintings which reflect absinthe drinking in the cafe society are *At Grenelle, Absinthe Drinker* (1886), *The Absinthe Drinker* (1888), *Monsieur Boileau at the Cafe* (1893), *Still Life with Billiards,* and his 1887 portrait of van Gogh drinking absinthe in a cafe—probably the Café du Tambourin. He died in 1901, shortly after he was dismissed from a sanatorium, where his family had put him for alcoholism.[161]

If van Gogh's life symbolizes the artist's tragic struggle against the addictive forces of the era, Pablo Picasso (1881–1973) was fascinated with absinthe as a subject for his art, especially in the first part of the twentieth century, when absinthe addiction was frequently in the news and prohibition forces were denouncing the drink. Though Picasso was not an excessive drinker, he did drink absinthe occasionally, especially while under the influence of Alfred Jarry; but unlike van Gogh, Picasso did not damage his health with the drink. No doubt Picasso, like the majority of the French by this time, considered absinthe a poison, its popular name being "bottled madness" and "the green curse."[162] Picasso's interest in the subject was partly the result of "a tradition of urban realism in painting" that was advocated by Baudelaire in *Peintre de la vie moderne,* which urged artists "to paint the new phenomena of boulevard and cafe society." Absinthe was very much a part of this society, and between 1901 and 1914, Picasso chose absinthe as the subject for his art several times.[163]

Born in Malaga, Spain, Picasso received his first formal education

in art at Barcelona and Madrid, but he soon tired of the "rigid, academic approach" to art and "abandoned formal study."[164] In late 1900 Picasso and his friend Carlos Casagemas went to Paris, but in mid–February 1901, Casagemas committed suicide.[165] Picasso visited Paris again in 1901 and 1902, however, and finally, in 1904, enticed by "the prestige and the turbulent atmosphere of this centre of the arts" he moved permanently to Paris—"his real spiritual home."[166] He took up residence at 13 rue Ravignan in Montmartre in "an old studio building which was nicknamed *bateau-lavoir* because it resembled the bathing and laundry boats anchored in the Seine."[167] His studio there soon became the meeting place for artists, poets, and others, including Guillaume Apollinaire and Max Jacob.[168] Young and energetic, "the group came to be known as 'la bande Picasso'— the Picasso gang—and was notorious on the Butte Montmartre for its turbulence and high spirits."[169] But even so there was still time for study and serious work. During this time Picasso studied the work of such artists as Gauguin, van Gogh, and Toulouse-Lautrec, and he spent many hours at the Louvre studying the old masters.[170]

It was in 1901, when Picasso was 20 years old, that he painted two absinthe pictures—*The Absinthe Drinker* and *Woman Drinking Absinthe*. According to Arianna Huffington in the June 1988 issue of *The Atlantic Monthly*, "the summer of 1901 was a demonically creative one for Picasso." In fact, so productive and full of energy was he that art critic François Charles warned him "for his own good no longer to do a painting a day." But "Paris had unleased a surge of experimentation in [Picasso]," said Huffington. "It was a summer of reveling in the city, of celebrating his freedom from Spanish conventional morality, of flower still-lives, cancan dancers, the races, pretty children, and fashionable ladies." It was also during this time that "a noticeable change was beginning to take place in both [Picasso's] mood and his work." Like van Gogh, who in 1888 "tried to express the terrible passions of humanity by means of red and green," Picasso in 1901 "spurred by his inner turmoil, switched his focus to the solitude and pain of humanity and tried to express them by means of blue. So began the procession of beggars, lonely harlequins, tormented mothers, the sick, the hungry, and the lame." Picasso even did a portrait of himself—in blue—putting "his own suffering on display."[171] In his *Self-Portrait*, says Barr, "the artist shows us frankly the face of a man who has known cold and hunger and disappointment." Of his early months in Paris, Picasso later recalled "his room without a lamp, his meals of rotten sausages, even his burning a pile of his own drawings to keep warm."[172]

It is not clear why Picasso chose the color blue at this time, but some believe that the death of his friend Casagemas caused him "to paint in blue and green, the colors of absinthe."[173] Barr thinks Picasso's choice of blue probably came "from within Picasso himself." At any rate, "the lugubrious tone," he said, "was in harmony with the murky and sometimes heavy-handed pathos of his subject matter."[174]

The Absinthe Drinker (1901), Picasso's earliest treatment of absinthe as a subject, and *Woman Drinking Absinthe* (1901) were completed during Picasso's Blue Period, "when [his] paintings concentrated on images of poverty and emotional depression,"[175] both of which were common to the absinthe addict. Also during this period he concentrated on "the human figure," which "he placed usually alone and still against a simple, almost abstract background."[176] Though Picasso was very adept at drawing the human figure even as a teenager, according to Lael Wertenbaker in *The World of Picasso*, he "distorted it imaginatively during his Blue Period in order to convey the moral and physical decay of his characters."

Wertenbaker says of the *Absinthe Drinker*, which features a woman with a sharp, elongated, and pinched-looking face mostly in profile who sits alone at a table with a glass of absinthe before her, that the work, which "is executed almost entirely in one color—the blue is tinged with cool green—that emphasizes the dejected pose," is "not a portrait of an individual but a nearly abstract image of loneliness and despair." She believes the painting "epitomizes Picasso's Blue Period."[177] Says Brooks Adams, "[Picasso] used an accumulation of divisionist strokes and a conflation of near with far to shower his subject, who cups a hand to her ear as if to hear better as she stirs her lurid, green liqueur," noting further that "the tranquilizing effect of the absinth seems to transport the model almost beyond Picasso's reach."[178]

Also completed in 1901, *Woman Drinking Absinthe* displays the numbing and debilitating effects of absinthe on another woman. A dazed looking woman sits at a table which holds a water siphon and a glass of absinthe with arms across her chest and her chin cupped in her hand.[179]

Picasso's *The Poet Cornutti (Absinthe)* (1902–1903), a watercolor, may have been inspired by Max Jacob, a poet and would-be artist who became one of Picasso's close friends. It was in Paris in 1901 that Picasso met Jacob, after an exhibition of Picasso's art by Ambroise Vollard, who was also a dealer for Cézanne and Gauguin.

Jacob, who was "struck by Picasso's 'fire' and 'brilliance,'" visited with Picasso shortly after the Vollard exhibition and thereafter became an influential supporter of the artist and his work.[180] A note written by Jacob on the back of *The Poet Cornutti* says that Cornutti, "an ether addict," "died in obscurity, probably from malnutrition."[181] According to Adams,

The composition suggests a parable of survival and self-destruction. An absinth still life separates the figures in the composition from the artist. Cross-eyed and with arms akimbo, the poet has been transported to farther shores than his female companion. Her glance suggests that she senses her exploitation as model. Of the two, she is the more likely survivor..."[182]

Picasso did another absinthe painting in Barcelona entitled *Two Women Seated in a Bar.*[183]

Many of Picasso's paintings during this period focus on "gaunt prostitutes and idle dandies," who "stare out at the world with glazed eyes set in pallid, bloodless faces, as if overcome by the experience of city life," hinting of "the distortion and symbolism that would characterize Picasso's later work."[184]

It is of interest to note that a number of Picasso's absinthe paintings portray women, although prior to the 1900s, only male absinthe drinkers were depicted by the artists. By Picasso's time it was more common to find women at the bars, and the art of the period reflects this trend. Writing in 1903, "absinthe expert" Dr. J.A. Laborde, said:

Woman has a particular taste for absinthe and ... in Paris at least, she is frequently attracted by *les aperitifs* ... this intoxication has been for several years as common among women as among men and clear cases of chronic absinthism occur ... in young women and even young girls of eighteen to twenty years old.[185]

Picasso's interest in absinthe as a subject continued on into his cubist period. In 1911 Picasso painted *The Glass of Absinthe,* which was followed in 1912 by *Bottle of Pernod and Glass.*[186]

The culmination of Picasso's interest in absinthe as a subject is his 1914 bronze sculpture edition of *Absinthe Glass.* According to Brooks Adams in "Picasso's Absinthe Glasses; Six Drinks to the End of an Era," *Absinthe Glass* came about as a result of two controversies concerning Picasso's art in late 1913 and early 1914. In November 1913, Guillaime Apollinaire, the new editor of the magazine *Les Soirées de Paris,* "published photographs of Picasso's previously unexhibited *Guitar* and *Violin* war constructions." As a result, the little magazine lost thirteen of its fourteen subscribers. "Evidently Picasso's open-form musical instruments with their allusions to flayed

anatomies were too much for the literary cognoscenti," says Adams. Certainly, to Picasso, being rejected by the subscribers was like "a slap in the face from the avant-garde." Another controversy developed in March 1914 after Picasso's painting *The Family of Saltimbanques* sold for what many considered an exorbitant price of 11,500 gold francs. According to Adams,

Picasso's name was suddenly all over the conservative newspapers, which were scandalized by such exorbitant prices for contemporary art, especially since the *Family of Saltimbanques* looked unfinished, its figures were Picasso's friends impersonating carnival vagabonds, and the artist was a foreigner who had managed to bypass the Salons. *Haut monde* prices for bohemian subjects were too much for the bourgeois press.

Disgruntled about the reaction of the avant-garde and the press to his paintings, Picasso and his dealer, Kahnweiler, conceived of *Absinthe Glass*, a six-piece edition in bronze.[187]

The sculpture—which was reproduced six times—consists of an absinthe glass, a real spoon, and an imitation lump of sugar. According to Werner Spies in *Sculpture by Picasso*, the work should be "referred to in the plural" since "the six casts from [the] wax model were variously painted" and overlaid with different textures, causing them to appear to be different in form. Spies says the sculpture is "closely allied to synthetic Cubism, which not only introduces stronger colouring but organizes and simplifies a picture with the aid of colour." The thing that is new about this sculpture, according to Spies, "is the manner in which Picasso ... links an art object with reality"—the object in this case being "the celebrated spoon" of the absinthe drink. "Reference to reality," he says, "comes into being on three levels: a *representation* signifying the glass, a *reality* termed 'spoon,' and an *imitation* of a lump of sugar." The glass is "one of the major themes in Cubism" and was "a favorite motif" of Picasso. Werner believes *Absinthe Glass* "was ... destined to contribute more than any other work to the extension of techniques and forms."[188]

According to Adams, "Each *Absinthe Glass* was intended as a little still life extract, alienated from its functional context." "The sculptures were not only meant to paraphrase the artist's earlier styles," he says, but "their celebration of the endangered absinth was an emblem of his youth and of a whole era's excess—little bombs thrown in the face of high seriousness."[189] Adams' description of the sculpture, which indicates that he has closely studied its details, is worth repeating.

Picasso, striving for transformation in sculpture's static body, grasps acrobatic structure in the "Absinth Glass" edition. Each piece's lower half is

Pablo Picasso. *Absinthe Glass* **(1914). Painted bronze, 8¾" high.
Philadelphia Museum of Art: A.E. Gallatin Collection (52-61-114).**

stable, with base and stem on a central axis to allow for the first, drastic open-
ing at the knop. This conventionally solid section is hollowed out into a
basin and umbrella that, like an out of season fountain, provides for a flow
of water, now absent, and air. Each Glass' upper half revolves around a sec-
ond axis to accommodate the gaping, open space of the bowl and the crossing

of a horizontal liquid level with its vertical edge. Between these two sides . . .
Picasso balanced a real silver strainer [spoon]. If the *Absinth Glass* were func-
tional, one would pour water through this strainer to dissolve the sugar cube
and sweeten the liqueur's natural bitterness.

The actual strainer and painted bronze sugar cube are insouciant, crown-
ing touches; like a Wallenda high wire routine, they're brilliant but dumb,
achieved at a certain cost but seemingly effortless. The six silver strainers
and imitation cubes decorate each Glass, giving them a specific identity.
Decked out, they recall Degas's *Little Dancer* (1880), with her bronze body,
real tutu and silk hair ribbon. The *Absinthe Glass* series compacts questions
of sculptural realism into overlapping, alcoholic levels. Their process is
alchemistic in that the original wax is lost to the bronze casts that Picasso
overpainted. This denies bronze's traditional richness and affirms his own
brand of spectacle, poor but rich like his circus friends. The double identity
of each *Absinthe Glass* lets it depict reflection and transparency while
resembling opaque ceramics.[190]

The front of the finished sculpture is more interesting than the back;
the right side is religious and the left side is profane. Picasso also left
his fingerprints on the sculpture.[191]

Though the form for each Glass is the same, each Glass appears
to be very different. According to Adams,

In the black-and-white *Absinth Glass* Picasso strikes an absolutist, life over
death stance. Turning it around, this piece alternately sticks out its tongue
and makes a sign of the cross towards death. . . . Since absinth is ultimately
fatal, all of Picasso's glasses qualify as sculptural *memento mori*. Transfixed
by its own symbology of life's extremes, the black-and-white *Glass* allows for
the play of natural shadows on its tongue and orifice.[192]

Refusing to be limited to the materials traditionally used for
sculpture, Picasso used sand to cover part of one glass; he then put
a coat of transparent paint over the bottom and made the top tex-
tured. "With its tangible analogy to stippling and light particles,"
says Adams, "sand muffles transparency and buries meaning under
a metaphoric layer of time." In 1930 Picasso used sand again, this
time in his creation "Sand Reliefs." It is interesting to note that
of the Glasses, Picasso kept only the sanded one. He also kept the
"Sand Reliefs." Picasso used sheet metal for the inside of one
Glass.[193]

One almost totally black glass—except for stippled colors on the
edges and the interior—according to Adams,

recalls the Satanic lull of absinth taking effect, beginning to light up the body.
Black conveys the vacuum produced by absinth, and stippled colors conjure
up its magic, tranquilizing effect. The verbal equivalent for Picasso's twink-
ling color is *la fée verte*, green fairy—a common French phrase for absinth.

The back of another black Glass has darts of black with red dots resembling sequins running up the back.[194]

Adams sums up his discussion of *Absinthe Glass* by saying:

[*Absinthe Glass*] initiates the onslaught of roles that Picasso played, often simultaneously, from his core. Each *Glass* emerges as a complex and contradictory entity with its own personal history. The edition's very existence as sculpture advocates absinth's right to exist in 1914. By painting each sculpture differently, Picasso celebrates the individual's freedom of choice in matters of alcoholic consumption. The sculptures' open form suggests Picasso's open, political attitude about drug control. Legal restrictions on drugs repressed only the symptoms of workers' problems that were going to explode regardless. There is an element of prophecy in Picasso's "Absinth Glass" and an attempt to control *avant garde* imagery in the edition's small size and number.[195]

Picasso's "strange little sculpture would be the last work of art inspired by absinthe." Ironically, absinthe was banned less than six months after Picasso completed the work.[196]

Other artists of the absinthe era also painted the people who drank the elixir and the places they congregated. These paintings include Emile Benasset's lithograph *L'Absinthe* (1862); Albert Maignan's 1895 *The Green Muse*; Guillaume's *Under the Spell* (1908); Jean Beraud's *Le Boulevard, la Nuit*; the Irish artist Sir William Orphen's *The Absinthe Drinker* (1910); the English painter Albert Rutherston's *The Glass of Absinthe* (1905); and Jules Monge's 1884 portrait of Monticelli, *L'Absinthe*.[197]

5

NEW ORLEANS AND ELSEWHERE IN THE UNITED STATES

It will free you first from burning thirst
that is born of a night of the bowl,
Like a sun 'twill rise through the inky skies
That so heavily hang o'er your souls,
At the first cool sip on your fevered lip
You determine to live through the day,
Life's again worth while as with a dawning smile
You imbibe your absinthe frappe.[1]

In the July 13, 1907 issue of *Harper's Weekly,* the writer of an article entitled "'The Green Curse' in the United States" expressed concern about "the growing consumption in America of absinthe, the 'green curse of France,'" saying the problem had "attracted the attention of the Department of Agriculture," which had ordered an investigation "to determine to what extent it [was] being manufactured in this country." The writer was particularly concerned because wormwood at that time was growing wild in abundance in the eastern part of the United States, and its oil was fetching high prices on European markets, where most of it was sold. Fearing that wormwood cultivation would become a problem in the United States, the writer advocated some kind of government control over its production, explaining that for some time "absinthe [had been] recognized as being almost as fatal as cocaine in its blasting effects upon mind and body...." He blamed absinthe's growing popularity in the United States "to a great extent" on "a song from a popular

opera." "Before the song was sung," he said, "[absinthe] was little known and less indulged in among the general public, but the catchy air served to familiarize it."[2] The writer is no doubt referring to com-poser Victor Herbert's song "Absinthe Frappe," which was named after the drink made popular at the Old Absinthe House in New Orleans and whose lyrics were written by Glenn MacDonough.[3] Actually, as early as 1837, the drink "absynthe" was already appearing in liquor advertisements in Louisiana though it was probably not much known in other parts of the country. Absinthe was first imported to the United States from France and Switzerland.[4] It was banned in 1912 by the United States Food and Drug Administration, and wormwood is still listed as an unsafe and dangerous herb.[5]

Louisiana, especially New Orleans, was a likely place for absinthe drinking to become popular since the inhabitants of the state were closely aligned to France in sympathy and in culture in the nineteenth century, and the French-speaking inhabitants there felt a kinship with Parisians and other French-speaking people. The New Orleans French connection goes back to the early eighteenth century. It was founded in 1718 by French Canadian Jean Baptiste le Moyne, Sieur de Bienville, and was later named after Louis Philippe, Duc d'Orleans, who was prince regent of France after Louis XIV died.[6] Almost a century later in 1803, France sold Louisiana to the United States, but the French inhabitants there did not readily and willingly become American citizens; in fact, most remained loyal to France and stubbornly held on to their language and culture. By 1810 Louisiana had a population of 76,500 people, with 26,000 living in New Orleans, and by 1828 that number had increased to 41,000.[7] New Orleans was the capital of the state until 1830, after which Donaldsonville became capital for a short time, followed again by New Orleans and later Baton Rouge.[8]

As in France, the custom of drinking was an early part of the culture of New Orleans, according to Lura Robinson in *It's an Old New Orleans Custom,* but unlike the French, who preferred to drink wine, New Orleanians supplemented their wine with more potent mixtures. The "simple and logical explanation" given by the inhabitants for their "copious consumption of ardent spirits," said Robinson, was "the foul flavor of the Mississippi water."[9] Many apparently doubted its purity. Certainly, in early times there was a great deal of disease in New Orleans, including malaria, yellow fever, and cholera, partly because the damp and sultry climate around the Mississippi produced a breeding ground for mosquitoes and other disease-carrying insects.[10] But even though a certain amount of alcohol

may have been consumed by inhabitants who believed it would help ward off disease or who preferred drinking to the traditional treatment for disease—bloodletting and calomel[11]—it is safe to say that not all of the drinking was for that purpose.

As early as the nineteenth century, it was apparent even to visitors that drinking was a part of the good-time spirit that prevailed in New Orleans. After visiting the city in 1812, a Major Stoddard seemed perplexed about the amount of alcohol that was consumed and the reasons given for the consumption: Said the Major:

One has the gout, and stimulating potions will drive it away . . . a second is cold, and they will warm him. A third is warm, and they will cool him. A fourth is disturbed in his mind, and they will obliterate his cares. . . . [S]uch reasoning as this . . . is considered as conclusive against all the opposite sentiments of the divine, moralist, and philosopher.

Another traveler declared that "the habit of promiscuous drinking" in New Orleans, "however mischievous in itself, does not seem to produce the same pernicious effects [there] that it does elsewhere." But another visitor said the opposite: "The men," he said, "will not only get tipsy, but stagger and reel in the presence of the ladies," and, furthermore, "this intemperance at table incurs no disgrace; the men walk with devious steps before the ladies, and the ladies laugh at the eccentricity of their walk."[12] Said Englishman Henry Bradshaw Fearon in *Sketches of America* after visiting the city in 1819: "To all men whose desire only is to be rich and to live a short life but a merry one, I have no hesitation in recommending New Orleans."[13]

All things considered, it is not surprising, then, that absinthe drinking should become popular in New Orleans, which was considered "the little Paris of North America." Along with its residents' copious consumption of alcoholic spirits, very early in the nineteenth century New Orleans acquired a reputation for being one of the most vice-ridden cities in America. According to Albert E. Fossier in *New Orleans, the Glamour Period*, "vice was to a large extent unknown" among the original settlers, a condition that continued through "the first decade of the nineteenth century." But shortly after the United States purchased New Orleans, it became popularly known as a place of quick and easy wealth, causing an influx of people, among them gamblers, saloon operators, prostitutes, and others of questionable character. Said Fossier:

. . .misnamed places of amusement and operators of dens of iniquity, grog shops, gambling joints, and vulgar ballrooms . . . sprang up in increasing proportion to the yearly increase of prospective customers. Brawls, robberies,

fights and even murders were of daily occurrence. New Orleans was an open city, a place of amusements of all sorts, a resort which catered to the most vulgar, but at the same time provided pleasures for the most refined and cultured members of its society, both Creole and American.[14]

It was mainly due to this "refined and cultured" society that the "fairy with the green eyes" appealed when it was introduced to the city.

For New Orleans, the early part of the nineteenth century was a period of growth and change. According to the 1820 census, New Orleans had a population of 29,000, including foreigners, slaves, and "free" blacks, with the black population slightly outnumbering the white population.[15] By this time the population was somewhat stratified, with the descendants of the original settlers, the Creoles, at the top, the members of the world of vice—"the Swamp"—at the bottom, and the Americans, slaves, and "free people of color" somewhere in between.[16] According to Liliane Crete in *Daily Life in Louisiana: 1815–1830,*

New Orleans had never been livelier, gayer, more attractive than during the 1820s. It was an era of hilarity and eloquence, of mortal duels and lighthearted pranks, of fabulous balls and memorable banquets. To be sure, every summer brought an epidemic of yellow fever, but the majority of the victims were mere visitors or recent settlers in New Orleans—the better Creole and American families made a point of retiring from the city during the dog days of summer. Some took up residence on their plantations, some along the salubrious shores of Lake Ponchartrain. When the heat abated, the fashionable families flocked back to the city, eager for conviviality and entertainment. New Orleans resumed its joyful, hectic rhythm.[17]

According to Crete, "Americans, especially New Englanders, were scandalized by the 'eat, drink, and be merry' spirit of the Creoles, which struck them as outrageously pagan." One visitor said: "New Orleans is a dreadful place in the eyes of a New England man. They keep Sunday as we in Boston keep the Fourth of July."[18] So New Orleans quickly became known for what one writer later called "its tolerance of human frailty and its attitude of 'live and let live.'"[19]

Chartres Street was the major business area of the city in the 1830s, with its shops featuring "the latest Parisian fashions in clothing and millinery, imported glass and tableware, 'fancy goods,' and beautiful jewelry." In 1834 New Orleans boasted of 721 merchants, many of whom moved to Canal Street in the 1840s.[20] By 1835, said Fossier, "New Orleans had the most luxurious drinking palaces in the country. Their grandeur and their luxury far excelled those of the North.... Drunkenness was very prevalent and drunkards

could be found in every section of the city." Isidore Lowenstern, a visitor to the city in 1837, described it in this way:

In New Orleans strong drinks are used in excess. Not only the richest and the most considered are observed to take ten or twelve tumblers of grog or whiskey punch before dinner.

There are in every American hotel an antechamber where all sorts of wines and liquors are sold from early morning to midnight, and where the gentlemen rarely pass without stopping to imbibe, standing and in haste, their glass of gin or bitters, as coachmen do at home in the wine cellars. A bar is a most profitable business, so much so, it is even found on steamboats. It is especially in New Orleans where the business is most thriving, for they serve a buffet table twice a day, from one to two, and eight to eleven o'clock in the evening. The food is free for the customers, but the custom of having luncheon, and a hasty supper, amply compensates that prodigality.[21]

Fossier observed that "the Anglo-Saxons were addicted to hard drinks, principally whisky, which they gulped down in a hurry, whilst the French, following their ancestors, sat at a table, and leisurely imbibed their favorite wines and liquors."[22]

According to Harold Sinclair in the *Port of New Orleans*, by 1836, with a population of 60,000, New Orleans was already earning its reputation as the sin capital of the United States. At that time it had 543 licensed drinking establishments, which averaged out to one drinking place for each 110 people. Many others no doubt sold liquor without a license.[23] The two major attractions of the city were its more than 500 gambling houses and the numerous brothels.[24] Gambling was a part of the culture even as early as the Louisiana Purchase. Said C.C. Robin, an observer of that period, "In the evening when the business of the day is over, fortunes are lost over and over again.... All indulge in it." Though over the decades, some "plush" and orderly gambling houses could be found in New Orleans, according to Huber, "many more ... became focal points for crime and disorder."[25]

Prostitution was already going strong in New Orleans in the first half of the nineteenth century. One of the earliest and toughest houses of prostitution was the Swamp, located on Girod Street near the Mississippi. Said Huber, "The prostitutes were tough females, many of whom could fight as well as men.... Patronized by the rough flatboatmen who moored their boats nearby, the Swamp was for years a local den of iniquity."[26]

In 1857 an ordinance legalizing prostitution was passed, after which some attempt was made to control its operation through licensing and taxation. But this law was challenged by a madam who sued because she objected to paying for a license; the celebration

following the announcement that she had won the case was described by one historian as "one of the lewdest spectacles in American history." "It was made up of hundreds of bawds, carriage borne, driving through the city streets, variously costumed, a great many nude," he said. "The whores shouted obscenities ... and snatched male bystanders with whom they improvised erotic displays along Canal Street and in the French Quarter," leaving "little doubt in the public mind that a victory had been won by the sin industry."[27] Later in the nineteenth century a sweeping reform movement got under-way in New Orleans, including an ordinance which designated a part of the city—later called Storyville—as the only district where prostitution was legal. For many years, Storyville was ruled by Tom Anderson, an oilman who was a member of the state's legislature and who owned several saloons there. According to Huber, "[The] advertisement of Anderson's three saloons and his picture [even] appeared in a souvenir program of the National Convention of Chiefs of Police held in New Orleans in 1903!"[28]

Many lavish houses of prostitution were located on Basin Street—as many as 14 according to one edition of *The Blue Book,* a readily available publication that contained the names and addresses of the prostitutes in Storyville and the places where they worked.[29] "It was on Basin Street in the last half of the nineteenth century, that the world's oldest profession was to achieve a peak of elegance and style heretofore unknown on this continent," said Hodding Carter in *The Past as Prelude.* Indeed, according to Carter, "the income of its whores [ranked] second only to the port, itself, in dollar volume." "It was here," he said, "that the great houses were to be built, and great fortunes made, and great scandals unfolded, and even greater legends formed."[30]

Many of these palaces were lavishly furnished. An advertise-ment for the Arlington, for example, described it as "absolutely and unquestionably the most decorative and costly fitted out sporting palace ever placed before the American public." "Within the great walls of this mansion," it said, "will be found the work of great artists from Europe and America."[31] Carter tells of some of the early madames who ran "the pleasure palaces" on Basin Street: Hattie, a "veteran strumpet" from Cuba, who was greatly helped in her enter-prise by a senator, whom she later shot in cold blood; Kate Town-send, whose miniature Versailles brothel was three stories high and featured marble mantels, plush red carpet, and chamber pots "em-bossed in gold"; the voodoo Queen, Fannie Sweet, whose "chief at-traction" was an alleged "utterly frigid" girl named "Josephine Ice-

Box," for which large rewards were offered to "any man who could move her"; Mary Thompson, who furnished virgins for a price; and Miss Carol, who furnished boys to "affluent homosexuals."[32] Needless to say, in this atmosphere a large criminal element flourished, including gamblers, pickpockets, thieves, and others. Unable to cope with the situation, city government officials, and even the police, often joined with the criminals; as a result, New Orleans became known as one of the most corrupt cities in the country.[33] Though absinthe was probably consumed at times by those who were a part of this steamy, corrupt underworld, so many choices for debauchery existed that absinthe drinking was only a small indulgence.

But in spite of the corruption and vice that flourished in New Orleans, "there were oases of dignity and grace and beauty." According to Sinclair,

If the streets were quagmires underfoot they were also channels of moving, living color that could be matched nowhere in America. The multicolored stucco and brick walls of the French Quarter were weathered into the loveliest of pastel tints; the doorways and fanlights were models of wooden grace; the hand wrought ironwork of grills and balconies and street lamps has hardly been matched elsewhere in the United States. . . . [T]he land was also fertile almost beyond belief and everywhere, practically the year round, there was a riot of foliage and flowers. There were graceful houses where the very best in the physical aspects of existence were taken for granted and such luxuries as the time afforded were commonplace. Houses were dressed with the finest in silver, china, glassware, and furniture that the world's best craftsmen could produce, and life moved with a liquid rhythm that was as perfect as any until then designed in the New World. . . . [A]lmost every household of consequence had its slave or slaves. . . .[34]

It was this beauty, romance, and intrigue that appealed to another class of citizens who were drawn to New Orleans for reasons other than its bad reputation.

New Orleans' population continued to increase rapidly. As a port for the cotton industry, New Orleans flourished and by 1840, as the fourth largest city of the United States, it boasted a population of 102,193, and the port of New Orleans was considered to be "one of the great commercial gateways of the world . . . exceeded in tonnage and tonnage valuation" in the United States only by New York and in the world by London and Liverpool. Its dollar amount of trade exceeded $300,000,000.[35] The prosperity and growth of Louisiana and New Orleans in the first part of the nineteenth century continued on into the second half of the century. By 1850 New Orleans

had a population of 116,000 and upward and ranked fifth in the nation in size,[36] and by 1860 its population had grown to 160,000.

Sugar cane production, the cotton industry, and cattle farming did much to assure the prosperity of the region. There was a large slave population, which increased from 40,000 in 1812 to 330,000 in 1860, and which did the work on the huge plantations.[37] Of even greater importance to the region's economy was the brisk trading that took place at the port of New Orleans, which was the port for the cotton industry in the South.[38] With the coming of the river steamer, river commerce improved greatly, along with a significant increase in exports from New Orleans.[39]

Even though New Orleans was considered the "Queen City of the South," she was the South's "most un–Southern City."[40] The government was mainly aristocratic, and the social life of New Orleans was dominated by members of the older, successful Creole families, wealthy planters, and even wealthier merchants.[41] The inhabitants of New Orleans, especially the aristocracy, still considered themselves French, and in fact, any public announcement or law was published in both French and English to accommodate those who still persisted in speaking the French language. Said Sinclair:

The French tradition so gripped the Creole mind that the aristocracy still thought of France as the mother country—and a very close mother. The city mourned Napoleon's death to a degree second only to Paris itself, and Orleanians who would not dream of visiting New York or Washington knew Paris as well as they knew their own Vieux Carré. They sent their sons and daughters there to be educated as a matter of course, and in most cases even their slaves were more articulate in French than English.[42]

And a great deal of freedom was afforded her inhabitants. Announced the *Daily Picayune,* a New Orleans newspaper, in the March 5, 1851 issue, "Everyone in this good city enjoys the full right to pursue his own inclinations in all reasonable and, oftentimes, unreasonable ways."[43] Such an atmosphere appealed to such free spirits as Walt Whitman, who lived in New Orleans for three months in 1848 while working at *The Crescent,* a newspaper. He may have been referring to that period of time while reminiscing in later years. "My life, young manhood, times South," he said, "have been jolly bodily, and doubtless open to criticism. Tho' unmarried, I have had six children. . . . [One] southern grandchild, fine boy, writes to me occasionally. . . ."[44]

The Civil War brought economic disaster to Louisiana. Buildings and cotton were burned; horses and cattle were destroyed

or taken by enemy forces; and the slaves were set free. Though Reconstruction began right away in Louisiana, economic recovery was slow. The port of New Orleans was devastated and suffered a loss of almost all major commerce for many years after the war. But in spite of this loss, New Orleans recovered more quickly than most areas of the state, mainly because of the New Orleans Harbor and the expansion of the railroads in the area, and it once again became the social, cultural, and the economic center of the state. During this period, said Joe Gray Taylor, in his history of Louisiana, "New Orleans did not share the Puritan ethic of North Louisiana and most of the South." But even though "the native and the visitor found all pleasures of the flesh commercially available, and they proved a great attraction to visitors," New Orleans "also demonstrated greater interest in music, drama, and the other arts than other Louisiana communities."[45]

For that reason, literary people and artists were drawn to the area. In 1872 Degas, whose mother was a Creole from New Orleans, must have felt right at home when he went to New Orleans to see his brothers, Achille and René, who were cotton merchants there. While in New Orleans, he took up residence at the home of his wealthy uncle, Michael Musson, who lived in a "large gallaried mansion" at 2308 Esplanade. In 1873 Degas painted *Cotton Market of New Orleans*, which includes both his brothers and his uncle. It now hangs at the Museum Pau in France.[46] He also did about twenty other pieces while visiting there, among them a painting of Degas' sister-in-law, Estelle Musson, which was later acquired by the Isaac Delgado Museum of Art. Museum officials had to pay $190,000 for the piece, however, which they finally raised by donations. In May 1965, the exhibition "Degas—His Family and Friends in New Orleans," was presented at the Delgado.[47] While in New Orleans, Degas wrote to a friend, "Everything is beautiful in the world of the people," but as a "pronounced Parisian . . . [I still prefer] one Paris laundress, with bare arms."[48]

Absinthe drinking was probably one of the minor vices of New Orleanians, who were tempted daily to depart from the straight and narrow path. It was, by and large, restricted to the refined class, the adventurers, and the artists, who were admirers of French culture and who had enough leisure and money to spend in the respectable and comfortable bars where absinthe was served. The most famous of the bars was the Old Absinthe House, located at the corner of Bourbon and Bienville streets, where many famous adventurers, traders, and Creole gentlemen flocked to sip their absinthe. According

to an article in a November 1926 edition of the *New York Times,* "the place [has] been identified with some of the most colorful meetings in the history of New Orleans. The military of the old Spanish regime and then of the French rubbed shoulders there with actors, artists and noted men of all professions."[49] Indeed, legend has it that the Old Absinthe House was at one time the headquarters of the pirate Jean Lafitte and that he met there with General Andrew Jackson and helped make secret plans to defend New Orleans against the British "while sipping an absinthe frappe." It is unlikely that such a meeting took place, however, since the building did not become a saloon until ten years after the Battle of New Orleans and several years after Lafitte left New Orleans.[50]

According to the thirties-era WPA *New Orleans City Guide,* the building was constructed in the early nineteenth century, its purpose being to serve as a residence and as an importing and commission firm for two men, Francisco Juncadella and Pedro Font of Barcelona, Spain.[51] Several years later, after Francisco died and Pedro returned to Spain, the building was used as a commission house by relatives of the two men who sold such items as tobacco, shoes, clothing, and food; in later years the building housed a grocery store, or an *épicerie,* for a while and even later it became a boot and shoe store, or a *cordonnerie.*[52] By 1826 absinthe and other alcoholic beverages were being sold there in what was later called the "first established saloon in New Orleans."[53] In 1846 a nephew of Juncadella opened a drinking establishment, or saloon, called "Aleix's Coffee-House" in a room on the ground floor of the building. In 1869 Cayetano Ferrer, from Barcelona, who had learned to mix drinks as the bar man at the French Opera House, took a job with Aleix as the "principal drink-mixer." Ferrer leased the room in 1874, calling it "The Absinthe Room" after his specialty, the dripped absinthe, which was "served in the Parisian manner." Customers flocked to the drinking establishment, causing Cayetano and his entire family to become famous. Explains Stanley Clisby Arthur in *Famous New Orleans Drinks and How to Make 'Em,*

What the customers came for chiefly was the emerald liquor into which, tiny drop by tiny drop, fell water from the brass faucets of the pair of fountains that decorated the long cypress bar. These old fountains, relics of a romantic past, remained in the *Casa Juncadella* for many years.[54]

The building in which the drinking establishment was located was later called "The Old Absinthe House." After the doors to the bar were nailed shut by the United States marshal during Prohibition,

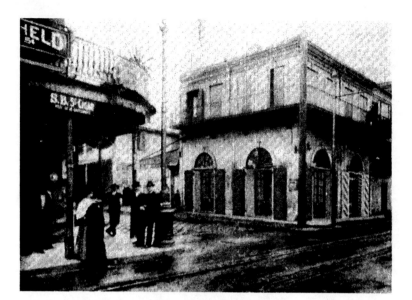

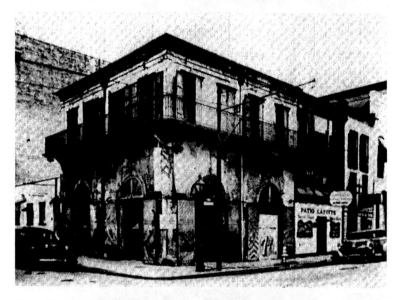

Top: The building on Bourbon and Bienville where the Absinthe House was located. Both photos courtesy of the Historic New Orleans Collection. VCS Sq.65 238.240. *Bottom:* A later view of the Absinthe House (circa 1930s). The signs on the front indicate that the building was constructed in 1752 and the business established in 1806. VCS Sq.65 234.290.

Pierre Cazebonne bought the cash register, the paintings on the wall, the old water dripper and the marble topped bar from which the absinthes had been served and moved them to what is now the Old Absinthe Bar at 400 Bourbon Street. They remain popular French Quarter tourist attractions to this day.[55] The original Absinthe House is also a tourist attraction. Of much interest is the wooden staircase, which was constructed with wooden pegs and which is still in use today. In his pictorial history of New Orleans, Huber describes the Absinthe House at 327 Bourbon Street as "a fine example of early nineteenth-century New Orleans combined commercial and residential building, with an intermediate floor, or *entresol*, and lighted by the fanlight transoms of the doors on the ground floor," saying it is notable for its fine wrought-iron balcony railing and supporting brackets. He said the bar "was noted for its excellent absinthe frappe, which was slowly 'dripped' from its fountains" and that "in later years (before Prohibition), it became a custom to tack the cards of patrons on the walls and ceilings, giving the place a very picturesque look."[56]

The original recipe for the absinthe drink for which Cayetano Ferrer became famous but which later used an absinthe substitute is as follows:

> 1 lump sugar
> 1 jigger absinthe substitute
> 1 glass cracked ice

Pour the jigger of absinthe substitute into a bar glass filled with cracked ice. Over it suspend a lump of sugar in a special absinthe glass which has a small hole in the bottom (use a strainer if you haven't a glass) and allow water to drip, drop by drop, slowly into the sugar. When the desired color which indicates its strength has been reached and most of the sugar dissolved, stir with a spoon to frappe. Strain into a serving glass.[57]

After absinthe was banned, bartenders used a substitute such as Herbsaint and kept the aniseed flavor. According to one New Orleans resident, "While 'absinthe' drinks are not as popular in New Orleans [in the late twentieth century] as they once were, such 'absinthe' based drinks as the Sazerac Cocktail, the Ojen Cocktail, the Absinthe Frappe and the Absinthe Suissesse can still be found, especially on the menus of such institutions as Brennan's Restaurant and the Sazerac Room of the New Orleans Fairmont Hotel. Absinthe

Opposite: **Interior of New Orleans absinthe house (circa 1903). Note the marble fountains on the cypress bar where ice water from brass faucets was dripped over sugar on a slotted spoon or in a small glass with a hole in the bottom into the absinthe in the glass. Library of Congress.**

substitutes such as Pernod or Herbsaint are also used in most local versions of Oysters Rockefeller."[58]

Prohibition forces were at work very early in the history of the United States, and even admist all of the drinking, early on New Orleans had a temperance society, although a very ineffective one. Its members reasoned in 1841 that "situated as New Orleans is, having intimate intercourse with so many of the states of the Union, it will readily be perceived that it is important that her standards of morals should be as such to bear a favorable comparison with, or be recommendable for imitation to, others." But with an annual expenditure at that time of $3,000,000 on alcoholic beverages, New Orleans was far from setting an example of morality for the rest of the nation.[59] Prohibition became a serious national issue in the late nineteenth and early twentieth centuries. Theodore Roosevelt led the fight to close the saloons on Sunday in New York while he was the police commissioner there. When challenged by the owners of the drinking establishment, he mobilized 6,000 policemen to help search out and arrest those breaking the civil Sabbath law. Roosevelt wrote of his experiences as the police commissioner in New York in the September 1897 issue of the *Atlantic Monthly*.[60] Finally, after many years of fighting, Prohibition forces won, and the 18th amendment, which "made illegal the manufacture, transport, and sale of alcohol for drinking purpose in the United States . . . became law on January 16, 1920."[61]

According to John Magill, "the *Times-Picayune* predicted that 'the funeral of John Barleycorn' would be the greatest mortuary function in the history of New Orleans." But Magill says that "although throngs of people filled downtown streets, the public party was tamer than anticipated" and that New Orleans actually "slid quietly into the dry and roaring twenties." The Volstead Act, which was passed on October 28, 1919, made it illegal to sell anything "with an alcoholic content of over ½%," eliminating most beer and wine. "Gloom, Deep Dark and Dismal, Descends as Drought Comes," said A. Souse in the *Times-Picayune*. "Dig out the sackcloth and ashes, get on the wagon, welcome Old Man Gloom and pretend you like it."[62] It was during this time that Martin Behrman, who was major of New Orleans for nine terms between 1904 and 1926, remembered New Orleans as it was in the latter part of the nineteenth century. "I can remember the time," he said, "when there were nearly 2,000 saloons in New Orleans. . . . There were famous places for their drinks, such as Gin Fizz, Sazarac Cocktail, Absinthe, imported beer and so forth." He contended that "these 2,000 saloons

did not get as much space in the newspapers then" as the "rumors and reports" about illegal activities in the drinking establishments did "after the Volstead Act or National Prohibition Act was passed by Congress over President Wilson's veto on October 27, 1919." The act was an attempt to aid enforcement of the Eighteenth Amendment, which was passed in January, 1919. That act also "defined the alcoholic content specifications for intoxicating beverages as containing more than .5 percent alcohol."[63]

Actually, plenty of spirits, including absinthe, which was banned several years earlier, remained available in New Orleans for those who were willing to put forth a little effort. During the years of Prohibition, according to Louis Andrew Vyhnanek in *The Seamier Side of Life: Criminal Activity in New Orleans During the 1920s*, "New Orleans served as a major center for the importation of illegal liquor," the principal avenues of smuggling being "Lake Ponchartrain, Lake Borgne, the passes at the mouth of the Mississippi River, and the numerous bayous and inlets of St. Bernard Parish."[64] Lake Ponchartrain and St. Bernard Parish, especially, were havens for smugglers in the early 1920s, and "rum-running became a way of life for many people."

Many people made home brew, and estimates in 1920 indicated that as many as 10,000 citizens had "already broken the law."[65] According to Vyhnanek, on one occasion in 1922, "prohibition agents discovered a major bootleg cache including both liquor and champagne valued at between $50,000 and $75,000 in the area of Lake Pontchartrain between West End and Spanish Fort."[66] And even after prohibition came to New Orleans in 1919, "there were plenty of places which sold the bootlegger's product." Although saloons disappeared, they were replaced by "the soft drink stand and the speakeasy," though "there was nothing soft about the contents of the beverages served there." The speakeasy "generally catered to a more select clientele and served a better quality of liquor. Bootleg establishments were everywhere. Eight establishments were even located across the street from the police station. Vyhnanek tells the story of a man who obtained his flask at one of these, slipped it in his back pocket, and proceeded down the stairs; unfortunately, he slipped and fell, hitting his backside rather hard. Upon examination, he discovered that his pants legs were wet in the back, whereupon he exclaimed, "God! I hope it's blood!" Most restaurants and cafes had liquor available for their customers, though they took special care in hiding it from the public view.[67] Said Magill, "there were speakeasies in downtown office buildings, and there was an automobile that served

drinks at the curbside along downtown streets. In some restaurants waiters sold drinks from hip flasks, straight liquor in demitasses with mixers on the side—were served."[68] Adding to the illegal activities in New Orleans in the 1920s was drug smuggling. New Orleans was the center of trafficking in drugs, including opium, morphine, cocaine, and marijuana. Marijuana was first introduced to the city around 1910. Morphine was the most popular of the drugs. Users of these drugs were called "junkers."[69]

Federal agents at the U.S. Custom House who were in charge of enforcing the law were usually understaffed and had great difficulty dealing with all the lawbreakers. Thus, on one occasion in 1923, they enlisted the services of Izzy Einstein, who was notorious for his ability to find where booze was being sold. According to one writer, in an investigation "to learn where drinks were the easiest to find, New Orleans won with a score of 35 seconds. Between the railroad station and his hotel, Izzy asked his taxi driver where drinks were sold. The driver offered to sell him a bottle from under the seat."[70] Though the local police were required to participate in the raids against establishments suspected of illegal activities, usually they did so half-heartedly, and often were guilty of selling alcohol illegally themselves or were hired "as lookouts for smugglers."[71]

Sherwood Anderson (1876–1941), an American writer of short stories, lived in New Orleans for a while after 1924 with his second wife, Elizabeth. She describes the scene in New Orleans in the early 1920s in her book *Miss Elizabeth: A Memoir.*

New Orleans was unlike anything I had seen before and I was immediately enthralled with it. The silver-gray, hanging strands of Spanish moss made even an ugly tree look graceful and lazy and somehow very Southern. The Latin Quarter was bustling and busy, with rattling streetcars and honking automobiles, street vendors calling out their wares with a music that was new to me. The narrow streets were crowded with artists and prostitutes and writers and nuns and easily recognizable tourists with glazed eyes and gaping mouths. Speakeasies flourished openly, and far into the night their music blared out and mingled on the still busy streets. There was a rich, spicy aroma made up of coffee roasting, seafood and the winy-beery smell of bars.[72]

She says that New Orleans was "a literary center of sorts and there were many young writers and artists living nearby." Anderson would meet each month with his literary friends to put together the magazine *Double-Dealer,* which was published for a while in New Orleans. William Faulkner became acquainted with the Andersons in New Orleans and published some sketches in the *Double-Dealer*

called "New Orleans" in January and February of 1925. Ernest Hemingway also published some of his first works in that magazine.[73]

As described by Elizabeth Anderson, the literary crowd in New Orleans during the twenties had a grand old time. "There was a great deal of drinking among us," she said, "but little drunkenness." She continued:

We all seemed to feel that Prohibition was a personal affront and that we had a moral duty to undermine it. The great drink of the day was absinthe, which was even more illegal than whiskey because of the wormwood in it. Bill Spratling [a teacher at Tulane University] had bought ten large jugs of it from some woman whose bootlegger husband had died, and he shared his booty liberally with his friends. It was served over crushed ice, and since it did not have much taste of alcohol that way, it was consumed in quantities.[74]

Elizabeth recounted an incident concerning a reporter who wanted to interview her to get a domestic view of Anderson. According to Elizabeth, she invited the lady reporter to meet her at the Absinthe House, where they talked for some time while sipping an absinthe. She was outraged by the reporter when she wrote for her Midwest audience: "Miss Elizabeth spends her days sipping absinthe in a popular New Orleans bistro." Though she said that Sherwood "drank absinthe," he was just as fond of other drinks and sometimes did not drink at all. She said she saw him drunk only once.[75]

By 1925, some agents were calling New Orleans the "liquor capital of America." Thus, the decision was made to "clean up" the city for once and for all. Two hundred agents made several raids, confiscating 10,000 cases of liquor—the most, they said, "they had ever seen." One bootlegger later said that they "didn't get such an awful amount" and that he didn't "believe the price of liquor in New Orleans [would] go up—much." But the agents continued their raids, intent on closing all the drinking establishments by New Year's Day. According to news reports, 86 drinking establishments were closed by December 10, 1926, and by 1927, "New Orleans had more padlocked 'speakeasies' than any other city in the nation."[76]

During the Prohibition years, the proprietors of the Absinthe House had a great deal of trouble with authorities who were trying to enforce the Volstead Act. According to a news article, on May 19, 1925, "the old Absinthe House ... was closed ... under padlock proceedings, along with five other cabarets and soft drink stands" after "charges were brought by the District Attorney's office that the places were illegally selling liquor." The "temporary restraining order

commanded them to show cause why they should not be padlocked for a year."[77] The old Absinthe House was ordered padlocked again on November 5, 1926, "upon testimony that the proprietors had violated the Volstead Act." According to the news article covering the closing,

The place has been identified with some of the most colorful meetings in the history of New Orleans. The military of the old Spanish regime and then of the French rubbed shoulders there with actors, artists and noted men of all professions. The marble font bears deep fissures worn by the constant dripping of soda in the preparation of the milky concoction from which the place drew its name.[78]

The *New Orleans-Picayune* sadly and nostalgically noted that the

doors of the historic old Absinthe House were closed on its hundredth anniversary Saturday when the United States Marshal nailed them together following a padlock injunction of the United States Court. . . . The famous old house was established in 1826, serving absinthe continually until Prohibition, and, the court avers, after.[79]

This was the "record year" for Prohibition agents, according to the December 10, 1926, issue of the *New Orleans Item*. "Holiday visitors to New Orleans will be greeted by 86 padlocked cabarets and night life resorts, closed by order of the federal district court during 1926. They will also find a total of 44 resorts operating under the restraint of $1,000 bond furnished to the federal court here as a guarantee that they will not violate any of the dry laws. Many of the resorts which have run afoul of the law have made this city famous, the pride of restauranteurs and night club operators. Among some of the celebrated places actually under padlock [is] the Old Absinthe House." The article continued, "These proprietors who have been fortunate enough to secure bond from the court to operate their establishments must obey the strict provision that no intoxicating liquor is bought at their tables or brought in by guests. Recent ruling from the bench even indicate that the indiscriminate sale of 'ginger-ale and ice' may be cause to forfeit the bond of the establishment and re-instate the original padlock."[80] After the bar of the old Absinthe House was moved to its new location, it was again padlocked on October 2, 1929. Reported the *Morning Tribune*,

The old Absinthe house bar, famed landmark of New Orleans, and once a habitat of buccaneers, submitted to the ignominy of a federal padlock. . . . On Wednesday deputy United States marshals descended on the old bar, placed the proprietor, Pierre Cazebon, and the bartender, Sam Mitchell, under arrest, and clamped a padlock on the door.[81]

By 1928 most of the whiskey available in New Orleans was "unsanitary" and "even lethal" moonshine. On April 13, 1933, drinks with no more than 3.2 percent alcohol were legalized, and there were reportedly "911 retail beer permits issued in the city within a few days." In December 1933, the 21st Amendment was passed repealing Prohibition.[82] But by this time, absinthe had been illegal for almost two decades, and most bar owners would not have risked breaking the law for the few who remembered the drink. Drinks resembling the older ones are still served at many American bars, especially in New Orleans, but without the toxic oil of wormwood. Visitors to the Old Absinthe house in its heyday included both the famous and the infamous, including, among others, such names as Jean Lafitte, Andrew Jackson, William Howard Taft, Theodore Roosevelt, Mark Twain, William Makepeace Thackeray, General Pierre Beauregard, Walt Whitman, Oscar Wilde, O. Henry, Jenny Lind, and composer Victor Herbert.[83]

The major nineteenth century American poets—Bryant, Emerson, Longfellow, Whittier, Holmes and Lowell—were not affected by the trend to drink absinthe or any intoxicating substance. To the contrary, according to prohibitionist Ferdinand C. Inglehart in *King Alcohol Dethroned*, "these men were all singularly clean in their social habits and free from alcohol." He points out that "Lowell lived to be seventy-three; Longfellow to be seventy-five; Bryant to be eighty-four; Whittier and Holmes each to be eighty-five."[84] But, he says, these men "did not reflect the sentiment of their times, which was almost universally in favor of the use of liquor." He continues with,

The sideboard with its decanter and glasses was considered a necessary article of furniture in the home of luxury or even of respectability, and the little brown jug could be found nearly everywhere in the home of the artisan as a promoter of happiness and industrial efficiency; political life and drinking were associated with each other as a matter of course. Some of the greatest statesmen and orators of the nation drank heavily, sometimes to drunkenness, and little was thought of it except maybe to laugh at the silly things such wise men would say or do, or pity them that they should use to excess a thing which in moderation was so good for them. The capital of the nation itself was a colossal bar, where the representatives of the people could the more conveniently drink and get happy and even drink in their revels, a disgrace to them and to their constituencies.[85]

One notable exception to abstinence among the American poets was Edgar Allan Poe (1809–1849), who, at least in his time, was considered a major American poet. Poe's addiction to intoxicating substances has been dealt with at length in many articles and books

about the author. Most agree that Poe's death was hastened by his excessive drinking and that his alcoholism had a debilitating effect on his life. None have attributed his death to absinthe drinking, though there is a possibility that such may have been the case. It is also known that, at times, Poe sought inspiration and consolation from *la fée verte*. It has been said that when Poe and his lawyer friend Henry Beck Hirst would visit Philadelphia with Poe's publisher John Sartain—who was a heavy absinthe drinker—they drank a mixture of absinthe and brandy. After the group became slightly inebriated, Hirst, who was an ornithologist, would beg Poe to give a recitation of "The Raven."[86]

Poe's alcoholism may have had its roots in his childhood. Though little is known about his parents, it is believed that his father, David Poe, an actor who died when Edgar was two, "was given to excessive drinking"; his brother, Henry, gave himself up "entirely . . . to drink," and his sister, Rosalie, "shared [Poe's] extreme susceptibility to alcohol, being adversely affected by even a glass of wine."[87] If, indeed, the Poe children inherited a susceptibility to drink, their treatment in their early years increased the likelihood that they would be drawn to strong drink. Upon visiting the Poe home for the first time, one visitor noticed that the Poe children were all "thin and pale and very fretful," requiring a great deal of attention from their nurse. "To quiet them," she said, "their old nurse . . . took, them upon her lap and fed them liberally with bread soaked in gin, [and] soon they fell asleep." The nurse later said that "she had, from the very birth of the girl [Rosalie], freely administered to them gin and other spirituous liquors, with sometimes laudanum 'to make them strong and healthy' or to put them to sleep when restless."[88]

It is clear that Poe had a drinking problem when he was a student at the University of Virginia. Known to be excessively "nervous" and "restless" at times, according to one classmate, Poe would "too often put himself under the influence of [alcohol]" to calm himself down. Another student said, "Poe's passion for strong drink was as marked and as peculiar as that for cards. It was not the taste of the beverage that influenced him; without a sip or smack he would seize a full glass, without water or sugar, and send it home at a single gulp" after which he "'rarely returned' to the bottle." Later at West Point, his dissipation continued; and he continued to drink while living in Baltimore with his aunt, Mrs. Clemm. When in August 1835 Poe took a job as assistant editor to the *Southern Literary Messenger* in Richmond, he was described by the editor Thomas Willis White as already "unfortunately very dissipated."[89]

According to the *National Cyclopedia of American Biography,*

It was about this time that Poe was first publicly known to drink to inebriety. The indulgence with which he had harmlessly dallied as a youth now became to his strained organism a menacing vice, but he fought it down and devoted himself with unremitting industry to literary work. He was not a drunkard, and he never became one; yet, notwithstanding the mass of proof to the contrary, there is a general feeling that he was a confirmed inebriate. The truth is, he was not even a tippler. He seldom drank strong liquors—and this is true of him to the end—but when he did so he invariably became intoxicated.[90]

But the fact is he continued to go on sprees, and he lost his job in January 1837, "because of his repeated lapses from sobriety."[91] When Poe wrote to White a few months later asking for reinstatement to his job, it was with obvious difficulty that White refused him. "That you are sincere in all your promises, I firmly believe," he said. "But, Edgar, when you once again tread these streets, I have my fears that your resolves would fall through—and that you would again sip the juice." He told him to look to God for strength and to move in with a family "where liquor is not used. No man is safe who drinks before breakfast!" he said.[92]

After that Poe apparently tried to control his drinking. Around February of 1837, Williams Gowans, a bookseller who shared a floor of an apartment building in New York with Poe and his wife Virginia and her mother Maria Clemm, wrote that Poe had been sober for eight months and, indeed, exhibited no vices. To the contrary, he was a "courteous, gentlemanly, and intelligent" companion.[93] In July 1838 Poe wrote to the Secretary of the Navy, James Kirke Paulding, hoping to receive an appointment, "to relieve [himself] altogether, and without a struggle."[94]

In spite of his best efforts, Poe continued to return to the bottle. Thomas Dunn English, a young poet, was singularly impressed with Poe and visited with him and his family frequently in the first half of 1839. He was shocked one night to find Poe drunk "struggling in a vain attempt to raise himself from the gutter."[95] But Poe continued to reassure others that he was not "intemperate" in his drinking, and "was never in the habit of intoxication."[96] In January 1842, Virginia became seriously ill with tuberculosis, an illness that was constant until her death five years later. Poe later said that the "horrible never-ending oscillation between hope and despair" during Virginia's illness "led him to seek solace in excessive drinking."[97] He had a "drinking bout" when he was in New York in June 1842 and another in March 1843 when he visited Washington.[98]

In the following years, Poe's life was a downhill battle with alcohol. By this time he was being publicly denounced as a "drunkard," a "besotted driveller," and "a degenerate alcoholic." On one occasion he was found "crazy-drunk in the hands of the police," and on another occasion he appeared intoxicated almost to the point of delirium at the home of Sarah Helen Whitman, to whom Poe was engaged for a few months. She decided against marriage after Poe failed to keep his promises to stop drinking.[99] In July 1849 he was arrested for drunkenness in Philadelphia. He later appeared at John Sartain's studio "pale and haggard" apparently having hallucinations.[100] Poe wrote to Mrs. Clemm after this incident, begging her to write him instantly, a request to which she complied. His reply to her was one of relief:

Oh, if you knew how your dear letter comforted me! It acted like magic. Most of my suffering arose from that terrible idea which I could not get rid of—the idea that you were dead. For more than ten days I was totally deranged, although I was not drinking one drop; and during this interval I imagined the most horrible calamities.... All was hallucination, arising from an attack which I had never before experienced—an attack of *mania-a-potu*. May Heaven grant that it prove a warning for me for the rest of my days.[101]

Shortly afterwards, however, he had a relapse, during which time he nearly died. In August he joined the Sons of Temperance, pledging that he would "abstain from alcohol." In early October 1849, Poe, while in route to Philadelphia, stopped in Baltimore, where he was greeted by old friends who insisted that he have a drink with them. According to his doctor, "This was the first drink he had taken for several months," and "sad enough for Poe, it revived his latent appetite for drink, and the result was a terrible debauch which ended with his death." He was later found "stupefied with liquor"— so "insensible" that he had to be carried "to the carriage as if a corpse," and "the muscles of articulation seemed paralyzed to speechlessness, and mere incoherent mutterings were all that we heard." Poe died on October 7, 1849, at Washington College Hospital after experiencing many hours of "violent delirium"; his last words were, "Lord help my poor Soul."[102]

Though it is not known that Poe was addicted to absinthe, the severity of his hallucinations and other symptoms suggest that absinthe drinking may have been part of his problem. According to researchers, absinthe drinkers had all the symptoms of the alcoholic, but they appeared more quickly and were more severe. Also, some of the symptoms, especially hallucinations, were likely to recur for

some time after the drinking ceased. Poe's symptoms fit the description of those of the absinthe addict. "The effects of absinthe in a small dose," said one researcher, "are giddiness, vertigo, muscular disorders, and convulsive movements ... [and] in a stronger dose it causes attacks of epilepsy, more or less violent, which are not produced by alcohol." This 1906 study, along with others of the period, may help explain Poe's illness and death.[103]

Other Americans also knew about absinthe. In 1913, California writer Jack London (1876–1916), in *John Barleycorn*, a book of alcoholic memoirs he wrote after swearing off drinking, explains how he was first introduced to absinthe:

I reached the Marquesas, the possessor of a real man's size thirst. And in the Marquesas were several white men, a lot of sickly natives, much magnificent scenery, plenty of trade rum, and an immense quantity of absinthe, but neither whisky nor gin.... I have never been plastic, and I accepted the absinthe. The trouble with the stuff was that I had to take such inordinate quantities in order to feel the slightest effect... From the Marquesas I sailed with sufficient absinthe in ballast to last me to Tahiti.[104]

In 1913 *John Barleycorn* was serialized in the *Saturday Evening Post* and was later published by Century. Its success can be attributed to the fact that Prohibition forces seized upon the book to support their cause. Said Upton Sinclair later, "That the work of a drinker who had no intention of stopping drinking should become a major propaganda piece in the campaign for Prohibition is surely one of the choice ironies in the history of alcohol." London, in a state of depression and financial ruin, may have taken his own life at the age of 40.[105]

Absinthe was certainly indulged in by many of the socially elite and the wealthy, who frequently travelled to countries where absinthe was popular. American poet Harry Crosby (1898–1929), a millionaire whose godfather was J. Pierpont Morgan, Jr., adopted a hedonistic lifestyle in Paris, after rejecting the land of his birth. According to Conrad, "for Crosby, the drink that had charmed Wilde, Lautrec, Rimbaud, and the other pre–War dandies and artists, was worth an ocean of associations, a morbid green paradise." It was to him "a sacrament of a bygone age." Crosby served in the Army in World War I, during which time, like Hemingway, he drove an ambulance and narrowly escaped death when a shell totally destroyed his vehicle, critically injuring his friend and "miraculously" leaving him unhurt.[106] His brush with death and the scenes of horror he witnessed as an ambulance driver had a major impact on him for

the remainder of his short life. After the war, Crosby, who always believed he was "marked for early death," was described by a friend as being "wild as the blazes"; some even believed he was shell-shocked.

A lover of books, Crosby came under the influence of Oscar Wilde; he read and reread *The Picture of Dorian Gray*, from which he copied passages. His notebooks and journals frequently refer to the following passage, in which Lord Henry Wotton instructs Dorian Gray in his hedonistic lifestyle:

The mutilation of the savage has its tragic survival in the self-denial that mars our lives. We are punished for our refusals. Every impulse that we strive to strangle broods in the mind, and poisons us. The body sins once, and has done with its sin, for action is a model of purification. Nothing remains then but the recollection of a pleasure, or the luxury of a regret. The only way to get rid of temptation is to yield to it. Resist it, and your soul grows sick with longing for what its monstrous laws have made monstrous and unlawful.[107]

According to Geoffrey Wolff's account of Harry's life in *Black Sun*, Crosby lived out the philosophy advocated by Lord Wotton in *The Picture of Dorian Gray*, and he added to it "the articles of faith of the Yellow Book decadence of the Nineties in England, and earlier of the French Symbolists." He wore a black cloth flower on the lapel of his coat, and "expressed his hedonism through an indulgence in whatever came to hand: opium, hashish, absinthe."[108] He became a disciple of Baudelaire, going so far as to send "imaginary irises to the genius of disease" on Baudelaire's birthday. An April 1925 sonnet to Baudelaire, which was inspired by Baudelaire's "melancholy" poem "Spleen IV," reveals the influence that the earlier poet had on Crosby:

> I think I understand you Baudelaire
> With all your strangeness and perverted ways
> You whose fierce hatred of dull working days
> Led you to seek your macabre vision there
> Where shrouded night came creeping to ensnare
> Your phantom-fevered brain, with subtle maze
> Of decomposed loves, remorse, dismays
> And all the gnawing of a world's despair.
>
> Within my soul you've set your blackest flag
> And made my disillusioned heart your tomb,
> My mind which once was young and virginal
> Is now a swamp, a spleenfilled pregnant womb
> Of things abominable; things androgynal
> Flowers of Dissolution, Fleurs du Mal.[109]

Says Wolff, "It's no trick to imagine what effect "Spleen" had on Harry. He recognized its beauty, shining like a black pearl in a cup of dead-green absinthe."[110]

While Crosby often drank absinthe, he used other drugs to such excess that absinthe was a minor vice. In Paris, Crosby and his wife frequented Montmartre, where they indulged in whatever was available at the time, including cocaine, hashish, kief, and opium. But "opium was the drug of choice" for Crosby, and he preferred to smoke it.[111] In *Opium and the Romantic Imagination*, Alethea Hayter says Crosby had "a restless mental curiosity about strange and novel mental experiences" and that he delighted in "secret rites and hidden fellowships, in being initiate." Crosby knew the horrors of addiction to opium, but he used it anyway, careless of the consequences, which included memory loss, the inability to concentrate, and problems with digestion. According to Hayter, he also experimented with hashish, "adding it to opium and cicaube and passifloreine and brandy and absinthe and any odd thing that fell to hand."[112]

Crosby's diaries are filled with references to opium, which he indulged in at wild parties, with friends or his wife, and sometimes alone.[113] On one occasion, he and his wife Caresse "bought four jars of ... the best brand" of opium while in North Africa. A friend recounted that "they kept the opium, which looked to her like a pot of blackberry jam, in her toy chest and that prior to its appearance 'there was a Verlaine jag with absinthe, so that we had a great deal of absinthe around the flat.'"[114]

Absinthe was a part of Crosby's life and present at almost any occasion. He drank absinthe with a count in France, made toasts to Oscar Wilde with absinthe at the Rue des Beaux-Arts, drank "absinthe cocktails and vintage champagne" at the Ritz, and, at the bullfights in Spain, took "one absinthe two absinthes three absinthes," until he wandered the streets at night "wet and dark," and then the next day "cold absinthe in tall glasses" as Ernest Hemingway drove past in a carriage, and "a last round of absinthe" before the bullfight—and so the absinthe drinking continued. Crosby became acquainted with Hemingway in 1926 at St. Moritz. The novelist later introduced Harry to James Joyce.[115] On December 10, 1929, after making plans with his wife and mother for a visit with J.P. Morgan and an evening at the theatre with Hart Crane, Crosby met his mistress at the Hotel des Artistes near Central Park in New York. In what appeared to be a planned double suicide, Crosby shot his mistress after which he killed himself.[116]

Harry was not alone in his indulgences with absinthe and other

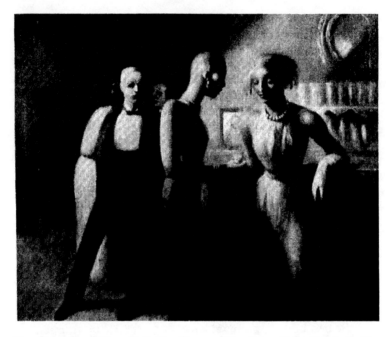

Guy Pene Du Bois. *Absinthe House.* **Courtesy of the Regis Collection, Minneapolis, Minnesota.**

drugs. On one occasion Ezra Pound "visited Jean Cocteau, then addicted to opium, and found him in bed beneath heaps of blankets, with an electric heater blasting at him while the temperature outside stood in the eighties." Ernest Hemingway recalled delivering a cold-cream jar filled with opium, at Pound's request, to Ralph Cheever Dunning, a poet who forgot to eat, who could only drink milk while he was smoking, whose wits had been addled by the juice of *Papaver somniferum.*[117]

While attending the bullfights in Spain, Ernest Hemingway drank absinthe, which was readily available there. In fact, the company of Pernod Fils moved to Tarragona, Spain, after absinthe was banned in France. After Hemingway moved to Florida, he usually had a regular supply—probably purchased in Cuba—where he frequently fished for marlin. Hemingway was also in Spain during the Spanish Civil War, and he continued to drink absinthe. That he was very familiar with the drink is certain; it appears often in his writing. In *The Sun Also Rises,* the main character, Jake Barnes, drinks absinthe with his friend, Bill, after Lady Brett leaves with the bullfighter.

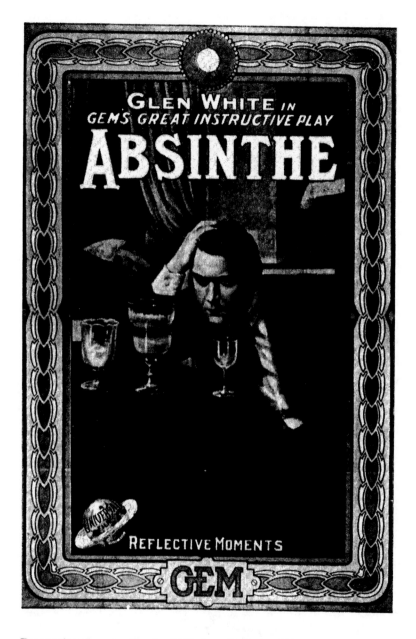

Promotional poster for the 1913 play *Absinthe*. Library of Congress.

In *Death in the Afternoon,* Hemingway says he decided to give up bullfighting because he had to drink three or four absinthes "to get up his courage to go into the ring, and while they inflamed his courage, they slightly distorted his reflexes."[118]

Hemingway was aware of the drink's potential to destroy; for example, in *For Whom the Bell Tolls,* Robert Jordon, on one occasion, told a gypsy that "real" absinthe had wormwood in it and was "supposed to rot your brain out."[119] In *To Have and To Have Not,* after one of the characters drank three Spanish absinthes, he was warned "not to follow the drinks with any other drink" because they were very potent.[120] And in *The Sun Also Rises,* it was observed that absinthe would "make [one] sick if he drank it too fast."[121]

In *For Whom the Bell Tolls,* Robert Jordon hands a canteen of absinthe to a gypsy, hoping he would take of it sparingly.

It was milky yellow now with the water and he hoped the gypsy would not take more than a swallow. There was very little of it left and one cup of it took the place of the evening papers, of all the old evenings in cafes, of all the chestnut trees that would be in bloom now in this month, of the great slow horses of the outer boulevards, of book shops, of kiosques, and of galleries, of the Parc Montsouris, of the Stade Buffalo and of the Butte Chaumont, of the Guaranty Trust Company and the Ile de la Cite, of Foyot's old hotel, and of being able to read and relax in the evening; of all the things he had enjoyed and forgotten and that come back to him when he tasted that opaque, bitter, tongue-numbering, brain-warming, stomach warming, idea-changing liquid alchemy.[122]

Though most Americans may have been introduced to absinthe in another country or in New Orleans, it was available in most major American cities. A perusal of early twentieth century California newspapers reveals that absinthe was a part of the scene there, particularly in San Francisco; but it was still not considered "a problem" in 1908, many years after it had become popular in New Orleans, at least according to one observer.[123] But that it was on its way to becoming a problem is evident in the reaction to its banning and the bar owners' attempts to sell the beverage for years after it was banned. On October 2, 1912, the day after absinthe was banned from San Francisco, the *San Francisco Call* reported that "wholesale liquor dealers and hotelmen ... attempted to have 3,000 cases [of absinthe] stored in the bonded warehouses released, but permission was denied," resulting in the absinthe's being "shipped to some other country."[124] But attempts to sell the drink outside the law continued. In December 1915, Californian H. Irving Hodgkins was "called upon

by the Federal authorities to explain why he had shipped to him a number of cases of absinthe which were seized by Customs House officials." According to the *San Francisco Examiner*'s coverage of the event, "the twenty-five cases were labeled 'Logan blackberry cordial,' which "made inspectors curious." As a result, "they seized several cases to examine the ingredients and discovered they contained absinthe instead of cordial."[125] In December 1917 a woman detective helped apprehend the owner of Caesar's Grill by going undercover and purchasing absinthe there. "Thousands of dollars' worth of absinthe was found hidden away, and several quarts were found at [the owner's] home."[126] As late as February 1923, a raid "on the exclusive Merchants' Exchange club" resulted in a stock so large that "eight big traveling grips were necessary to hold the bottles which were found 'all over the club.'"[127] Absinthe was also served at many of the bars in New York, Chicago, and Philadelphia.[128]

Since absinthe was banned in the United States in 1912, its role in American literature and art was minor; however, Guy Pene du Bois painted a scene from the Absinthe House in New Orleans, and absinthe is also frequently referred to by early twentieth century American writers, especially by Hemingway and some of the New Orleans writers. In 1913 *Absinthe,* a "great instructive play" on "the insidious French drink," was released. Written by Gem, and starring Glen White, the play's purpose was to portray "an artist's struggles against addiction." A poster advertisement for the film is housed in the Poster Collection at the Library of Congress.[129] And as late as 1935, about 500 hundred copies of "Over an Absinthe Bottle," an 1897 short story about absinthe by W.C. Morrow, described as "an important Pacific Coast writer of the past," were printed by the Grabhorn Press in San Francisco for distribution to members of the Book Club of California. The story revolves around a penniless young man and a dice-throwing, absinthe-drinking bank robber, both of whom die after several rounds of gambling and drinking absinthe.[130]

CONCLUSION

It is not insignificant that the greatest period of absinthe drinking occurred during periods of great social and political upheavals, when life itself was turbulent and unpredictable. Social historians have found that there is a relationship between increased alcoholism and social instability. Said one writer, "The massive and habitual use of alcohol . . . just as with the abuse of narcotics, is a means of coping with inner stress and tension." Others have "linked the propensity to drink with hard times."[1] Early medical researchers associated absinthe drinking with "certain social problems which today would be considered typical of a modern industrial society," such as an increase in communicable diseases, violent crime, and shifts in population growth.[2] Researchers have also found that, because of tension and stress and instability, alcoholism increases before, during, and in the aftermath of wars.

The drinking of absinthe ran its course, in the main, between the French-Algerian War in the early nineteenth century and the end of World War I in the early twentieth century, with the highest consumption taking place in Europe, particularly in France, prior to military endeavors. This time period also coincides with the Industrial Revolution, along with an increased amount of travel, the development of new and better methods of manufacturing goods, and the desire of the people to experience new lifestyles, ideas, and feelings. The excitement and desire for new experiences appealed especially to the young, to the intellectuals, who were quick to adopt the new and to ridicule the old. To these people, absinthe brought with it intrigue, romance, good times, and adventure. It was cheap enough for the poor and the common; sophisticated enough for the worldly and refined; exotic enough for the poets and the artists; an easy trip to the world of the sublime and the ecstasy of the soul.

There was a general increase in social drinking during the late nineteenth and early twentieth centuries, and absinthe was simply a

part of that general trend. Those who had little of the world's goods may have indulged to relieve their pain and suffering—but as the industrial revolution brought more conveniences and a better standard of living to the masses, French social historians believe several other conditions resulted in the increase in drinking: the proliferation of *débits de boissons* during the period; the lack of availability of good housing, in contrast to the attractive cafés; increased availability of money to spend on drinking and more leisure time to indulge in it (the people were working fewer hours and getting better pay); and a sheer lack of nothing better to do. Getting drunk together was a social thing. So attractive was the drink, that once it became a part of social life, it was difficult to stop its use.

As a product of an age of uncertainty, absinthe seduced many of the gifted people, and some of the period's greatest talents were among its victims. Already emotionally unstable, or isolated because their talents, unfortunately, set them apart from the masses, these people turned to absinthe: it appealed to their imagination, eased their loneliness, and comforted them in their despair. It is worth mentioning that many of these people, most notably perhaps Verlaine and van Gogh, had a religious bent and suffered pangs of conscience because they failed to live up to their own expectations and the expectations of family and friends. Many, also, failed at love, and most exhibited self-destructive behavior. A large number of those addicted to absinthe or caught up in the absinthe craze committed suicide. It may be that, even without absinthe, they would have destroyed themselves, but it is difficult to overlook the fact that one of the side effects of overindulgence in absinthe is a preoccupation with death.

Other writers and artists and the socially elite turned to absinthe for different reasons. It was new, it was different, it was the rage. To sit idly in the cafés and lazily watch the water drip through the sugar cube and the swirling drink turn to green; to lazily sip the licorice flavored drink while conversing with congenial friends—this was an enjoyable activity. Most were little harmed by "the green fairy," but to others the fairy became "the queen of poisons."

Absinthe was especially appealing to the young and inexperienced, many of whom viewed it as the gateway to the world of maturity. A short story by Coulson Kernahan, published in *Chambers's Journal* in 1930 and entitled "Two Absinthe-Minded Beggars," deals with absinthe's appeal to young intellectuals. Two young men, who have only read "about Parisian or Bohemian life" in novels and short stories, decide to learn about absinthe "first-hand." Says

one to the other, "You and I, dear fellow . . . are literary men, or hope to be, and one day we may give the world a work of art in which we shall have to picture an absinthe-addict, or the effect of absinthe upon the taker, and our knowledge ought to be first-hand." They are also interested in experiencing "the magical effect of the thing in lifting any weight one has on one's mind." As it turns out, instead of exhilaration they experience depression and despondency.

They are willing to take great risks to learn the secret of Verlaine's "inspiration" for his poetry. The scene after their ordering of the drink follows:

The waiter . . . set before each of us a tumbler half-filled with a thinnish liquid of some sort. Within the tumbler, as within a receptacle—we wondered whether he was about to show us a conjuring trick—stood a wine-glass, also filled, but to the brim, with a liquid of some sort, which was viscous . . . and which, by the look of it, might have been gum. Then bowing, the waiter withdrew, and we two children, who fancied ourselves men of the world, were left wondering what in the same world we were next supposed to do.[3]

Because they have "never had absinthe before," they ask the waiter to help them with the drink. The two young men are horrified at the drink's diabolic and sinister appearance as the waiter serves it, no doubt, in the English manner.

[The waiter] said nothing, but, lifting the wine-glass, first tilted, and finally inverted it over the tumbler until the gum-like liquid had oozed heavily and stickily—to writhe, snake-like, and smoke-like, in nacreous curls, coils, and spirals, until the two liquids within the tumbler, in combining, assumed the colouring and the cloudiness of an opal. I did not like the look of the stuff, and by the heavy and drugged smell, felt sure I should dislike the taste. "It is an unholy looking dope," I said. The stealthiness with which the thicker liquid curled, coiled, and spiralled itself around the thinner liquid made me think of a python enfolding and crushing its victim.[4]

The two order again and again, hoping to feel the gladness, cheer, and exhilaration promised them by the waiter.

Though the case against absinthe may not seem strong today, during the time of its greatest use medical experts, scientists, and chemists agreed, and rightly so, that it should not be consumed. But prohibiting absinthe did not solve the problems that many believed it would; complex social problems can hardly be solved by banning one drink—more than likely, such problems have their roots in many causes.

Since absinthe was banned in most countries within the first two decades of the twentieth century, not much modern research has

been done on the effect of absinthe poisoning. But even as early as 1892, medical researchers were using absinthe in experiments in an attempt to determine the origin of the convulsions associated with epilepsy. According to these studies, convulsions were easily produced in animals—and in humans—by administering absinthe. According to Dr. Isaac Ott, in a paper read at the American Neurological Association in New York in June 1892, "after the [subjects were injected] *per jugular* of two drops of essence of absinthe . . . the facial muscles begin with single clonic spasms, passing into a state of tremulous spasm." Then the "order of convulsions passes rapidly down the body until the tonic spasm in the limbs is extremely marked," after which "tonic spasm gives way to a long series of clonic twitches." Along with the convulsions were "profuse salivation and sometimes escape of urine" and on occasion "unconsciousness and coma." Says Ott, "It is evident that in this medicant we have a most valuable means to study the origin and seat of the convulsive dis-, order."[5]

Dr. Emma Walker, in the October 13, 1906, issue of *Medical Record,* refers to a number of studies done before that time, all of which reveal that there was a difference between alcoholism and absinthism, the main differences being in the convulsions and hallucinations produced by absinthe and the tendency for the hallucinations to recur even after the absinthe has been withdrawn for some time.[6] A 1931 study on epilepsy, conducted in the Neuro-Surgical Laboratory of Columbia University, also confirms that absinthe produces convulsions. In a study involving the bilateral removal of the adrenal glands in cats, absinthe was used to produce epilepsy-like convulsions. The study was designed to support the idea that "the autonomic nervous system participates in the general motor phenomena" during convulsions and "to determine the effect that bilateral removal of the adrenal glands would have upon the reaction of animals to a convulsing agent such as absinth." The solution given the cats consisted of "1 cc. of oil of absinthe to 19 cc. of 95 percent ethyl alcohol," which was the "same solution . . . used for over six hundred animal experiments" that had previously shown that "in normal cases, the minimum convulsing dose varied between 0.03 and 0.04 cc. of the standard solution per pound of weight."[7]

According to W.N. Arnold, writing in the June 1989 issue of *Scientific American,* "Artemisia species [are] praised as sources of insect repellents, anthelmintics, and antimalarials." In 1971 researchers discovered that the species *Artemisia annua* was effective in treating malaria, something the Chinese had known for centuries.

And "thujone and its chemical cousin camphor played [positive] roles in . . . research on epilepsy and convulsive therapy." Says Arnold, "Absinthe tippling . . . was judged to be negative and destructive, and, in retrospect, the interdiction was tardy but surely justified. Opinions to the contrary have been expressed in the past 20 years, but they seem to be based on romantic and wishful thinking."[8]

REFERENCES

1. A History of the Drink

1. Regina Nadelson, "The Sweet Taste of Decadence," *Metropolitan Home,* Nov. 1982, 62–67.

2. Michael R. Marrus, "Social Drinking in the *Belle Epoque,*" *Journal of Social History* (Winter 1974): 115.

3. Nadelson, 65.

4. P.E. Prestwich, "Temperance in France: The Curious Case of Absinth," *Historical Reflections* (Canada) 6 (1979): 301.

5. *Encyclopedia Americana,* 1984 ed.

6. Barnaby Conrad, III, *Absinthe: History in a Bottle* (San Francisco: Chronicle Books, 1988), 86.

7. Prestwich, 302–303; Nadelson, 62.

8. *New International Encyclopedia,* 1911 ed.

9. James Mew and John Ashton, *Drinks of the World* (London: Leadenhall Press, 1892), 162–163. Republished by Gryphon Books, Ann Arbor, Mich. 1971; *Encyclopedia International,* 1963 ed.

10. *London Times,* 8 June 1914, 29.

11. H.E. Turner, "The Clinic: The Shaky Case Against Absinthe," *The American Mercury* (May 1935): 103.

12. Jerome Moses, *Factors Affecting Artemisia Absinthium Control,* North Dakota State University, 1985. Unpublished thesis, 3. See also William A. Emboden, "Absinthe, Absintheurs, and Absinthism," *Terra* (Spring 1983): 14, and W.R. Bett, "Vincent Van Gogh (1853–90): Artist and Addict," *British Journal of Addiction* 51 (April 1954): 10.

13. Wilfred Niels Arnold, "Absinthe," *Scientific American* 260 (June 1989): 112.

14. Nadelson, 62.

15. Paul Achtemeier, *Harper's Bible Dictionary* (New York: Harper and Row, 1985), 1142–1143.

16. Rodney Wayne Fye, *Absinthe and Wormwood,* San Francisco State College, 1964. An unpublished thesis and a creative work.

17. Moses, 3.

18. Emboden, 14–15; Maurice Zolotow, *Playboy,* June 1971, 172; Arnold, 112.

19. Conrad, 86.

20. Zolotow, 174.

21. Emboden, 14.

22. Conrad, 85.

23. Arnold, 112.

24. Conrad, 86.

25. Emboden, 14–15.

26. Conrad, 87; Arnold, 114.

27. Emboden, 14–15.

28. Emboden, 15.

29. Emboden, 15.

30. Emboden, 15–16.

31. Emboden, 15–16.

32. Emboden, 14.

33. John F. Mariani, *The Dictionary of American Food and Drink* (New York: Ticknor and Fields, 1983), 3–4.

34. Pliny, *Natural History,* trans. W.H.S. Jones (Cambridge, Mass.:

Harvard University Press, 1969), Bk. XX, Vol. 6, 113; Nadelson, 67.

35. Nadelson, 67.

36. Frederic Rosengarten, Jr., *The Book of Spices* (Wynnewood, Penn.: Livingston Pub. Co., 1969), 102.

37. Michael Kenyon, "A Bottle of Absinthe," *Gourmet* (Oct. 1990): 247.

38. Nadelson, 67.

39. Pliny, 109.

40. Pliny, 109–113.

41. Rosengarten, 102.

42. Frank J. Anderson, *An Illustrated History of the Herbals* (New York: Columbia University Press, 1977), 109–111.

43. *Magic and Medicine of Plants* (New York: *Reader's Digest*, 1986), 87.

44. Nadelson, 62.

45. *New York Times*, 12 December 1880, 6; Mariani, 3–4.

46. *Encyclopedia International*, 1963 ed.; Conrad, 88–89.

47. Prestwich, 302.

48. "France Banishing Absinth," *Literary Digest* 50 (May 1915): 1084–1085.

49. "'The Green Curse' in the United States," *Harper's Weekly*, 13 July 1907, 1035.

50. *New York Times*, 12 Dec. 1880, 5.

51. Sterling Heilig, "Absinthe Drinking," *Atlanta Constitution*, 19 Aug. 1894, 6.

52. Nadelson, 65.

53. Stanley Clisby Arthur, *Famous New Orleans Drinks and How to Mix 'Em* (Pelican, 1977), 34; *New International Encyclopedia*, 1911 ed.

54. Mariani, 3.

55. *Monthly Catalog of U.S.*

Government Publications, July 1912, 6. Food Inspection Decision 147.

56. Turner, 103; Dewey Stoddard, "The Question of Absinthe," *Nation* 101 (Aug. 1915): 223; "France Banishing Absinth," 1084.

57. "France Banishing Absinth," 1084.

58. "Fight on Absinthe Renewed in France," *New York Times*, 9 September 1925, 27; "Imitation Absinthe to Go," *New York Times*, 27 Oct. 1922, 29; "Paris Cafes Sell Absinthe," *New York Times*, 9 April 1920, 16.

59. Nadelson, 65.

60. *New York Times*, 14 Oct. 1879, 4.

61. Marie Corelli, *Wormwood* (London: Methuen, 1897), 211; Arthur, 37.

62. "France Banishing Absinth," 1084.

63. "Urges Ban on Absinthe," *New York Times*, 25 April 1930, 6.

64. Nadelson, 64.

65. "Science Watch: Van Gogh's Hallucinations," *New York Times*, 7 July 1981, C2; "Absinthe Makes the Heart Grow Fonder," *Popular Science* 219 (1981): 26.

66. Fritz Novotny, *Toulouse-Lautrec* (New York: Crown 1983), 6–7.

67. Emboden, 13.

68. Nadelson, 62.

69. Turner, 104.

70. Emboden, 13.

71. Marie-Claude Delahaye, *L'Absinthe: Histoire de la Fée Verte* (Paris: Berger-Levrault, 1983), 76.

72. Emboden, 13.

73. Zolotow, 172.

2. *Abuse and Prohibition in France*

1. Corelli, 11. All other quotes from this book will be indicated by page numbers.

2. Prestwich, 301–302; Conrad, 89; *Encyclopedia International*, 1963 ed.

3. Marrus, 120–121.

4. Arthur, 34; "Absinthe," *London Times*, 8 June 1914, 29.

5. C.W.J. Brasher, M.D., "Notes, Comments, and Abstracts: Absinthe

and Absinthe Drinking in England," *Lancet,* April 26, 1930: 944.

6. Marrus, 124.

7. "The Charms of Absinthe," *New York Times,* 19 Oct. 1884, 5.

8. George Heard Hamilton, *Manet and His Critics* (New Haven: Yale University Press, 1954), 23.

9. Anne Coffin Hanson, *Manet and the Modern Tradition* (New Haven: Yale University Press, 1977), 54.

10. Hamilton, 22.

11. Marrus, 124.

12. Ada E. Hirschman and Ronald K. Siegel, "Absinthe and the Socialization of Abuse: A Historical Note and Translation," *Social Pharmacology* 1 (1987): 4–5.

13. Hirschman and Siegel, 4–5.

14. Hirschman and Siegel, 4–5.

15. Hirschman and Siegel, 6–7.

16. Delahaye, 81.

17. Lucy H. Hooper, "Parisian Maniacs and Madhouses," *Lippincott's* 21 (June 1878): 764.

18. Prestwich, 303.

19. "The Wine Trade," *London Times,* 8 June 1914, 28; Marrus, 128; Prestwich, 302.

20. Marrus, 128.

21. Prestwich, 302.

22. Marrus, 128.

23. "Revolt of France's Wine Growers," *Harper's Weekly* 51 (Jan. 1929): 962.

24. *New York Times,* 14 Oct. 1879, 4.

25. *New York Times,* 12 Dec. 1880, 6.

26. Joanna Richardson, *Verlaine* (New York: The Viking Press, 1971), 245.

27. Susanna Barrows, "After the Commune: Alcoholism, Temperance, and Literature in the Early Third Republic," in *Nineteenth-Century Europe,* ed. John M. Merriman (New York: Holmes and Meier, 1979), 205–217.

28. Marrus, 130.

29. Marrus, 130.

30. Barrows, 214. Quoted from Emile Zola, *Les Rougon-Macquart* (Paris: Gallimard, 1961), 2, 1539–40.

31. Marrus, 130. According to Prestwich, a *débitant* was "not simply a bartender but anyone who sold alcohol [304, note 12]; this could mean a grocery, a pastry shop owner, or even a coal merchant."

32. Barrows, 213.

33. Marrus, 28.

34. Marrus, 131.

35. Marrus, 131. For a discussion of the role of the café in the literary and artistic world in Paris since the nineteenth century, see Georges Bernier's beautifully illustrated book *Paris Cafes* (New York: Wildenstein, 1985).

36. Marrus, 124.

37. Prestwich, 301–302.

38. H. Anet, "The War Against Absinthe on the Continent," *Economic Review* 17 (April 1907): 189–192.

39. Marrus, 124.

40. Heilig.

41. Arnold, 114.

42. Mariana, 3.

43. Richardson, 245.

44. Donald D. Vogt, "Absinthium: A Nineteenth-Century Drug of Abuse," *Journal of Ethnopharmacology* 4 (1901): 339.

45. Corelli, 208.

46. Prestwich, 303; Richardson, 245.

47. Prestwich, 302–303.

48. Heilig.

49. Prestwich, 302.

50. Anet, 189–90.

51. Heilig.

52. Richardson, 245.

53. Heilig.

54. Delahaye, 81.

55. Marrus, 126.

56. George Saintsbury, *Notes on a Cellar-Book* (London: Macmillan, 1963), 143–144.

57. Heilig.

58. Anet, 192.

59. Heilig.

60. Prestwich, 303.

61. Delahaye, 82–83; 35–36; 17–18.

62. Zolotow, 174.

63. Vogt, 341.

64. Prestwich, 303.

65. Barrows, 205; Marrus, 117.

66. *La Grande Dictionnaire de XIX^e siècle* (Paris, 1875), 1579. Quoted by Barrows.

67. Barrows, 206–208.

68. Michael De Montaigne, *Complete Works*, ed. William Hazlitt (New York: Worthington Co., 1889), 182.

69. Barrows, 206.

70. Emile Zola, *L'Assommoir* (Harmondsworth, England, 1970). Edited by Leonard Tancock, Penguin Classics.

71. Marrus, 118–119.

72. Prestwich, 304–305.

73. Marrus, 120.

74. Arnold, 116.

75. Arnold, 116.

76. Hirschman and Siegel, 1–12.

77. Prestwich, 306.

78. Arnold, 116.

79. Arnold, 116.

80. "France Grappling with the Drink Problem," *Catholic World* 61 (June 1895): 421–422. Quoted from *Cosmos.*

81. J. Leonard Corning, M.D., "The Efficacy of Wormwood (Artemisia Absinthium) in Certain Conditions of the Cerebrospinal Axis," *Medical Record,* 25 Jan. 1890, 88–89.

82. Emma E. Walker, M.D., "The Effects of Absinthe," *Medical Records,* 13 Oct. 1906, 568.

83. Prestwich, 303.

84. Marrus, 120.

85. Prestwich, 306.

86. Prestwich, 307–309.

87. Bett, 10.

88. Conrad, 93–94.

89. Ibid.

90. Ibid.

91. Zolotow, 170–72.

92. Prestwich, 312.

93. Prestwich, 311–314.

94. "The Green Curse in the United States," 1035.

95. W. Soltau, "The Drinking of Absinthe," *London Times,* 12 Aug. 1907, 16.

96. Anet, 189–192.

97. Anet, 189–192.

98. J. Napier Brodhead, "Present Crisis in France," *Nation* 84 (June 1907): 587.

99. Prestwich, 315.

100. Prestwich, 316.

101. Brooks Adams, "Picasso's Absinth Glasses: Six Drinks to the End of an Era," *Artforum* 18 (1980): 30–33.

102. Prestwich, 301, 317.

103. "France Banishing Absinth," 1084–85.

104. "France Banishing Absinth," 1084.

105. "Can the Allies Endure the Strain of Total Abstinence from Alcohol?" *Current Opinion* 58 (June 1915): 418.

106. "France Banishing Absinth," 1084–85.

107. "From French and German Pulpits," *Literary Digest* 50 (May 1915): 1086.

108. "From French and German Pulpits," 1086.

109. Stoddard, 223.

110. Stoddard, 223.

111. "Paris Cafes Sell Absinthe," *New York Times,* 9 April 1920, 16.

112. "Imitation Absinthe to Go," *New York Times,* 27 Oct. 1922, 29.

113. Prestwich, 319.

114. "Fight on Absinthe Renewed in France," *New York Times,* 27 Sept. 1925, 27.

115. "Alcohol Drinking Doubles in France," *New York Times,* 23 July 1925, 4.

116. Prestwich, 319.

117. Prestwich, 319.

118. Brasher, 944–946.

3. *Verlaine, Rimbaud, Wilde and the Others*

1. Marcel Pagnol, *The Time of Secrets.* Quoted by Kenyon, 247.

2. Vogt, 337.

3. Lawrence Hanson and Elizabeth

Hanson, *Verlaine: Fool of God* (New York: Random House, 1957), 126.

4. Paul Verlaine, *Confessions of a Poet*, trans. Ruth Saltzman Wolf and Joanna Richardson (New York: Philosophical Library, 1950), 107.

5. Edmond Lepelletier, *Paul Verlaine*, trans. E.M. Lang (New York: AMS Press, 1970), 77.

6. Marcel Coulon, *Poet Under Saturn: The Tragedy of Verlaine*, trans. Edgell Rickword (New York: Kennikat Press, 1970), 39.

7. Bergen Applegate, *Verlaine: His Absinthe-Tinted Song* (Chicago: Alderbrink Press, 1916), 3–4.

8. Applegate, 6.

9. Lepelletier, 449.

10. Alfred John Wright, Jr., *Paul Verlaine and the Musicians*, Dissertation, 1950, Columbia University.

11. Richardson, 6.

12. Verlaine, 57–59 and 101.

13. A.E. Carter, *Verlaine* (New York: Twayne, 1971), 18.

14. Verlaine, 63, 32.

15. Antoine Adam, *The Art of Paul Verlaine*, trans. Carl Morse (New York: New York University Press, 1963), 7.

16. Coulon, 50.

17. Lepelletier, 36, 68–69.

18. Verlaine, 73.

19. Carter, Preface.

20. Verlaine, 88–89.

21. Coulon, 60.

22. Lepelletier, 75.

23. R. Rudorff, *Belle Epoque* (London: Hamish Hamilton, 1972), 148–149.

24. Richardson, 15, 270.

25. Hanson, 102–103.

26. Richardson, 17.

27. Conrad, 25.

28. Richardson, 37.

29. Conrad, 25.

30. Hanson, 102–105.

31. Verlaine, 105–115.

32. Richardson, 37.

33. Hanson, 110.

34. Lepelletier, 187.

35. Hanson, 114–115.

36. Richardson, 44–45.

37. Verlaine, 7.

38. Lepelletier, 30.

39. Coulon, 54.

40. Richardson, 46–60.

41. Hanson, 116.

42. Lepelletier, 176–207.

43. Coulon, 89.

44. Richardson, 63.

45. Coulon, 81–86.

46. Verlaine, 168–170.

47. Carter, 42–43.

48. Verlaine, 174–175.

49. F.C. St. Aubyn, *Arthur Rimbaud* (Boston: Twayne, 1975), 16–17.

50. Enid Starke, *Arthur Rimbaud* (New York: W.W. Norton, 1947), 81–83.

51. Richardson, 71–74; Carter, 44–45.

52. Enid Rhodes Peschel, *Four French Symbolists: Baudelaire, Rimbaud, Verlaine, Mallarmé* (Athens: Ohio University Press, 1981).

53. Verlaine, 180–181.

54. Wallace Fowlie, *Rimbaud* (Chicago: University of Chicago Press, 1965), 26.

55. Peschel, 24.

56. Coulon, 16.

57. Richardson, 76–77.

58. Richardson, 77–81.

59. Conrad, 52.

60. Richardson, 73–86.

61. Carter, 49.

62. "All the Colours of Rimbaud," in *Bottoms Up!*, ed. William B. Ober (Carbondale: Southern Illinois University Press, 1987), 247–248.

63. Adam, 20–24.

64. Richardson, 78–85; Coulon, 94–100.

65. Richardson, 78–85.

66. Richardson, 85–88.

67. Carter, 47.

68. Peschel, 36.

69. Carter, 50–52.

70. Coulon, 94–96.

71. Carter, 51–52.

72. Arthur Rimbaud, *Illuminations and Other Poems*, trans. Louise Varese (New York: 1957), 43.

73. Richardson, 116–119.

74. Richardson, 104; Verlaine, 10–11.

75. Coulon, 44–45.
76. Richardson, 104; Verlaine, 10–11.
77. Coulon, 126–127.
78. Peschel, 6, 20–29.
79. Verlaine, Preface, 11.
80. Coulon, 196–197.
81. Adam, 45–46.
82. Applegate, 12.
83. Adam, 46.
84. Verlaine, Preface, 11–13.
85. Verlaine, 22.
86. Adam, 47; Coulon, 167–169.
87. Coulon, 171–172.
88. Philip Steven, *Paul Verlaine and the Decadence, 1882–90* (Manchester: Manchester University Press, 1975), 173; Peschel, 38.
89. Hanson, 298–299.
90. Peschel, 39.
91. Hanson, 300.
92. Verlaine, 14.
93. Peschel, 39; Adam, 51.
94. Verlaine, 14.
95. Richardson, 242.
96. Richardson, 243–247.
97. Adam, 52.
98. Richardson, 246–247.
99. Coulon, 65.
100. Jerrold Seigel, *Bohemian Paris* (New York: Viking Penguin, 1986), 243.
101. Richardson, 337–354.
102. Seigel, 243.
103. Richardson, 337–354.
104. "Prince of Poets," *Time*, 2 Dec. 1957, 95.
105. "Dangerous Liaison," *Newsweek*, 25 March 1974, 104–105.
106. Mark Longaker, *Contemporary English Literature* (New York: Appleton-Century-Crofts, 1953), 29.
107. Conrad, 36.
108. Conrad, 37.
109. Verlaine, Preface, 13.

110. Conrad, 37.
111. Conrad, 37–38, 41.
112. Conrad, 38.
113. D. Flower and H. Maas, *The Letters of Ernest Dowson* (London: Cassell, 1967), 175.
114. Flower and Maas, 441.
115. Mark Longaker, ed., *The Poems of Ernest Dowson* (Philadelphia: University of Pennsylvania Press, 1968), 33, 175, 441.
116. Thomas Burnett Swann, *Ernest Dowson* (New York: Twayne, 1964), 80–81.
117. Mark Longaker, *Ernest Dowson* (Philadelphia: University of Pennsylvania Press, 1945), 228–229.
118. Longaker, *Ernest Dowson,* 228–229.
119. Longaker, *Ernest Dowson,* 258–259.
120. Conrad, 38.
121. Conrad, 68.
122. Conrad, 69.
123. Conrad, 48.
124. Conrad, 71–72.
125. Seigel, 310–313.
126. Linda Klieger Stillman, *Alfred Jarry* (Boston: Twayne, 1983), 6–15; Seigel, 318–319; Conrad, 72–73.
127. Robert Shattuck, *The Banquet Years* (New York: Random House, 1955), 218–219.
128. Arianna Stassinopoulos Huffington, "Creator and Destroyer," *Atlantic Monthly* 261 (June 1988): 43–46.
129. Rachilde (pseud.), *Alfred Jarry* (Paris: B. Grasset, 1928), 181. Translated by Stillman, 9.
130. Conrad, 74.
131. Stillman, 1.
132. Seigel, 318.
133. Conrad, 73–74.
134. Stillman, Preface.

4. From Van Gogh to Picasso

1. Bett, 7.
2. *The Complete Letters of Vincent van Gogh* (Boston: New York Graphic Society, 1978), vol. 3, 608–609.
3. Frank Elgar, *Van Gogh* (New York: Praeger, 1966), 11–22.
4. *The Complete Letters of Vincent van Gogh,* vol. 1, xxv.

5. Albert J. Lubin, *Stranger on the Earth* (Henry Holt, 1972), 34–36.

6. Elgar, 22–26.

7. Lubin, 37–40.

8. Elgar, 30–33.

9. *The Complete Letters of Vincent van Gogh*, vol. 1, xxxii.

10. *The Complete Letters of Vincent van Gogh*, vol. 1, xxxiii.

11. *The Complete Letters of Vincent van Gogh*, vol. 1, xxxiii.

12. Wilfred Niels Arnold, "Vincent van Gogh and the Thujone Connection," *Journal of the American Medical Association* 260 (Nov. 1988): 3042.

13. *The Complete Letters of Vincent van Gogh*, vol. 1, xli.

14. Elgar, 99.

15. *Encyclopedia of World Art* (New York: McGraw-Hill, 1963), vol. 7, 826–828; Arnold, 3042.

16. Barbara Ehrlich White, *Impressionism in Perspective* (Englewood Cliffs, N.J.: Prentice-Hall, 1978), 3–6; Gilbert and McCarter, 490.

17. *Encyclopedia of World Art*, vol. 7, 826, 830, 840, 841.

18. Sir Lawrence Gowing, ed. *A History of Art* (Englewood Cliffs, N.J.: Prentice-Hall, 1983), vol. 1, 801.

19. Bennett Schiff, "Triumph and Tragedy in the Land of 'Blue Tones and Gay Colors,'" *Smithsonian* 15 (Oct. 1984), 80–81.

20. Arnold, "Absinthe," 114.

21. *The Complete Letters of Vincent van Gogh*, vol. 2, 557.

22. *The Complete Letters of Vincent van Gogh*, vol. 3, 63.

23. *The Complete Letters of Vincent van Gogh*, vol. 1, xli.

24. *The Complete Letters of Vincent van Gogh*, vol. 1, xli–xlii.

25. Conrad, 61.

26. Schiff, 78.

27. Humberto Nagera, *Vincent van Gogh: A Psychological Study* (New York: International University Press, 1967), 105–106.

28. Conrad, 61–64.

29. *The Complete Letters of Vincent van Gogh*, vol. 3, 76.

30. Conrad, 61–62.

31. Nagera, 105–106.

32. Arnold, "Vincent van Gogh and the Thujone Connection": 3042.

33. Rita Gilbert and William McCarter, *Living with Art*, 2d ed. (New York: Alfred A. Knopf, 1988), 424; H.W. Janson, *History of Art*, 3d ed. (New York: Harry N. Abrams, 1986), 645.

34. Lawrence and Elizabeth Hanson, *Noble Savage: The Life of Paul Gauguin* (New York: Random House, 1954), 133–134.

35. Robet Wernick, "Opening the Door to the Art of the 20th Century," *Smithsonian*, 19 (May 1988): 62.

36. Hanson, 135–141.

37. Wernick, 60.

38. Hanson, 140.

39. Schiff, 81; Elgar, 164.

40. *The Complete Letters of Vincent van Gogh*, vol. 3, 2.

41. *The Complete Letters of Vincent van Gogh*, vol. 3, 28–29.

42. *The Complete Letters of Vincent van Gogh*, vol. 3, 31; Schiff, 82–84.

43. David G. Wilkins and Bernard Schultz, *Art Past, Art Present* (New York: Harry N. Abrams, 1990), 424.

44. Wilkins and Schultz, 424.

45. *The Complete Letters of Vincent van Gogh*, vol. 3, 517.

46. Elgar, 164.

47. Conrad, 66; Elgar, 164. *The Arles Cafe* is now in Moscow.

48. Wernick, 63.

49. Wernick, 61–63.

50. *The Complete Letters of Vincent van Gogh*, vol. 1, xlv.

51. Hanson, 143–151.

52. Wilkins and Schultz, 425.

53. Gilbert and McCarter, 424.

54. Conrad, 69.

55. *The Complete Letters of Vincent van Gogh*, vol. 1, xlvi.

56. Elgar, 170–239; Arnold, 3042–3044; Bett, 9.

57. Wilkins and Schultz, 425.

58. Conrad, 67.

59. Wilkins and Schultz, 420–421.

60. Wernick, 61–62.

61. Hanson, 283–284.

62. Schiff, 81.

63. Schiff, 81.

64. Schiff, 81–82.

65. Michelle Osborn, "Van Gogh Fetches $82 Million," *USA Today*, 16 May, 1990, 1.

66. Gowing, vol. 1, 815.

67. Lubin, 188–189.

68. Karl Jaspers, "Van Gogh and Schizophrenia," in *Van Gogh in Perspective*, ed. Bogomila Welsh-Ovcharov (Englewood Cliffs, N.J.: Prentice-Hall, 1974), 99–101.

69. Francoise Minkowska, "Van Gogh as an Epileptic," in *Van Gogh in Perspective*, 102–104. See note 2.

70. Sven Hedenburg, "A Review of Psychiatric Opinion," in *Van Gogh in Perspective*, 106.

71. Minkowska, 102–104.

72. Lubin, 189–190.

73. Lubin, 190.

74. Arnold, "Vincent van Gogh and the Thujone Connection," 3042–3043; Barbara A. MacAdam, "Curse of the Muse," *ARTnews* 88 (March 1989): 17.

75. Arnold, "Vincent van Gogh and the Thujone Connection," 3043–3044.

76. Arnold, "Vincent van Gogh and the Thujone Connection," 3043–3044.

77. *The Complete Letters of Vincent van Gogh*, vol. 3, 116.

78. Arnold, "Vincent van Gogh and the Thujone Connection," 3043–3044.

79. Arnold, "Vincent van Gogh and the Thujone Connection," 3043–3044.

80. Frederick W. Maire, "Van Gogh's Suicide," *Journal of the American American Medical Association* 217 (Aug. 1971): 938–939.

81. "Vincent van Gogh and Glaucoma," *Journal of the American Medical Association* 218 (Oct. 1971): 595–596.

82. Thomas Courtney Lee, "Van Gogh's Vision: Digitalis Intoxication?" *Journal of the American Medical Association* 245 (Feb. 1981): 727–729.

83. *The Complete Letters of Vincent van Gogh*, vol. 1, lviii.

84. Geoffrey James, "The Inner Purpose of Vincent van Gogh," *Maclean's*, 12 Jan. 1987, 46–47.

85. Hamilton, 23; Paolo Lecaldano, ed., *The Complete Paintings of Manet* (New York: Harry N. Abrams, 1967), 88.

86. Gilbert and McCarter, 418.

87. Arnold, "Absinthe," 114.

88. Lecaldano, *The Complete Paintings of Manet*, 88.

89. Hanson, 54; Conrad, 9–11.

90. Hamilton, 22–24.

91. Gilbert and McCarter, 418; Hamilton, 22–24.

92. Hamilton, 9–10.

93. Wilkins and Schultz, 374.

94. Hamilton, 9–16; Wilkins and Schultz, 374.

95. Charles F. Stuckey, "Manet Revised: Whodunit?" *Art in America* 71 (Nov. 1983): 163–164.

96. Hamilton, 51; Gilbert and McCarter, 418.

97. Wilkins and Schultz, 374.

98. Germain Bazin, *A History of Art* (New York: Bonanza Books, 1959), 382–383.

99. Janson, 13–14; Gilbert and McCarter, 418.

100. John Rewald, *The History of Impressionism* (New York: Museum of Modern Art, 1973), 197–198.

101. Novelene Ross, *Manet's Bar at the Folies-Bergere* (Ann Arbor, Mich.: UMI Research Press, 1980), 1–2.

102. Janson, 621–622.

103. Ross, 1–6.

104. Larry L. Ligo, *"Baudelaire's Mistress Reclining* and *Young Woman Reclining in Spanish Costume*: Manet's Pendant Portraits of His Acknowledged 'Mistresses,' Baudelairian Aesthetics and Photography," *Arts Magazine* 62 (Jan. 88): 77–79.

105. William Feaver, "What Makes Manet Modern?" *ARTnews* 82 (Dec. 1983): 59.

106. John House, "Seeing Manet Whole," *Art in America* 71 (Nov. 1983): 185.

107. House, 185.

108. Gilbert and McCarter, 227.

109. Bernard S. Myers, ed., *McGraw-Hill Dictionary of Art* (New York: McGraw-Hill, 1969), vol. 2, 213.

110. Wilkins and Schultz, 384–385.

111. Arnold, "Absinthe," 114; Janson, 605–606.

112. Myers, vol. 2, 214–215.

113. Sue Welsh Reed, "Music in the Air," *ARTnews* 83 (Dec. 1984): 108.

114. Reed, 108.

115. Reed, 110.

116. Ronald Pickvance, *"L'Absinthe* in England," *Apollo* 77 (May 1963): 395.

117. Janson, 662.

118. Pickvance, 395.

119. Pickvance, 396.

120. Ross, 70.

121. Pickvance, 396.

122. Pickvance, 396.

123. Pickvance, 396.

124. Pickvance, 396.

125. Pickvance, 396.

126. Pickvance, 396.

127. Pickvance, 396.

128. Pickvance, 396.

129. Pickvance, 396.

130. Pickvance, 396.

131. Pickvance, 398.

132. Pickvance, 398.

133. Pickvance, 398.

134. Israel Shenker, "A Painter with Heart, in the Guise of a Misanthrope," *Smithsonian* 19 (May 1988): 66.

135. Myers, vol. 4, 470; *Praeger Encyclopedia of Art*, vol. 4 (New York: Praeger, 1971), 1652; *New Standard Encyclopedia of Art* (New York: Garden City Pub. Co., 1939), 289.

136. Arnold, "Absinthe," 114.

137. *The New Encyclopaedia Britannica*, 1911 ed.; *Collier's Encyclopedia*, 1987 ed.

138. Gilbert and McCarter, 28.

139. Jan Polasek, *Toulouse-Lautrec: Drawings* (New York: St. Martin's Press, 1975), 5–6.

140. Charles F. Stuckey, *Toulouse-Lautrec: Paintings* (Chicago: Art Institute of Chicago, 1979), 18.

141. Gilbert and McCarter, 28.

142. Gilbert and McCarter, 28.

143. Stuckey, *Toulouse-Lautrec: Paintings*, 18.

144. John Rewald, *Post-Impressionism* (New York: Museum of Modern Art, 1978) 3d. ed., 28–29.

145. Rewald, *Post-Impressionism*, 28–29.

146. Gilbert and McCarter, 28.

147. Polasek, 28–32.

148. Seigel, 230–231.

149. Polasek, 28–32.

150. *Collier's Encyclopedia*, 1987 ed.

151. Conrad, 55.

152. Nadelson, 62; Conrad, 55.

153. D.C. Rich, "Au Moulin Rouge," *Bulletin of the Art Institute of Chicago*, 23 (Feb. 1929): 15.

154. Rich, 14–15.

155. Janson, 657.

156. Conrad, 55–58.

157. Gilbert and McCarter, 28.

158. Stuckey, *Toulouse-Lautrec: Paintings*, 71.

159. Conrad, 55.

160. Sheldon Cheney, *A New World History of Art* (New York: Viking Press, 1956), 607–608.

161. Gilbert and McCarter, 28.

162. Conrad, 75.

163. Adams, 30–33.

164. Gilbert and McCarter, 42.

165. Conrad, 76.

166. Roland Penrose, *Portrait of Picasso* (New York: Museum of Modern Art, 1957), 26–27.

167. Milton S. Fox, ed. *Picasso: Fifty-Five Years of His Graphic Work* (New York: Harry N. Abrams, 1965), vii.

168. Fox, vii–viii.

169. Fox, viii.

170. Alfred H. Barr, Jr., *Picasso: Fifty Years of His Art* (New York: Museum of Modern Art, 1946), 19.

171. Huffington, 39.

172. Barr, 22–23.

173. Conrad, 76.

174. Barr, 22.

175. Gilbert and McCarter, 42.

176. Barr, 22.

177. Lael Wertenbaker, *The World of Picasso* (New York: Time, 1967), 40–44.

178. Brooks Adams, "Picasso's Absinth Glasses: Six Drinks to the End of an Era," *Artforum* 18 (1980): 31.

179. Conrad, 78–79.

180. Huffington, 39.

181. Adams, 31; Conrad, 80.

182. Adams, 31.

183. Conrad, 79.

184. Conrad, 79–80.

185. Conrad, 79. Quoted from J.V. Laborde, "Rapport au nom de la commission de l'alcoolisme sur les boissons spiritueuses, apéritifs et leurs essences et produits composant les plus dangereaux," *Bulletin de l'Académie de Médecine*, no. 48 (1902): 685–712.

186. Conrad, 81–82.

187. Adams, 31.

188. Werner Spies, *Sculpture by Picasso* (New York: Harry N. Abrams, 1971), 48–50.

189. Adams, 31.

190. Adams, 31–32.

191. Adams, 32.

192. Adams, 32.

193. Adams, 33.

194. Adams, 33.

195. Adams, 33.

196. Conrad, 83.

197. Conrad, 22, 31, 34, 35, 39, 40, 62.

5. New Orleans and Elsewhere in the United States

1. These words by Glenn MacDonough were set to music by Victor Herbert.

2. "'The Green Curse' in the United States," 1035.

3. Conrad, 99; Kenyon, 246.

4. Arthur, 34.

5. *Monthly Catalog of U.S. Government Publications*, July 1912, 6. Food Inspection Decision 147; *Magic and Medicine of Plants*, 348.

6. Nathaniel Cortlandt Curtis, *New Orleans: Its Old Houses, Shops, and Public Buildings* (Philadelphia: J.B. Lippincott, 1933), 21.

7. Leonard Victor Huber, *New Orleans: A Pictorial History* (New York: Crown, 1917), 6.

8. Joe Gray Taylor, *Louisiana* (New York: Teacher's College Press, 1966), 10–11.

9. Lura Robinson, *It's an Old New Orleans Custom* (New York: Bonanza Books, 1948), 196–198.

10. *World Book Encyclopedia*, 1963 ed.

11. Liliane Crete, *Daily Life in Louisiana: 1815–1830* (Baton Rouge: Louisiana State University, 1978), 194.

12. Robinson, 196–198.

13. Robinson, 212.

14. Albert E. Fossier, *New Orleans, the Glamour Period, 1800–1840* (New Orleans: Pelican, 1957), 381.

15. Crete, 71.

16. Hodding Carter, ed., *The Past as Prelude: New Orleans, 1718–1968* (New Orleans: Tulane University Press, 1968), 235–236.

17. Crete, 69, 39.

18. Crete, 71.

19. Huber, 1.

20. Huber, 7.

21. Fossier, 390–391.

22. Fossier, 390–391.

23. Harold Sinclair, *The Port of New Orleans* (New York: Doubleday, Doran, 1942), 182–143.

24. Robinson, 204.

25. Huber, 244.

26. Huber, 208.

27. Carter, 236.

28. Huber, 208–211.

29. Huber, 208–211.

30. Carter, 236–237.

31. Huber, 208–211.

32. Carter, 237–240.

33. Sinclair, 182–183.

34. Sinclair, 187–188.

35. Sinclair, 188, 194, 216, 293.

36. *World Book Encyclopedia*, 1963 ed.

37. Taylor, 12.

38. *World Book Encyclopedia,* 1963 ed.

39. Taylor, 12.

40. *Encyclopedia Americana,* 1989 ed.; Sinclair, 293.

41. Taylor, 12.

42. Sinclair, 188.

43. Robinson, Introductory quote.

44. Robinson, 226–227.

45. Taylor, 18–24; Sinclair, 292–326.

46. Huber, 168, 180, 306.

47. Carter, 157–158.

48. Shenker, 60.

49. "Absinthe House Padlocked; Once Haunt of Jean Lafitte," *New York Times,* 6 Nov. 1926, 1.

50. Herbert Asbury, *The French Quarter* (New York: Alfred A. Knopf, 1936), 135–136.

51. *New Orleans City Guide* (Boston: Houghton-Mifflin, 1938), 233–234. Written and compiled by the Federal Writers' Project of the Works Progress Administration for the City of New Orleans.

52. Arthur, 34–35.

53. "New Orleans: Old Absinthe House," advertisement; "Padlocked After Century," *New Orleans-Picayune,* 21 Nov. 1926.

54. Arthur, 35–36.

55. Arthur, 36; "Padlocked After Century."

56. Huber, 125–126, 206.

57. Arthur, 37.

58. Letter, Collin B. Hamer, Librarian, City of New Orleans, Public Library, to Doris Lanier, 9 July 1986.

59. Robinson, 204.

60. Iglehart, 193–200.

61. John Magill, "Welcome Old Man Gloom," *Historic New Orleans Collection Newspaper* 6, no. 3 (Summer 1988): 6–7.

62. Magill, 6.

63. John R. Kemp, *Martin Behrman of New Orleans: Memoirs of a City Boss* (Baton Rouge: Louisiana State University, 1977), xi, 154–155.

64. Louis Andrew Vyhnanek, *The Seamier Side of Life: Criminal Activity in New Orleans During the 1920s.* A dissertation written at Louisiana State University and Agricultural and Mechanical College, 1979.

65. Magill, 6.

66. Vyhnanek, 79.

67. Vyhnanek, 101–102.

68. Magill, 6.

69. Vyhnanek, 226–274.

70. Magill, 7.

71. Magill, 7.

72. Elizabeth Anderson and Gerald R. Kelly, *Miss Elizabeth: A Memoir* (Boston: Little, Brown, 1969), 80–88.

73. Anderson and Kelly, 80–88.

74. Anderson and Kelly, 90–91.

75. Anderson and Kelly, 90–91.

76. Magill, 7.

77. "Absinthe House Padlocked," *New York Times,* 20 May 1925, 29.

78. "Absinthe House Padlocked; Once Haunt of Jean Lafitte," 1.

79. "Padlocked After Century," 21 Nov. 1926.

80. "Many Famous Clubs Victims of Dry Agents," *The New Orleans Item,* 10 December 1926, 8.

81. "Old Absinthe House Bar Gets New Lock," *The Morning Tribune,* 3 Oct. 1929, 1.

82. Magill, 7.

83. Kenyon, 249.

84. Ferdinand C. Iglehart, *King Alcohol Dethroned* (New York: Christian Herald Bible House, 1917), 77–80.

85. Iglehart, 73–77.

86. Conrad, 98.

87. Dwight Thomas and David K. Jackson, *The Poe Log: A Documentary Life of Edgar Allan Poe, 1809–1849* (Boston: G.K. Hall, 1987) xxxvii–xxxviii.

88. Thomas and Jackson, 14.

89. Thomas and Jackson, xivii, 125, 167.

90. *National Cyclopedia of American Biography* (New York: James T. White and Co., 1898), vol. 1, 463.

91. Thomas and Jackson, xliii.

92. Thomas and Jackson, 171–172.

93. Thomas and Jackson, 242.

94. Thomas and Jackson, 248.

95. Thomas and Jackson, 263.

96. Thomas and Jackson, 322.

97. Thomas and Jackson, 358.

98. Thomas and Jackson, 370–371, 403–408.

99. Thomas and Jackson, xiviii.

100. Thomas and Jackson, 878.

101. Thomas and Jackson, 818–819.

102. Thomas and Jackson, 844–850.

103. Walker, 569.

104. Jack London, *John Barleycorn*, 181.

105. John Perry, *Jack London: An American Myth* (Chicago: Nelson-Hall, 1981), 254–255; 300–301.

106. Geoffrey Wolff, *Black Sun* (New York: Random House, 1976), 54.

107. Wolff, 59, 134.

108. Wolff, 134.

109. Wolff, 139.

110. Wolff, 140.

111. Wolff, 163.

112. Wolff, 164–165.

113. Edward Germain, ed. *Shadows of the Sun: The Diaries of Harry Crosby* (Santa Barbara, Calif.: Black Sparrow Press, 1977), 109, 128, 129, 141, 143, 165, 167, 177. There are also numerous other references to opium.

114. Wolff, 162–163.

115. Germain, 91, 112, 116, 151, 298.

116. Conrad, 143.

117. Wolff, 164–165.

118. Conrad, 137–138.

119. Ernest Hemingway, *For Whom the Bell Tolls* (New York: Scribner's, 1968), 55.

120. Hemingway, *To Have and To Have Not* (New York: Scribner's, 1937), 194.

121. Hemingway, *The Sun Also Rises* (New York: Scribner's, 1954), 222–223.

122. Hemingway, *For Whom the Bell Tolls* (New York: Scribner's, 1968), 51.

123. "France Strikes Back at Her Green Destroyer—Absinthe!" *The San Francisco Sunday Call*, 16 Aug. 1908, 8.

124. "Absinthe Barred Out, " *San Francisco Call*, 3 Oct. 1912, 4.

125. "Absinthe Imported as Berry 'Cordial,'" *San Francisco Examiner*, 19 Dec. 1915, 42.

126. "Caesar's Grill Owner Jailed," *San Francisco Examiner*, 7 Dec. 1917, 5.

127. "Absinthe Is Seized at Club," *San Francisco Examiner*, 16 Feb. 1923, 15.

128. Conrad, 99.

129. Poster Collection, Prints and Photographs Division, Library of Congress.

130. Morrow, William Chambers. "Over an Absinthe Bottle." Reprinted from *The Ape, the Idiot, and Other People* (Philadelphia: J.B. Lippincott, 1897).

Conclusion

1. Marrus, 116.

2. Prestwich, 307.

3. Coulson Kernahan, "Two Absinthe-Minded Beggars," *Chambers's Journal* 20 (June 1921), 452.

4. Kernahan, 452.

5. Isaac Ott, M.D., "The Seat of Absinthic Epilepsy," *The Journal of Nervous and Mental Disease* 19 (1892): 696–698.

6. Walker, 568–572.

7. Helen C. Coombs, Bernard Wortis, and Frank H. Pike, "The Effects of Absinth on the Cat, Following Bilateral Adrenalectomy," *Bulletin of the Neurological Institute of New York* 1 (1931): 145–151.

8. Arnold, "Absinthe," 117.

BIBLIOGRAPHY

"Absinthe." *The London Times,* 8 June 1914, 29.

"Absinthe Barred Out." *San Francisco Call,* 3 Oct. 1912, 4.

"Absinthe House Padlocked." *New York Times,* 20 May 1925, 29.

"Absinthe House Padlocked; Once Haunt of Jean Lafitte." *New York Times,* 6 Nov. 1926, 1.

"Absinthe Imported as Berry 'Cordial.'" *San Francisco Examiner,* 19 Dec. 1915, 42.

"Absinthe Is Seized at Club." *San Francisco Examiner,* 16 Feb. 1923, 15.

Achtemeier, Paul. *Harper's Bible Dictionary.* New York: Harper and Row, 1985.

Adam, Antoine. *The Art of Paul Verlaine.* Translated by Carl Morse. New York: New York University Press, 1963.

Adams, Brooks. "Picasso's Absinth Glasses: Six Drinks to the End of an Era." *Artforum* 18 (1980): 30–33.

"Alcohol Drinking Doubles in France." *New York Times,* 23 July 1925, 4.

"All the Colours of Rimbaud." In *Bottoms Up!,* ed. William B. Ober. Carbondale: Southern Illinois University Press, 1987, 221–261.

Anderson, Elizabeth, and Gerald R. Kelly. *Miss Elizabeth: A Memoir.* Boston: Little, Brown, 1969.

Anderson, Frank J. *An Illustrated History of the Herbals.* New York: Columbia University Press, 1977.

Anet, H. "The War Against Absinthe on the Continent." *Economic Review* 17 (April 1907): 189–192.

Applegate, Bergen. *Verlaine: His Absinthe-Tinted Song.* Chicago: Alderbrink Press, 1916.

Arnold, Wilfred Niels. "Absinthe." *Scientific American* 260 (June 1989): 112–117.

_____. "Vincent van Gogh and the Thujone Connection." *Journal of the American Medical Association* 260 (Nov. 1988): 3042–3044.

Arthur, Stanley Clisby. *Famous New Orleans Drinks and How to Mix 'Em.* Gretna, Louisiana: Pelican, 1977.

Asbury, Herbert. *The French Quarter.* New York: Alfred A. Knopf, 1936.

Balesta, H. *Absinthe et absintheurs.* Paris: Marpon, 1860.

Barr, Alfred H., Jr. *Picasso: Fifty Years of His Art.* New York: Museum of Modern Art, 1946.

Barrows, Susanna. "After the Commune: Alcoholism, Temperance, and Literature in the Early Third Republic." In *Consciousness and Class Experience in Nineteenth-Century Europe.* Edited by John M. Merriman. New York: Holmes and Meier, 1979, 205–218.

Bazin, Germain. *A History of Art.* New York: Bonanza Books, 1959.

Bernier, George. *Paris Cafes.* New York: Wildenstein, 1985.

Bett, W.R. "Vincent van Gogh (1853–90): Artist and Addict." *The British Journal of Addiction* 51 (April 1954): 7–14.

Brasher, M.D. "Notes, Comments, and Abstracts: Absinthe and Absinthe Drinking in England." *The Lancet,* April 26, 1930: 944–946.

Bridaham, Lester Burbank, ed. *New Orleans and Bayou Country.* Barre, Mass.: Barre Publ., 1972.

Brodhead, J. Napier. "Present Crisis in France." *The Nation* 84 (June 1907): 587.

Cadeac, C. et Meunier A. *Recherches experimentales sur les essences. Contribution a l'etude de l'alcoolisme.* Paris: Asselin et Houzeau, 1892.

"Caesar's Grill Owner Jailed." *San Francisco Examiner,* 7 Dec. 1917, 5.

Caffin, Charles H. "Jules Adler, Painter of Labor." *Harper's Monthly* 120 (March 1910): 583–592.

"Can the Allies Endure the Strain of Total Abstinence from Alcohol?" *Current Opinion* 58 (June 1915): 418.

Carter, A.E. *Verlaine.* New York: Twayne, 1971.

Carter, Hodding, ed. *The Past as Prelude: New Orleans, 1718–1968.* New Orleans: Pelican Pub. Co., 1968.

Castelot, A. *Histoires a table.* Plon, 1972.

"The Charms of Absinthe." *New York Times,* 19 Oct. 1884, 5.

Cheney, Sheldon. *A New World History of Art.* New York: Viking Press, 1956.

The Complete Letters of Vincent van Gogh. Boston: New York Graphic Society, 1978, Vols. 1 and 3.

Conrad, Barnaby, III. *Absinthe: History in a Bottle.* San Francisco: Chronicle Books, 1988.

Coombs, Helen C., Bernard Wortis, and Frank H. Pike. "The Effects of Absinth on the Cat, Following Bilateral Adrenalectomy." *Bulletin of the Neurological Institute of New York* 1 (1931): 145–151.

Corelli, Marie. *Wormwood.* London: Methuen, 1897.

Corning, M.D., J. Leonard. "The Efficacy of Wormwood (Artemisia Absinthium) in Certain Conditions of the Cerebrospinal Axis." *Medical Record,* 25 Jan. 1890, 88–89.

Couleau, E. *Au pays de l'absinthe y est-on plus fou ou plus criminel qu'ail'leurs?* Paris: Riviere, 1908, 246p.

Coulon, Marcel. *Poet Under Saturn: The Tragedy of Verlaine.* Translated by Edgell Rickword. New York: Kennikat Press, 1970.

Crete, Liliane. *Daily Life in Louisiana: 1815–1830.* Baton Rouge: Louisiana State University Press, 1978.

Curtis, Nathaniel Cortlandt. *New Orleans: Its Old Houses, Shops, and Public Buildings.* Philadelphia: J.B. Lippincott, 1933.

"Dangerous Liaison." *Newsweek,* 25 March 1974, 104–105.

Delahaye, Marie-Claude. *L'Absinthe, Art et Histoire.* Trame Way, 1990.

_____. *L'Absinthe: Histoire de la Fée Verte.* Paris: Berger-Levrault, 1983.

Dewey, Stoddard. "News-Making Against France—The Question of Absinthe—The Anarchists." *Nation* 101 (Aug. 1915): 223–224.

Didot-Bottin. *Annuaires Almanach du Commerce,* Paris et Province, 1820 a 1920.

Droz, G. *Feu ... l'absinthe.* Moutier: Prevote, 1973, 103p.

Elgar, Frank. *Van Gogh.* New York: Praeger, 1986.

Emboden, William A. "Absinthe, Absintheurs, and Absinthism." *Terra* 21 (Spring 1983): 13–16.

Encyclopedia of World Art. New York: McGraw-Hill, 1963. Vol. 7.

Feaver, William. "What Makes Manet Modern?" *ARTnews* 82 (Dec. 1983): 54–59.

"Fight on Absinthe Renewed in France." *New York Times,* 9 Sept. 1925, 27.

Fisher, Arthur, "Absinthe Makes the Heart Grow Fonder." *Popular Science* 219 (Oct. 1981): 26.

Flower, D., and H. Maas. *The Letters of Ernest Dowson.* London: Cassell and Co., 1967.

Fossier, Albert E. *New Orleans: The Glamour Period, 1800–1840.* New Orleans: Pelican Pub. Co., 1957.

Fowlie, Wallace. *Rimbaud.* Chicago: University of Chicago Press, 1965.

Fox, Milton S., ed. *Picasso: Fifty-Five Years of His Graphic Work.* New York: Harry N. Abrams, 1965. Vols. 7 and 8.

"France Banishing Absinth." *Literary Digest* 50 (May 1915): 1084–1085.

"France Grappling with the Drink Problem." *Catholic World* 61 (June 1895): 421–422.

"France Strikes Back at Her Green Destroyer—Absinthe!" *San Francisco Sunday Call,* 16 Aug. 1908, 8.

"From French and German Pulpits." *Literary Digest,* 50 (May 1915): 1086.

Fye, Rodney Wayne. *Absinthe and Wormwood.* Thesis, San Francisco State College, 1954. A creative work.

Germain, Edward, ed. *Shadows of the Sun: The Diaries of Harry Crosby.* Santa Barbara, Calif.: Black Sparrow Press, 1977.

Gilbert, Rita, and William McCarter. *Living with Art.* 2d ed. New York: Alfred A. Knopf, 1988.

Gowing, Sir Lawrence, ed. *A History of Art.* Englewood Cliffs, N.J.: Prentice-Hall, 1983. Vol. 1.

Le Grande Dictionnaire de XIXe siècle. Paris: 1875.

"'The Green Curse' in the United States." *Harper's Weekly,* 13 July 1907, 1035.

Guyot, Y. *L'absinthe et le delire persecuteur,* Paris, 1907.

Hamilton, George Heard. *Manet and His Critics.* New Haven: Yale University Press, 1954.

Hanson, Anne Coffin. *Manet and the Modern Tradition.* New Haven: Yale University Press, 1977.

Hanson, Lawrence, and Elizabeth Hanson. *Noble Savage: The Life of Paul Gauguin.* New York: Random House, 1954.

_____. *Verlaine, Fool of God.* New York: Random House, 1957.

Hedenburg, Sven. "A Review of Psychiatric Opinion." In *Van Gogh in Perspective,* Ed. Bogomila Welsh-Ovcharov. Englewood Cliffs, N.J.: Prentice-Hall, 1974, 106.

Heilig, Sterling. "Absinthe Drinking." *Atlanta Constitution,* 19 Aug. 1894, 6.

Hemingway, Ernest. *For Whom the Bell Tolls.* New York: Scribner's, 1968.

_____. *The Sun Also Rises.* New York: Scribner's, 1954.

_____. *To Have and To Have Not.* New York: Scribner's, 1954.

Hirschman, Ada E., and Ronald K. Siegel. "Absinthe and the Socialization of Abuse: A Historical Note and Translation." *Social Pharmacology* I (1987): 1–12.

Hooper, Lucy H. "Parisian Maniacs and Madhouses." *Lippincott's* 21 (June 1878): 761–764.

House, John. "Seeing Manet Whole." *Art in America* 71 (Nov. 1983): 178–187.

Huber, Leonard Victor. *New Orleans: A Pictorial History.* New York: Crown, 1917.

Huffington, Arianna Stassinopoulas. "Creator and Destroyer." *Atlantic Monthly* 261 (June 1988): 37–78.

Iglehart, Ferdinand C. *King Alcohol Dethroned.* New York: Christian Bible House, 1917.

"Imitation Absinthe to Go." *New York Times,* 27 October 1922, 29.

Jacquet, L. "La lutte contre l'absinthe," dans la *Societe Medicale des Hopitaux,* Paris, 1906.

James, Geoffrey. "The Inner Purpose of Vincent van Gogh." *Maclean's* 12 Jan. 1987, 46–47.

Janson, H.W. *History of Art.* 3d ed. New York: Harry N. Abrams, 1986.

Jaspers, Karl. "Van Gogh and Schizophrenia." In *Van Gogh in Perspective.* Ed. Bogomila Welsh-Ovcharov. Englewood Cliffs, N.J.: Prentice-Hall, 1974, 99–101.

Keith, H.M. et G.W. Stavraky, "Convulsions experimentales induites par administration de thuyone," dans *Archives of Neurology and Psychiatry,* no. 34, 1935, 1022–1040.

Kemp, John R. *Martin Behrman of New Orleans: Memoirs of a City Boss.* Baton Rouge: Louisiana State University Press, 1977.

Kenyon, Michael. "A Bottle of Absinthe." *Gourmet* (Oct. 1990): 144, 245–250.

Kernahan, Coulson. "Two Absinthe-Minded Beggars." *Chambers's Journal* 20 (June 1930): 451–454.

Laborde, J.V. "Rapport au nom de la commission de l'alcoolisme sur les boissons spiritueuses, apéritifs et leurs essences et produits composant les plus dangereaux." *Bulletin de l'Académie de Médecine,* no. 48 (1902): 685–712.

Lalouette, J. "Les debits de boissons urbains entre 1880 et 1914," dans *Ethnologie francaise,* no. 12, Berger-Levrault, 1982, 131–135.

Lecaldano, Paola, ed. *The Complete Paintings of Manet.* New York: Harry N. Abrams, 1967.

Ledoux, E. *L'Absinthe et l'absinthisme,* Besancon, 1908, 31.

Lee, Thomas Courtney. "Van Gogh's Vision: Digitalis Intoxication?" *Journal of the American Medical Association* 245 (Feb. 1981): 727–729.

Lepelletier, Edmond. *Paul Verlaine.* Translated by E.M. Lang. New York: AMS Press, 1970.

Ligo, Larry L. "*Baudelaire's Mistress Reclining* and *Young Woman Reclining in Spanish Costume:* Manet's Pendant Portraits of His Acknowledged 'Mistresses,' Baudelairian Aesthetics and Photography." *Arts Magazine* 62 (Jan. 1988): 76–85.

London, Jack. *John Barleycorn.* Cambridge: Robert Bentley, Inc., 1964.

London Times. 8 June 1914, 29.

Longaker, Mark. *Contemporary English Literature.* New York: Appleton-Century-Crofts, 1953.

––––––––. *Ernest Dowson.* Philadelphia: University of Pennsylvania Press, 1945.

––––––––, ed. *The Poems of Ernest Dowson.* Philadelphia: University of Pennsylvania Press, 1968.

Lubin, Albert J. *Stranger on the Earth.* Henry Holt, 1972.

MacAdam, Barbara A. "Curse of the Muse." *ARTnews* 88 (March 1989): 17.

Magic and Medicine of Plants. New York: Reader's Digest, Inc., 1986.

Magill, John. "Welcome Old Man Gloom." *The Historic New Orleans Collection Newsletter* 6 (Summer 1988): 6–7.

Maire, Frederick W. "Van Gogh's Suicide." *Journal of American Medical Association* 217 (Aug. 1971): 938–939.

"Many Famous Clubs Victims of Dry Agents." *New Orleans Item,* 10 Dec. 1926, 8.

Mariani, John F. *The Dictionary of American Food and Drink.* New York: Ticknor and Fields, 1983.

Marrus, Michael R. "Social Drinking in the *Belle Epoque.*" *Journal of Social History* (Winter 1974): 115–141.

Mew, James, and John Ashton. *Drinks of the World.* London: Leadenhall Press, 1892. Republished by Gryphon Books, Ann Arbor, Mich., 1971.

Minkowska, Francoise. "Van Gogh as an Epileptic." In *Van Gogh in Perspective,* Ed. Bogomila Welsh-Ovcharov. Englewood Cliffs, N.J.: Prentice-Hall, 1974, 102–104.

Monod, W. *Un probleme moral: l'alcoolisme,* Paris, 1902, 5.

Montaigne, Michael De. *Complete Works.* Edited by William Hazlitt. New York: Worthington Co., 1889.

Monthly Catalog of U.S. Government Publications. July 1912, 6. Food Inspection Decision 147.

Morrow, William Chambers. "Over an Absinthe Bottle." Reprinted from *The Ape, the Idiot, and Other People.* Philadelphia: J.B. Lippincott, 1897.

Moses, Jerome. *Factors Affecting Artemisia Absinthium Control.* Thesis, North Dakota State University, 1985.

Myers, Bernard S., ed. *McGraw-Hill Dictionary of Art.* New York: McGraw-Hill, 1969. Vol. 2.

Nadelson, Regina. "The Sweet Taste of Decadence." *Metropolitan Home,* Nov. 1982, 62–67.

National Cyclopedia of American Biography. New York: James T. White and Co., 1898.

New Encyclopaedia Britannica. 1911 ed.

New Orleans City Guide. Boston: Houghton-Mifflin Co., 1938. Written and compiled by the Federal Writers' Project of the Works Progress Administration for the City of New Orleans.

"New Orleans: Old Absinthe House," advertisement.

New Standard Encyclopedia of Art. New York: Garden City Pub. Co., 1939.

New York Times, 14 Oct. 1879, 4; Dec. 1880, 5 and 6; 14 Oct. 1879, 4; 12 Nov. 1922, sec. IV, 3.

Novotny, Fritz. *Toulouse-Lautrec.* New York: Crown Publishers, 1983.

"Old Absinthe Bar Gets New Lock." *Morning Tribune,* 3 Oct. 1929, 1.

Osborn, Michelle. "Van Gogh Fetches $82 Million." *USA Today,* 16 May 1990, 1.

Ott, M.D., Isaac. "The Seat of Absinthic Epilepsy." *Journal of Nervous and Mental Disease* 19 (1892): 696–698.

"Padlocked After Century." *New Orleans-Picayune,* Nov. 21, 1926. N.P.

Pagnol, M. *Le temps de secrets,* 1977.

"Paris Cafes Sell Absinthe." *New York Times,* 9 April 1920, 16.

Penrose, Roland. *Portrait of Picasso.* New York: Museum of Modern Art, 1957.

Perry, John. *Jack London: An American Myth.* Chicago: Nelson Hall, 1981.

Peschel, Enid Rhodes. *Four French Symbolists: Baudelaire, Rimbaud, Verlaine, Mallarmé.* Athens: Ohio University Press, 1981.

Pickvance, Ronald. "*L'Absinthe* in England." *Apollo* 77 (May 1963): 395–398.

Pliny. *Natural History.* Translated by W.H.S. Jones. Cambridge, Mass.: Harvard University Press, 1969. Bk. XX, Vol. VI.

Polasek, Jan. *Toulouse-Lautrec: Drawings.* New York: St. Martin's Press, 1975.

Praeger Encyclopedia of Art. New York: Praeger, 1971. Vol. 4.

Prestwich, P.E. "Temperance in France: The Curious Case of Absinth." In *Historical Reflections* (Canada) 6 (1979): 301–319.

"Prince of Poets." *Time,* 2 Dec. 1957, 95–96.

Rachilde (pseud.). *Alfred Jarry.* Paris: B. Grasset, 1928.

Reed, Sue Welsh. "Music in the Air." *ARTnews* 83 (Dec. 1984): 108–113.

"Revolt of France's Wine Growers." *Harper's Weekly* 51 (Jan. 1929): 962.

Rewald, John. *The History of Impressionism.* New York: Museum of Modern Art, 1973.
_____. *Post-Impressionism.* New York: Museum of Modern Art, 1978.

Rich, D.C. "Au Moulin Rouge." *Bulletin of the Art Institute of Chicago,* 23 (Feb. 1929): 15.

Richardson, Joanna. *Verlaine.* New York: Viking Press, 1971.

Rimbaud, Arthur. *Illuminations and Other Poems.* Trans. Louise Varese. New York: 1957.

Ripley, Eliza. *Social Life in New Orleans.* New York: D. Appleton, 1912.

Robinson, Lura. *It's an Old New Orleans Custom.* New York: Bonanza Books, 1948.

Rosengarten, Frederic, Jr. *The Book of Spices.* Wynnewood, Penn.: Livingston Publishing Co., 1969.

Bibliography

Ross, Novelene. *Manet's Bar at the Folies-Bergere.* Ann Arbor, Mich.: UMI Research Press, 1980.

Rudorff, R. *Belle Epoque.* London: Hamish Hamilton, 1972.

St. Aubyn, F.C. *Arthur Rimbaud.* New York: W.W. Norton, 1947.

Saintsbury, George. *Notes on a Cellar-Book.* London: Macmillan, 1963.

Schiff, Bennett. "Triumph and Tragedy in the Land of 'Blue Tones and Gay Colors.'" *Smithsonian* 15 (Oct. 1984): 76–87+.

"Science Watch: Van Gogh's Hallucinations." *New York Times,* 7 July 1981, C2.

Seigel, Jerrold. *Bohemian Paris.* New York: Viking Penguin, 1986.

Shattuck, Robert. *The Banquet Years.* New York: Random House, 1955.

Shenker, Israel. "A Painter with Heart, in the Guise of a Misanthrope." *Smithsonian* 19 (May 1988): 58–63+.

Sinclair, Harold. *The Port of New Orleans.* New York: Doubleday, Doran, 1942.

Soltau, W. "The Drinking of Absinthe." *London Times,* 12 Aug. 1907, 16.

Starke, Enid. *Arthur Rimbaud.* New York: W.W. Norton, 1947.

Stephan, Philip. *Paul Verlaine and the Decadence, 1882–90.* Manchester: Manchester University Press, 1975.

Stillman, Linda Klieger. *Alfred Jarry.* Boston: Twayne, 1983.

Stuckey, Charles F. "Manet Revised: Whodunit?" *Art in America* 71 (Nov. 1983): 158–177, 239–241.

_____. *Toulouse-Lautrec: Paintings.* Chicago: Art Institute of Chicago, 1979.

Swann, Thomas Burnett. *Ernest Dowson.* New York: Twayne, 1964.

Taylor, Joe Gray. *Louisiana.* New York: Teacher's College Press, 1966.

Thomas, Dwight, and David K. Jackson. *The Poe Log: A Documentary Life of Edgar Allan Poe, 1809–1849.* Boston: G.K. Hall, 1987.

Tissot, D.R. *Encore la verte.* Brochure, La Chaux-de-Fonds, 1908.

Turner, H.E. "The Clinic: The Shaky Case Against Absinthe." *American Mercury* (May 1935): 103–105.

"Urges Ban on Absinthe." *New York Times,* 25 Apr. 1930, 6.

Varenne, E., et L. Godefroy. *Etude su l'absinthe.* Brochure, Paris, 1903, 20p.

Verlaine, Paul. *Confessions of a Poet.* Translated by Ruth Saltzman Wolf and Joanna Richardson. New York: Philosophical Library, 1950.

"Vincent van Gogh and Glaucoma." *Journal of the American Medical Association* 218 (Oct. 1971): 595–596.

Vogt, Donald D. "Absinthium: A Nineteenth-Century Drug of Abuse." *Journal of Ethnopharmacology* 4 (1901): 337–342.

_____, and Michael Montagne. "Absinthe: Behind the Emerald Mask." *International Journal of the Addictions,* 17 (1982): 1015–1029.

Vyhnanek, Louis Andrew. *The Seamier Side of Life: Criminal Activity in New Orleans in the 1920s.* Dissertation, Louisiana State University and Agricultural and Mechanical College. 1979.

Walker, Emma E., M.D. "The Effects of Absinthe." *Medical Records,* 13 Oct. 1906, 568–572.

Wernick, Robert. "Opening the Door to the Art of the 20th Century." *Smithsonian,* 19 (May 1988): 59–69+.

Wertenbaker, Lael. *The World of Picasso.* New York: Time, 1967.

White, Barbara Ehrich. *Impression in Perspective.* Englewood Cliffs, N.J.: Prentice-Hall, 1978.

Wilkins, David G., and Bernard Schultz. *Art Past, Art Present.* New York: Harry N. Abrams, 1990.

"The Wine Trade." *London Times,* 8 June 1914, 28.

Wolff, Geoffrey. *Black Sun.* New York: Random House, 1976.

Wright, Alfred John, Jr. *Paul Verlaine and the Musicians.* Dissertation, Columbia University, 1950.

Zola, Emile. *L'Assommoir.* Ed. Leonard Tancock. Harmondsworth, England: 1970. Penguin Classics.

————. *Les Rougon-Macquart.* Paris: Gallimard, 1961.

Zolotow, Maurice. "Absinthe." *Playboy,* June 1971, 169–174.

INDEX

abolitionists in France 36
absinthe vii, 1, 2, 4, 7, 10, 12, 13,
 15, 16, 17, 18, 19, 20, 22, 23,
 25, 26, 27, 28, 30, 32, 34, 36,
 37, 38, 39, 40, 41, 42, 43, 44,
 45, 46, 47, 52, 53, 55, 59, 61,
 66, 67, 68, 70, 71, 72, 73, 74,
 75, 80, 81, 82, 83, 86, 87, 88,
 93, 94, 104, 115, 117, 118, 121,
 123, 124, 131, 132, 135, 142,
 144, 145, 147, 148, 150, 151,
 152, 153, 154, 155; abuse 44,
 45; addiction viii, 38, 40;
 advertisements 28, 29; alcoholic
 content 2; banning 4, 36, 37,
 38, 40, 41, 43, 44, 45; in Bible
 2, 3; bottle labels 29; manufac-
 turers 37; poisoning 92; spoons
 24
L'Absinthe (Benasset, lithograph)
 122
L'Absinthe (Degas, frontispiece)
 82, 105, 106, 108, 109
L'Absinthe (Monge) 82, 122
Absinthe (play) 151
Absinthe (poster) 149, 151
Absinthe (van Gogh) 80
Absinthe Drinker (Manet) 97, 99
The Absinthe Drinker (Lautrec)
 (1888) 115
The Absinthe Drinker (Manet)
 (1859) 16, 101
The Absinthe Drinker (Orphen) 122
The Absinthe Drinker (Picasso)
 (1901) 116, 117

Absinthe Drinkers (Raffaelli) 110
Absinthe et absintheurs (book) 16
Absinthe Frappe (drink) 135
"Absinthe Frappe" (song) 124
Absinthe Glass (Picasso) 118, 119,
 120, 121, 122
Absinthe House (Du Bois) 148
Absinthe Parisienne (poster) 11
"The Absinthe Room" (saloon)
 132
"Absinthe Suissesse" (drink) 135
absintheur 12, 13, 14, 15, 47
"Absinthia Taetra" (poem) 70, 71
absinthism 10, 14, 19, 28, 33, 40
Academy of Medicine 34, 44
advertisements 28, 29
alcoholism 30, 31, 32, 33, 38,
 40, 44, 142
alcool 32
alcool d'industrie 18, 19
alcool du vin 19
Aleix's Coffee-House 132
Algerian War 152
Algiers vii, 15
The (All) Night Café (van Gogh)
 85
Alps 23
American Journal of Pharmacy 30
Amony, Rober 33
Anderson, Elizabeth 138, 139
Anderson, Sherwood 138, 139
Anderson, Tom 128
Andrée, Ellen 106, 108, 109
animals in research 37
anise 1, 7, 8, 43, 44

177

aniseed 135
anisette 7, 44
Anything for a Quiet Life (Middleton) 4
apéritifs 22, 25, 27, 37, 43
Apollinaire, Guillaume 13, 116;
 Under the Spell 122
Arles 63, 81, 82, 83, 88, 89, 91, 92, 95
L'Arlésienne (van Gogh) 86
The Arlington (house of prostitution) 128
art-for-art's sake 68
Artemis 2
Artemisia 6
Artemisia absinthium vii, 1, 2, 32
Artemisia absynthium 5
Artemisia maritima 4
L'Assommoir (Zola) 31
At Grenelle, Absinthe Drinker (Lautrec) 115
At the Brothel (Bernard) 86
At the Café (Au Café) (Manet) 100, 106
At the Moulin Rouge (Lautrec) 113, 114
The Autobiography of Alice B. Toklas (Stein) 40
Auverssur-Oise 88
Avril, Jane 104, 113

Babylon 8
The Ballad of Reading Gaol (Wilde) 68, 75
Bar at the Folies-Bergère (Manet) 102
Barcelona (Picasso in) 116
bartender 21
Barth, Jean-Baptiste 30
Basin Street (prostitution) 128
Baton Rouge 124
Battle of New Orleans 132
Baudelaire, Charles 13, 31, 51, 98, 115, 146
Beauregard, General Pierre 141
Behrman, Martin 136

Beinville, Sieur de 124
Bel-Aire Insane Asylum 36
Balesta, Henri 16, 17, 26
Belgium 10, 45, 65, 79
Benasset, Emile 122
Beraud, Jean 122
Bernard, Emile 86
Berne 10
Bernhardt, Sarah 13
Bertrand, Victoire 53
Bible 2, 3
Bicetre 32
Bienville Street (New Orleans) 131, 133
The Blue Book 128
Bohemian(s) 46, 51, 58, 67
Bonnat, Léon 110
La Bonne Chanson (Verlaine) 48, 54, 55
Bordeaux 21, 34
Boston Medical and Surgical Journal 33
Bottle of Pernod and Glass (Picasso) 118
Bouches-du-Rhône 92
Le Boulevard, la Nuit (Beraud) 122
Bouligny, Mary S. 104
Bourbon Street (New Orleans) 131, 133, 135
Brazil 10
Brennan's Restaurant (New Orleans) 135
Brizard, Marie 7
Brouwer, Adrian 98
Bryant, William C. 141
Bubbles and Ballast (Bouligny) 104
Les Buveurs d'Absinthe (de Kock) 16

cabaret de luxe 21
cabarets and cafes 20, 26
Caesar's Grill 151
Cafe-Brasserie de Divorce 22
cafe-chantant 104
Café de Bade 101
Café de la Gare 83

Café de la Nouvelle-Athènes in Place Pigalle 105
Café du Tambourin 115
Café Duerbois 110
Café Guerbois 101
Café Napolitain 26
Café Weber 114
California 150
Callias, Nina de 51
Canal Street 126, 128
Caricature (magazine) 104
Casagemas, Carlos 116, 117
Cazals, F. A. 65, 66
Cazebonne, Pierre 135
Chamber of Deputies 35, 40
Champs Elysées 105
Chaveau, Paul 74
Charles, François 116
Charleville (in the Ardennes) 56
Chartres Street (New Orleans) 126
Chez le Père Latuille (Manet) 106
Chiron, the Centaur 2
Circe 22
Civil War 130
Clemm, Maria 143
Clemm, Mrs. 142, 144
Club des haschischins (Gautier) 58
cocaine vii, 1, 147
Cocteau, Jean 48
Commugny 36
Commune 18, 19, 20, 30
Confessions (Verlaine) 47, 56, 57, 63, 64
Confessions of an Opium Eater (De Quincy) 71
Congress 137
Congress of Hygiene 38
consumption (in France) 38
Coppée, François 48, 51
Coquelin 13
cordonnerie 132
Corelli, Marie (*Wormwood*) 12, 14, 15, 23
Cormon, Fernand 110
"la correspondance" 35
Corvet, Switzerland 8
Cosmos (journal) 33
cotton industry 129

Cotton Market of New Orleans (Degas) 131
Coulommes 63
coup d'état 20
Couture, Thomas 16, 98
Crane, Hart 147
Creoles 130, 131
Crete 8
La Croix 31
Cros, Charles 72
Cros, Dr. 59
Crosby, Harry 145, 146, 147
Crows Over the Wheat Field (van Gogh) 75, 96
Cubism 119
Culpepper, Nicholas 6

Darwin, Charles 14
Daubs 37
Daumier, Honoré 103, 104
David, Elizabeth 7
De Materia Medica (Dioscorides) 3
De Venenis (Lindestolophe) 32
Death in the Afternoon (Hemingway) 150
debit 20
débitant 21
débits de boissons 20, 153
Debussy, Claude 48
Decadents 48, 71
Degas, Edgar viii, 13, 27, 79, 101, 104, 105, 106, 110, 131; *L'Absinthe* (1878), frontispiece 105
Dehée, Elisa 48
Le Dejeuner sur l'Herbe (Manet) 101
Demeny, Paul 58
demi-mondaine 28
Les Demoiselles d'Avignon (Picasso) 73
Desboutin, Marcellin 106, 108, 109
Diana 2, 7
Dioscorides 3
diposmania 30
distilled alcohol 32, 34, 37
Donaldsonville, Louisiana 124
Double Dealer (magazine) 138

Doubs region (France) 15
Doubs River 35
Douglas, Lord Alfred 68
Dowson, Ernest 70, 72
drunkenness 32, 33, 39
Dubied, Major 9
Du Bois, Guy Pene 148, 151
Duc d'Orleans 124
Duc de Richelieu 7
Dujardins, Eliza 50, 52
Dunning, Ralph Cheever 148
Durand-Ruel 100

Ebers Papyrus 2
Edward, IV (King) 7
Egyptians 7
Eighteenth Amendment 137
eighteenth century 4
Einstein, Izzy 138
Emboden, William 6
Emerson, Ralph Waldo 141
England 6, 8, 30, 38, 45, 62, 68, 70
English, Thomas Dunn 143
The English Physician (Culpepper) 6
épicerie 132
epilepsy 91
Europe vii, 1, 2, 10, 39, 77, 10
Europeans 9, 10

The Family of Saltimbanques (Picasso) 119
Faulkner, William 138
Fearon, Henry Bradshaw 125
"la fée verte" (the green fairy) 9, 22, 121
fermented drinks 34
Ferrer, Cayetano 132, 135
Fêtes galantes (Verlaine) 56
Fleurs du Mal (Baudelaire) 98
Fleurville, Mathilde Mauté de 52, 53, 54, 55, 56, 57, 58, 59, 60, 64
Foley, Charles (Absinth) 40

Folies-Bergère 103
Font, Pedro 132
For Whom the Bell Tolls (Hemingway) 150
Fournier, E. M. 35
France vii, viii, 1, 9, 10, 13, 14, 15, 16, 18, 19, 20, 22, 23, 26, 27, 30, 31, 32, 33, 35, 36, 37, 38, 39, 41, 42, 44, 45, 68, 81, 92, 123, 124, 130
Franco-Prussian War 18, 56
Frantz, Eugenie 67
French 8, 9, 10, 15, 16, 18, 20, 23, 26, 30, 31, 43
French decadence vii
French Opera House 132
French Parliament 22
French Provincial Cooking (David) 7
French Quarter 128, 135
French Salon 99
French Symbolists 146
French temperance movement 28
French verse forms 48
Fry, Roger 109

Gachet, Paul 88, 89, 94
Galen 3
Gare du Nord 26
Gaston 14
Gauguin, Paul 82, 83, 85, 86, 87, 88, 89, 92, 93, 95, 116, 117
Gautier, Théophile 51
Gem 151
Geneva 10
Gerard, John (Herball) 1
Gide, André 66, 68, 72
Ginoux, Madame 86
Gironde (river) 23
The Glass of Absinthe (1876) (Degas) 13, 107, 118
The Glass of Absinthe (1911) (Picasso) 13, 118
Glatigny, Albert 51, 52
Goupil and Company 77, 79
Gourmont, Remy de 66, 72
Gowans, William 143

Grafton Gallery 106, 107
La Grande Dictionnaire du XIX siècle 30
Greek etymology 39
Greeks 7
guinguettes 21
Guitar and Violin (Picasso) 118

The Hague 77
Halicarnassus 2
Hamlet 7
Hampton, Christopher (*Total Eclipse*) 67
The Happy Prince and Other Tales (Wilde) 68
hashish 46
Hector de Callias 51
Hemingway, Ernest 13, 139, 145, 147, 148, 150
Henry, O. 141
Herball 1
Herbert, Victor 124, 141
Herbsaint 135, 136
Hill, Henry 106
Hill, John 4
Hippocrates 10, 45, 65, 79
Hirst, Henry Beck 142
Holland 10, 45
Holmes, Oliver Wendell 141
homosexuality 57, 68
Hortus Sanitatis (Meydenbach) 8
Hôtel de Ville de Paris 51
Hôtel des Artistes 147
Hugo, Victor 51
Huss, Maynus 30

Illuminations (Rimbaud) 60
The Importance of Being Earnest (Wilde) 68
Impression, Sunrise (Monet) 79
Impressionism 79, 80
impressionist 79, 110, 114
industrial alcohol 32
insanity, increase of 37

Institution Landry 49
Irises (van Gogh) 90
Isaac Delgado Museum of Art 131
Italy 45
ivresse 32

Jackson, General Andrew 132, 141
Jacob, Max 116, 117, 118
Jacquet, M. 38
James I (King) 8
Jardin des Plantes 50
Jardin, Mabille 105
Jarry, Alfred 72, 73, 74, 115
Jaspers, Karl 91
John Barleycorn (London) 145
Joyce, James 147
Juliana Codex (Dioscorides) 3
July's Husbandry 4
Juncadella, Francisco 132
junkers 138

Kahn, Gustave 72
Kay, Arthur 107
Kobayashi, Kideto 90
Kock, Henry de 16
Krantz, Eugenie 67

Lady Windermere's Fan (Wilde) 68
Lafitte, Jean 132, 141
Lake Borgne 137
Lake Ponchartrain 137
The Lancet (journal) 33
Lanfray, Jean 36
Latin Quarter 50, 51, 65, 66, 67
Lautrec, Albi 80, 81, 92, 110, 111, 112, 145
Leconte de Lisle 51
Ledoux, E. 15
Leenhoff, Leon 99
Lefebre 13

Left Bank (Paris) 66
Lepelletier, Edmond 47, 50, 54, 55, 57
Lind, Jenny 141
Lindestolophe, Johan 32
Little Dancer (Degas) 121
"little Paris of North America" (New Orleans) 10
The Little Student (Degas) 107
Littre, M.P. Emile 33
London 59, 60, 77, 107
London, Jack 118
Longfellow, Henry Wadsworth 141
Loue River 35
Louis XIV 15, 124
Louis-Napoléon, decree of 20
Louis-Philippe (King) 104
Louisiana 124
Louisiana Purchase 127
Lowell, James Russell 141
Loyer, Ursular 77
Lunois 13, 50
Lycée Bonaparte 50
Lyon 10

MacDonough, Glenn 124
Magnan, Dr. V. 33
Maignan, Albert (*The Green Muse*) 122
La Majeste l'Alcool 9
Mallarmé, Stephané 72, 73
Malvy, Louis 40
Man with Pipe (van Gogh) 88
Man with Severed Ear (van Gogh) 88
Manet, Edouard viii, 16, 27, 97, 98, 99, 100, 101, 102, 103, 104, 106
Marce, Louis 32
marijuana 138
Marquesas 145
Marriott, Charles 109
Marseille 10, 25, 82
Maupassant, Guy de 13
Maurer, Alfred 40
Mausolus 2

Medical Record (journal) 34
Mediterranean Sea 23
Melmoth, Sebastian (*Melmoth, the Wanderer*) 68
Mercure de France 73
The Merry Wives of Windsor (Shakespeare) 4
Meydenbach, Jacob 8
Middle Ages 3
Middleton, Thomas (*Anything for a Quiet Life*) 4
Midsummer Eve 4
A Midsummer Night's Dream (Shakespeare) 6
minister of the interior 40
Mississippi River 124, 137
Monet, Claude 79, 101, 102
Monge, Jules 82, 122
Monod, Wilfred 42
Monsieur Boileau at the Cafe (Lautrec) 112, 115
Monticelli, Adolphe Joseph Thomas 81, 82, 92
Montmartre 73, 104, 110, 111, 112, 116, 147
moonshining 43
Moore, George 109
Moreas, Jean 65
Moreau, Gustave 115
Morgan, J. Pierpoint, Jr. 145, 147
morphine 138
Morwyng, Peter 4
Morrow, W.C. 151
Moses, Jerome 3
Motet, Dr. 32
Moulin Rouge 104, 110, 111, 113, 114
Moyne, Jean Baptiste le 124
Munich 107
Museum Pau 131
Musser, Alfred de 16
Musson, Estelle 131
Musson, Michael 131

National Assembly 35, 40, 44
National Prohibition Act 137

Natural History (Pliny) 7
Netherlands 45
New Orleans vii, viii, 10, 124, 125, 126, 127, 129, 130, 131, 132, 135, 136, 137, 138 139, 140, 141, 150; cotton market 131; Fairmont Hotel 135; harbor 131.
New York 42, 77
Night Cafe (van Gogh) 84, 86, 95
nineteenth century 1, 27, 30, 33, 46
North Carolina 43
Notes on a Cellar book (Saintsbury) 27
Notre Dame 51
La Nouvelle Athenes 106

Oberon 6, 7
Old Absinthe Bar 135
Old Absinthe House 124, 131, 132, 133, 135, 139, 140, 141, 148, 151
opium 16, 46, 147, 148
Ordinaire, Pierre 8, 9
Orphen, Sir William 122
"Over an Absinthe Bottle" (story) 151

Paracelsus 3
Paris 10, 13, 14, 15, 18, 19, 21, 22, 23, 25, 26, 27, 32, 40, 42, 49, 52, 56, 57, 59, 60, 63, 68, 73, 77, 79, 80, 81, 87, 93, 101, 102, 107, 110, 131
Paris Asylum at Sainte-Anne 33
Parliament 41
Parnassians 48, 51, 57
Parragona 13
pastis 44
Paulding, James Kirke 143
Pepys, Samuel 4
Pernod 136
Pernod, Henry-Louis 9

Pernod Fils (factory) 9, 15, 35, 148
Pernod incident 35
Petronius 47
Peyron, Dr. 91
Philippe, Louis (Duc d'Orleans) 124
phylloxera (plant lice) 18
Picasso, Pablo viii, 13, 73, 115, 116, 117, 118, 119, 120, 121, 122; Blue Period 13, 117
The Picture of Dorian Gray (Wilde) 68, 70, 146
Pissarro, Camille 79, 88, 101
Place Pigalle 106
Plato 31
Pliny, the Elder 4, 7, 8
Poe, David 142
Poe, Edgar Allan 13, 141, 142, 143, 144
Poe, Henry 142
Poe, Rosalie 142
Poèmes saturniens (Verlaine) 56
The Poet Cornutti (Picasso) 117, 118
Ponchon, Raoul 72
Pontarlier (France) vii, 9, 15, 35
Port of New Orleans (Sinclair) 129
Portrait of Dr. Gachet (van Gogh) 90
The Potato Eaters (van Gogh) 85, 95
Pound, Ezra 148
prefects 20, 41
prohibition 14, 37, 39, 41, 42, 43, 44, 45, 132, 135, 136, 139, 145
prostitution (New Orleans) 127, 128, 129
Pyrenees 23
Pythagoras 8

Quartier Latin (Latin Quarter) 50
Queen Artemisia II 2

Raffaelli, Jean-François 79, 107, 109
Ravel, Maurice 72
"The Raven" (poem) 142
Reconstruction 131
Reid, Alexander 107
Renoir, Auguste 27, 79, 101
Repetition (Degas) 107
Rethel (France) 63
Rey, Felix 88, 91
Riese, Walter 91
Rimbaud, Arthur viii, 13, 18, 56, 57, 58, 59, 60, 61, 62, 67, 68, 145
Robert, Henri 38
Robin, Charles P. 33
Romances san paroles (Verlaine) 48, 59
Romans 7, 8
Romanticism 51
Roosevelt, Theodore 136, 141
Rops, Félicien 13
Roulin, the postman 83
Royal Academy of Painting amd Sculpture 99
Rue des Beaux-Arts 67
Rue Descartes 67
Russia 10, 41
Rutherston, Albert (The Glass of Absinthe) 122
Rutter, Frank 109

Sagesse (Verlaine) 48, 50, 61
St. Alban's Hawking Book 4
St. Luke's Day 3
Saint Remy 88, 91, 93
Saint Sauveur 27
St. Thomas's Hospital 4
Saintsbury, George 27
Salon 98, 101, 102, 103, 110
Salon des Réfusés 101, 102, 103, 110
San Francisco 150
Sartain, John 142, 144
Saunier, L. Baudry de 9
Sazerac Room 135

Schmidt, Henri 35
A Season in Hell (Rimbaud) 62
Seine 50, 51
Self Portrait (Picasso) 116
Self Portrait (van Gogh) 87, 116
Senate and National Assembly 35, 40
Senefelder, Alois 103
Shakespeare, William 4, 6
Sherard, Robert H. 71
Sidewalk Cafe at Night (van Gogh) 95
Signac, Paul 79, 93
similaires 43
Sivry, Charles de 52, 54
Smithers, Leonard 72
Société Medicale des Hospitaux de Paris 38
Society for the Study of Addiction 75
Sons of Temperance 144
Southern Literary Messenger 142
Spain 1, 10, 13, 45
Spanish Civil War 148
speakeasy 137
The Starry Night (van Gogh) 75, 89, 95
statistics 39
Stein, Gertrude 40
Stenzelius, Christianus 32
Still Life with Billiards (Lautrec) 115
Stoddard, Major 125
Storyville (section of New Orleans) 128
Stowe, Harriet Beecher 105
Strindberg und van Gogh (Jaspers) 91
sugar cane production 130
The Sun Also Rises (Hemingway) 148, 150
Sunny Memories of Foreign Lands (Stowe) 105
the Swamp (New Orleans house of prostitution) 127
Swinburne, Algernon Charles 109
Swiss doctors 36